EVERYDAY
ICON

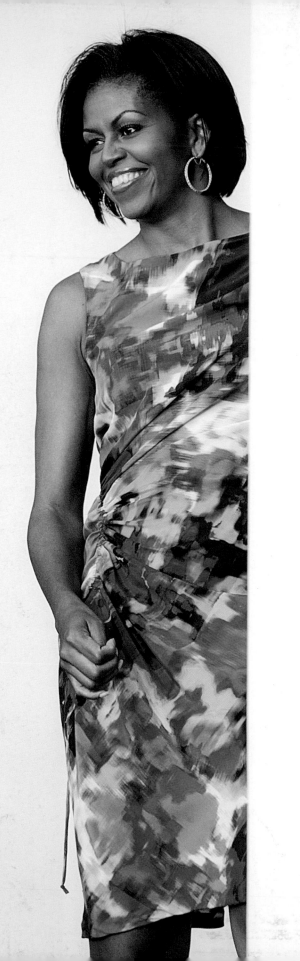

EVERYDAY
ICON

MICHELLE
OBAMA
AND THE
POWER
OF
STYLE

KATE BETTS

CLARKSON POTTER/PUBLISHERS
NEW YORK

Library of Congress Cataloging-in-Publication Data

Betts, Kate.
Everyday Icon: Michelle Obama and the power of style / Kate Betts.—1st ed.
p. cm.
1. Clothing and dress—United States. 2. Fashion—United States. 3. Women's clothing—
United States. 4. Popular culture—United States. 5. Obama, Michelle, 1964-–
Clothing. 6. Presidents' spouses—Clothing—United States. I. Title.
GT615.B48 2011
973.932092—dc22 2010008895

ISBN 978-0-307-59143-2

Printed in China

Design by Stephanie Huntwork

10 9 8 7 6 5 4 3 2 1

First Edition

For my mother,
Glynne Robinson Betts

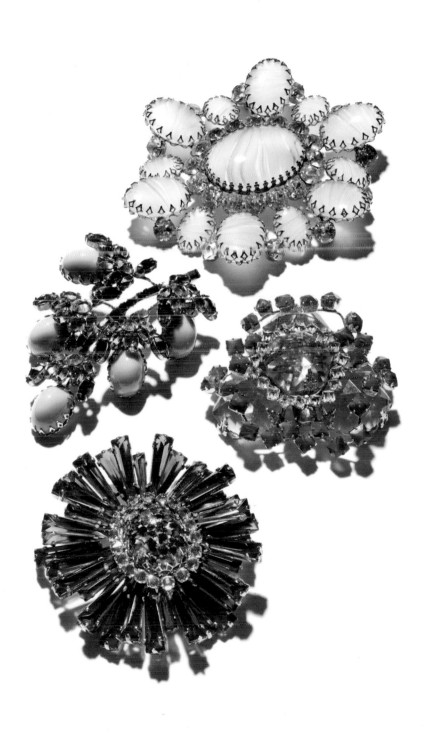

CONTENTS

INTRODUCTION ix

1 FIRST IMPRESSIONS 1

2 STYLE VERSUS SUBSTANCE 21

3 THE DRESSMAKERS' DETAILS 59

4 THE EVERYDAY ICON 91

5 WELCOME TO THE WHITE HOUSE 133

6 ONLY CONNECT 183

7 FIND YOUR SPOT, FIND YOUR PLACE 207

ACKNOWLEDGMENTS 223

NOTES 227

INDEX 238

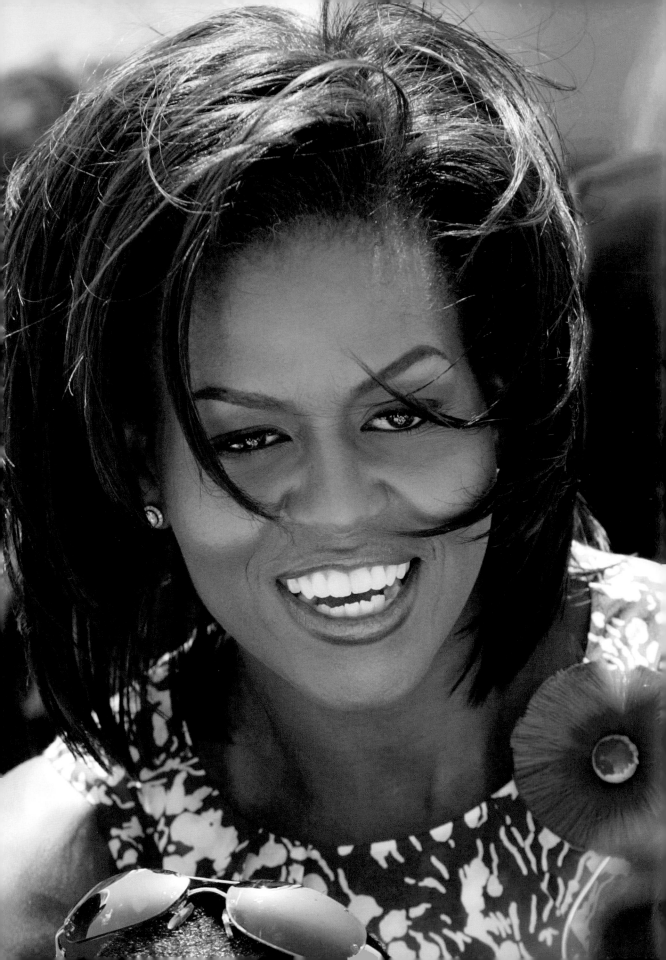

INTRODUCTION

Thinking book is about why style matters, and why in particular the style of the new American First Lady Michelle Obama matters.

In many cultures—French, Italian, Russian, and Japanese, to name a few—why style matters is self-evident and arguing in defense of it is like arguing on behalf of music or art or even clean water and fresh air. But Americans are ambivalent about style. We are by turns attracted to and afraid of style, fascinated and suspicious. We confuse it with transient fashion trends and logo-splashed clothes. Too often American women subvert their sense of style and don a uniform instead. They play it safe so as not to detract from their intellectual contributions. Style is frivolous; style is for airheads. Tenacious conventions pit style against substance and suggest we have to choose one or the other as a defining focus or sensibility: you can work for shoes and bags or you can work for world peace. But not both.

Somehow having style has come to be associated with the idea that people can be judged solely on their appearance rather than, as

Martin Luther King Jr. famously remarked in another context, the content of their character. Nothing could be further from the truth. Style is a part of the content of one's character.

Michelle Obama's style matters, and one of the reasons she exemplifies the power of style is that she is helping to liberate a generation of women from the false idea that style and substance are mutually exclusive. She reminds us that while style can certainly be expressed in the way you look and what you wear, it is inextricably bound up in who you are and what you believe in. It reflects your values. It bespeaks your manners, your sense of occasion, your individuality and self-respect. It also illuminates in the best sense your desire to make an impression, your awareness of others and the community we share. Style, simply put, is a civilizing force.

Michelle Obama would not have made such a strong impression on the women of my generation if we had completely resolved the tensions of substance and style. Both of us were born in 1964—the last year of the baby boom—and benefited from the pioneers of feminism who came ten and twenty years before us, women who shattered glass ceilings, occupied corner offices, and delivered on the seemingly impossible promise of having it all.

I got my aesthetic education like many kids growing up in New York City in the early 1970s. Style, like language, was something you absorbed unconsciously from the culture of the city itself. The style classrooms of New York were the city's streets and art galleries, its nightclubs and rush-hour lobbies. New York then seemed full of trailblazing women who were conquering new professional worlds with their personal style in full bloom. Women like Barbara Walters reporting on the *Today* show about Vietnam, Gloria Steinem starting *Ms.* magazine, and Diane von Furstenberg launching her famous wrap dress. Looking back I can see that one of the reasons they stood out was that they were the exceptions not the rule. It wasn't until I

Striking the pose: At Princeton in February 1985, Michelle Robinson (*at left*), then a senior, modeled student-designed fashions along with fellow student Kim Battle for a story in the *Newark Star-Ledger*. *Page viii*: Many years later as First Lady, Michelle Obama demonstrates the same innate sense of style as she greets sailors at the Norfolk Naval Station in July 2009.

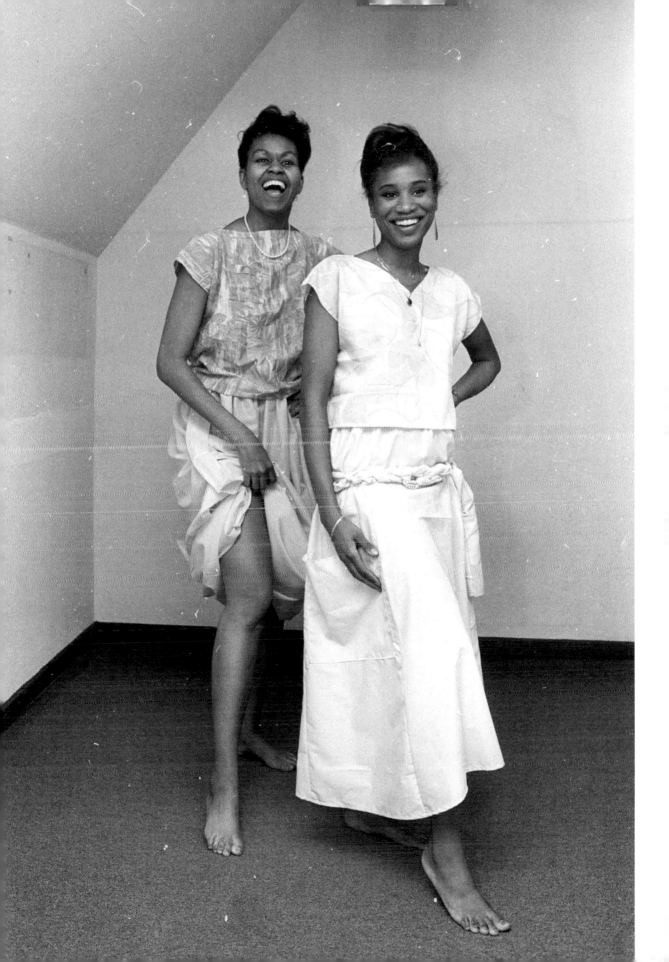

moved to Paris that I was fully immersed in a culture that understood style was substance, and that a lack of style could signal a deficit of substance. Later I was inspired by the bravura motto of the legendary *Harper's Bazaar* editor Carmel Snow who called her muse "the well-dressed woman with the well-dressed mind." But time and again I would run up against women who seemed more comfortable with style and substance inhabiting two separate worlds.

As the generation led by the new First Lady consolidates and extends the gains of its predecessors, American women still wrestle with the question of appearance. We worry whether paying attention to what we wear will automatically entitle people to disregard what we say or do. We wonder whether the wrong outfit will violate some cultural no-fly zone. The unwritten rules have certainly been relaxed over the decades of feminist-driven change, but we are still confronted with having to figure out what the rules are.

This, I think, is another reason why so many women are drawn to the style of the woman in the White House. I've tried in this book to trace the role Michelle Obama's innate sense of style played in her journey from the South Side of Chicago to Princeton to that dizzying inaugural morning when she appeared before the world as an almost shockingly sudden new icon of style. What the world saw in January 2009, and many Americans had first glimpsed at the Democratic National Convention in the summer of 2008, was already evident when the future First Lady was a student at Princeton University in the early 1980s. When a small group of black women students at the university decided to put on a fashion show of clothes they'd sewn themselves, the first person they asked to model was a statuesque junior then known as Michelle Robinson. As a student she didn't wear anything trendy—some of her sleeveless dresses were remarkably similar to clothes she wears now in the White House— but she carried herself with an athletic ease and grace and seemed to have an implicit understanding of Coco Chanel's famous dictum:

"Dress shabbily and they notice the dress; dress impeccably and they notice the woman."

Now in the White House, Michelle Obama is using her self-possessed style to set the tone and to define a new etiquette of power. She represents in many ways the fulfillment of the dreams millions of mothers and grandmothers had for their daughters. She seems remarkably unintimidated by traditions that have subjugated women for centuries. She's not afraid her dignity might be compromised by a barefoot dash across the White House lawn. She's not worried about some scandalous breach of protocol when she spontaneously touches the Queen of England. She has reached out to touch women from many different backgrounds, high and low, rich and poor; women of many ethnicities and creeds. Her gospel generally falls along the lines of empowering women for what they might make of their lives. It is a gospel that is rooted in the substance of style, a gospel that defines style as knowing who you are and being unafraid to show it to the world.

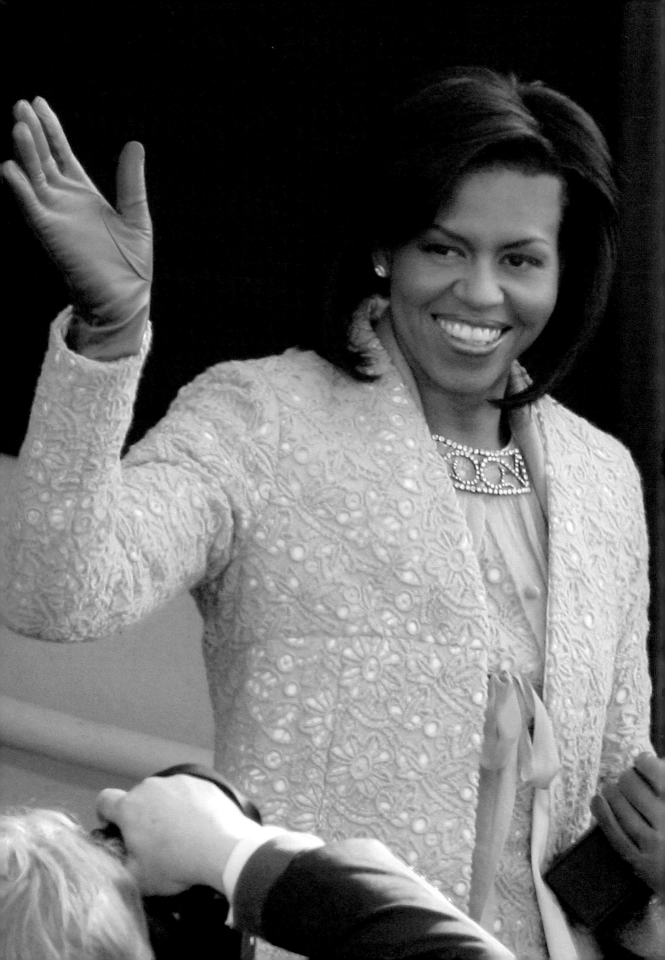

1 FIRST IMPRESSIONS

It was as close to a coronation as exists in the world's oldest democracy. As she emerged from Blair House with her husband, Barack Obama, at the start of that historic inaugural day in January 2009, there seemed something truly regal about Michelle Obama.

The incoming First Lady and president-elect were on their way to morning services at St. John's Episcopal Church, the first of many stops on a schedule parsed to the minute. They paused for a moment under the green canopy that extends from the Federal-style facade of Blair House, the nation's guest quarters across the street from the White House. Before the cameras, the incoming First Lady seemed artlessly at ease, confident, almost aglow. She carried herself in that effortless way of stylish women, as if she had hardly given a thought to what she might wear on such a momentous

On the historic day of her husband's inauguration, Michelle Obama chose to wear a wool lace coat in lemongrass, a color that designer Isabel Toledo described as a symbol of rebirth.

occasion but had managed nonetheless to throw together an outfit that was perfectly suited to the moment—exactly and unforgettably right.

On that bright frigid morning, she was wearing a knee-length straight coat and dress made by the Cuban-born designer Isabel Toledo. The cut of the coat was simple, but the texture and composition of the fabric—wool lace from Switzerland lined with a stiff, taffetalike fabric called radzimir and silk net—was complex. Even more remarkable was the color. Journalists around the world struggled to pin it down—a *Wall Street Journal* writer saw it as pale gold. A correspondent from London's *Guardian* newspaper described it as a "glinting, greenish gold." Part of what made the shade so intriguing, if not elusive, was the contrast it offered to the standard Washington power palette of bully reds and blues traditionally chosen for inaugurals. In the hue of her coat—which designer Toledo called lemongrass and hoped would evoke the idea of rebirth and renewal—Michelle Obama, the first African American First Lady, had found a potent symbol of the electorate's hunger for change, a symbol that could be read in any language by the millions of people at home and abroad who were following the historic day on television. The glamorous shimmer of the radzimir vied with the sparkling Victorian brooch she had pinned at her neck—not one of those million-dollar necklaces high-end jewelers loan actresses for the Academy Awards but a piece of paste jewelry worn without pretension. When she lifted her hand to wave, she revealed a jade green glove—a glove not from some recherché couture house, but a practical accessory any woman could afford from a retailing mainstay of American malls, J.Crew.

All that day, you could not help but watch her. At the swearing-in on the West Front of the Capitol, at the lunch in the rotunda, during the out-of-the-limo stroll down Pennsylvania Avenue, and later that night throughout an epic round of balls and parties, all

eyes were on the new First Lady. She seemed almost inhumanly at ease, natural, relaxed, spontaneous, as if playing a part she was born to play. It was an astonishing debut on the grandest stage, and all the more amazing for the calculation and the work that went into it.

GIVEN MICHELLE OBAMA'S conquest of the inaugural stage and her triumphant whirlwind tour of European capitals two months later, it's easy to forget that in the early days of her husband's campaign for the presidency, she had appeared to be more of a liability than an asset. If it's hard in politics to create a good image, it's even harder to shake a bad one. Three months after her husband announced his bid for the presidency, Michelle Obama put her own career on hold—no small sacrifice for a graduate of Harvard Law School with a $300,000-a-year job as a vice president of community and external affairs at the University of Chicago Hospitals. She began traveling with the campaign and making speeches. In some of her early appearances, she struck many people as impoliticly blunt, impulsive, sometimes overly candid, relaying out-of-school tales about how her husband didn't pick up his socks. As Obama senior adviser David Axelrod would later say to *The New Yorker,* Michelle's forthrightness "occasionally . . . gives campaign people heartburn." *New York Times* columnist Maureen Dowd was of the opinion that Mrs. Obama was "emasculating." Even the depth of her patriotism was questioned when, alluding to the hunger for change she sensed among voters, she told the crowd at a Milwaukee rally in February 2008, "For the first time in my adult life, I am really proud of my country." Conservative commentators at the *National Review* began calling her "Mrs. Grievance." No doubt she had stirred the ghost of old racial stereotypes in a country that, apart from entertainers like Oprah Winfrey, had very little experience with black women as national figures. What might have been seen as refreshing "maver-

ick" candor in a white political figure struck some people as confrontational. The syndicated columnist Cal Thomas dubbed her "an angry black woman"—a charge amplified in the echo chamber of Fox News.

Tellingly, the wardrobe she favored at the time didn't do much to counteract the spin. In the formidable if subtle way of fashion, her sculpted, pinstripe Armani-esque power suits and streamlined MaxMara-style tweeds may have even reinforced some of these negative stereotypes. Sure, the pointy stiletto boots, snug tailored jackets, and power pearls suggested a refined sense of personal style. But the image they conveyed was of a hard-edged businesswoman, dressed for corporate conference rooms and exasperated by the inconvenience of her husband's far-fetched ambitions, which left her juggling career and kids while he crisscrossed the country giving speeches to adulatory crowds.

By the time Barack Obama clinched the Democratic nomination in June 2008, a worrisome percentage of voters still held reservations about his Ivy League wife. Her approval rating lingered at 43 percent. Something had to be done. Political dreams have been dashed on less daunting obstacles than an unpopular spouse. With a savvy sense of what was necessary, and no hint of strain, in a matter of weeks Michelle Obama appeared to make a vital midcourse correction. She changed the content and tone of her speeches. She changed the way she dressed. She replaced the corporate armor of sleek jackets and pantsuits with soft cardigans and June Cleaver–esque 1950s-style floral print dresses. On the surface it looked as if Michelle Obama was swapping Power Woman for Power Wife. It would be easy to say that the changes she made in her tone and her appearance were pure political expedience and a regrettable, self-canceling step backward for independent women. But that would underestimate Michelle Obama's acute awareness of style, its role in culture, and the part it played in her effort to define herself as she traveled from a working-class neighborhood

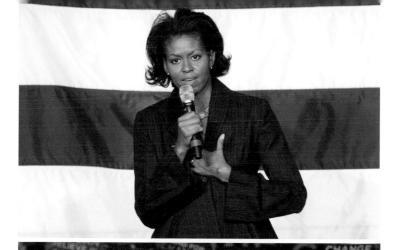

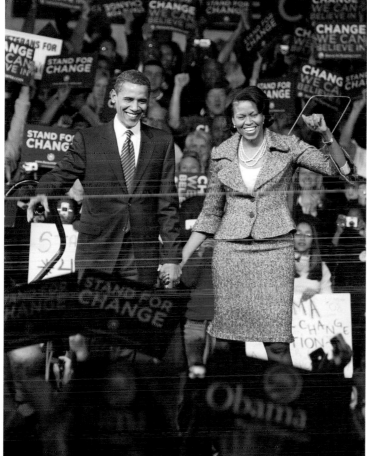

In the early days of her husband's presidential campaign, Michelle Obama stuck to corporate style suits. She was all business in pinstripes at a fund-raiser in New York in March 2007 (*top*). She stepped out in a Peter Soronen tweed suit to celebrate her husband's victory in the South Carolina primary in January 2008 (*middle*), and at a fund-raiser in Atlanta she accessorized her pinstripes with pearls— and a hug (*bottom*).

on the South Side of Chicago to the elite enclaves of Princeton and Harvard, and eventually to the lordly offices of life as a corporate lawyer.

Perhaps more than any First Lady before her, with the exception of Jackie Kennedy, Michelle Obama understands that style is much more than an aesthetic choice or political tool; it is the expression of one's life, one's way of being. Style is who we are. It speaks to what we would like to be and what we inescapably are. It registers both the persona and the person. The slightest stylistic gesture can reveal a wealth of information about not only someone's essence but also her aspirations. Often a person's style is the only thing that reveals the secret aspects of the self. Style is a form of unspoken communication. Bright colors typically demonstrate confidence; bold patterns signal a determination to differentiate oneself from the crowd. Traditional suiting implies power; jeans symbolize youth and freedom. No matter how we dress, even if we cover our heads with a burqa, our clothes reveal something about our identity and our beliefs. As such, Michelle Obama's casual cardigans and ultrafeminine dresses were an expression of her real self: a woman confident enough in her own accomplishments and beliefs to remove her corporate armor.

On the campaign trail Michelle Obama also recognized style as a language every woman understands regardless of her pedigree or heritage. You don't have to know who Azzedine Alaïa is to appreciate the thought that goes into a well-cut dress or the confidence you can derive from wearing a dazzling evening gown or a glorious shade of cyclamen. Where Jackie Kennedy used style to elevate American taste, Michelle Obama uses it to connect to women—both the women who might be uncomfortable with an African American First Lady and the millions of young African American women who finally have a brainy, hard-driving, professional success story to emulate. Without ever talking about it, she would deploy her style to convey a universal message of self-definition. She would show

women how to use their appearance to improve their self-image and, ultimately, their lives. With that in mind, she made the critical decision during a crucial juncture in the campaign to break out of the corporate mold and embrace her own innate sense of style—a decision that amplified her influence and effectiveness beyond her wildest dreams.

CANDOR AND CARDIGANS

Style makeovers, of course, are nothing new in politics, especially when it comes to First Ladies. Hillary Clinton overhauled her image many times. (Oh, the headbands!) At the end of Hillary's own presidential campaign, Oscar de la Renta was advising her to soften the edges by wearing pale pink and lavender instead of black. Laura Bush also benefited from de la Renta's nonpartisan counsel, while her mother-in-law, Barbara Bush, was almost exclusively dressed and advised by Arnold Scaasi. Some First Ladies needed designers and image makers to guide them, while others, like Nancy Reagan and Jackie Kennedy, arrived at the White House with an established look and a fluency in fashion. Although these two presidential spouses tweaked their images once they got to the White House, they knew exactly what they wanted to convey, and they crafted their respective looks with the help of handpicked designers.

As Michelle began to substitute homey anecdotes about tucking her kids into bed at night for stump speeches about public policy, she made parallel adjustments to her wardrobe, softening her look and enhancing the idea of accessibility through her clothing. She also began to flaunt her more fashion-forward sensibility. Although her workday uniform as a hospital administrator included

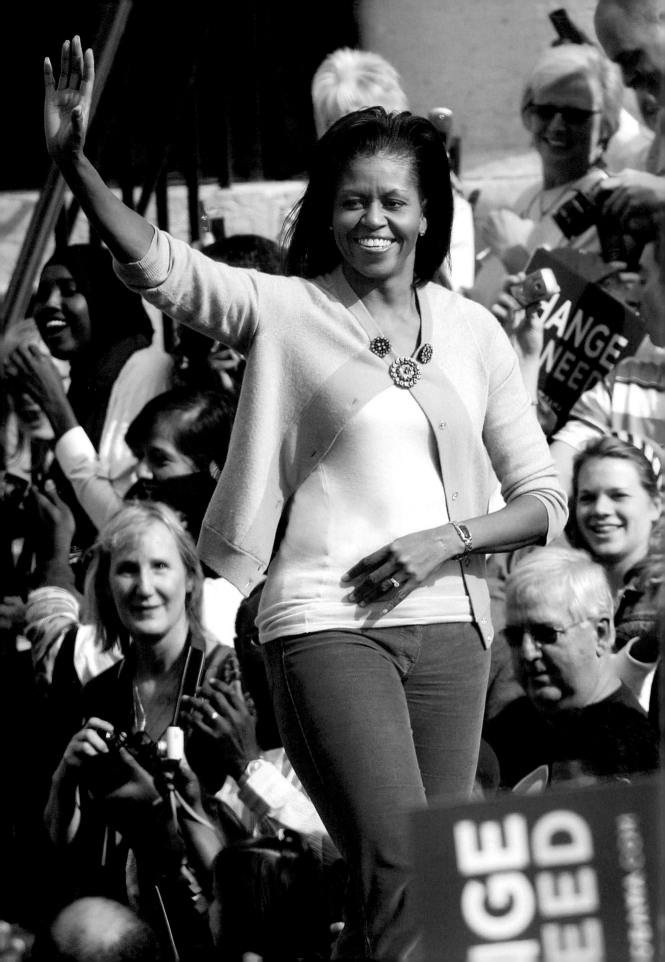

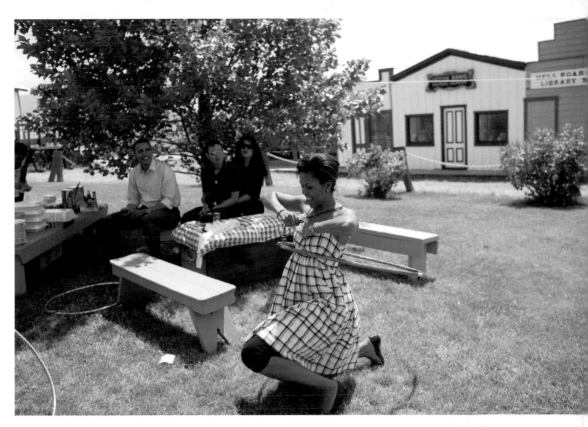

By the time she got to Columbus, Ohio in November 2008, Michelle Obama had transitioned from power wife to power mom. Her keep-it-real message came through loud and clear in Columbus (*opposite*) when she pulled out the signature cardigan and accessorized it with vintage brooches. Only a Hula-Hoop could match the easy style of a Gap sundress at a picnic in Butte, Montana (*above*). And when her kids traveled with her to Pueblo, Colorado (*right*), Michelle's casual approach made even more sense.

a wardrobe of sculpted Peter Soronen suits in nubby tweeds and Maria Pinto dresses in unusual colors—a far cry from Hillary's cookie-cutter pantsuits—all the boardroom silhouettes were closeted by June 2008 when Michelle breezed into a New York City fund-raiser in a glamorous black chiffon tunic and flowing pants by Isabel Toledo. In keeping with her own sense of humor, she replaced the dutiful corporate collar of a double strand of pearls with a sparkling knot of rhinestones designed by Tom Binns, the Irish jewelry designer known for his punkish style. Then she did the rounds of television talk shows and magazine cover interviews and cover shoots in her colorful cardigans, sleeveless sheaths, and the trademark wide belt hiked up around her rib cage. She told *Marie Claire* magazine that she was a Target shopper and that Stevie Wonder was her favorite artist of all time. She traded fashion tips, telling the ladies of the daytime talk show *The View* that "it's fun to look pretty" and explaining how to accessorize the $148 sundress from White House/Black Market she was wearing with a few brooches so that "you've got something going on." She danced to Rihanna's "Don't Stop the Music" with Ellen DeGeneres and joked about her daughter Sasha's snow globe collection. She wore quirky flats with cocktail dresses, pinned retro-looking brooches to her brightly colored cardigans, and kept revisiting that goofy wide belt. All of these seemingly insignificant sartorial gestures helped to define Michelle Obama as an individual who was at ease with her own style, comfortable in her five-foot-eleven frame, and ready to take on the public spotlight without losing her hard-won sense of self.

The politicization of Michelle's clothing choices really hit home the week vice presiden-

Stepping out for a fund-raiser in New York City in June 2008, Michelle Obama ditched the corporate look, arriving at Calvin Klein's Perry Street apartment in a sleek Isabel Toledo tunic and pants topped off by a glamorous Tom Binns rhinestone necklace.

"What I owe the American people is to let them see who I am so there are no surprises. I don't want to be anyone but Michelle Obama. And I want people to know what they're getting."

—MICHELLE OBAMA

tial candidate Sarah Palin plundered Neiman Marcus and Nordstrom for $150,000 worth of designer duds. It was at exactly that moment when Michelle Obama plopped down in Jay Leno's chair and announced that her outfit only cost $340. "We ladies, we know with J.Crew, you can get some good stuff online," she said, eliciting cheers from the audience. When Leno pressed her on whether or not she ordered the stuff herself, she coyly replied: "When you don't have time, you've got to click." In other words, no need for some costly last-minute fashion emergency when you're a smart, frugal shopper. When was the last time a future First Lady with a Harvard Law degree openly discussed her shopping secrets on national television? Even the stylish socialite Jackie Kennedy had gone to great lengths to downplay her Paris shopping sprees before she got to the White House. Michelle's ability to reconcile the fun and frivolity of fashion with the gravity of her résumé was surprising, refreshing, and, to millions of women, immensely appealing. Her approval ratings started to rise. At the end of August they had climbed to 53 percent.

By the time Michelle Obama reached the podium at Denver's Pepsi Center on the opening night of the Democratic National Convention in late August, fist-bumping her husband in a ravishing sleeveless purple Maria Pinto dress, she had finessed her transformation from professional woman (and primary breadwinner in the family) to mom in chief. A few nights later, when she described herself to the crowd as a sister, a daughter, a wife, and a mother, she undercut much of the previous criticism about Mrs. Grievance, the Angry Black Woman. Up on the jumbo screen, in a fitted and ever so slightly conservative turquoise dress, she was a bold and glamorous example of an American everywoman, embracing her kids, invoking her husband, giving the world a glimpse into her world. Her husband's advisers had suspected that once she was able to tell her story, show people her "realness," the tough reputation would disappear. "With Michelle, it's about the real thing," said the Chicago-based designer Maria Pinto, who had been dressing

Obama since 2004. "Her style is thought out, but it's not contrived or deliberate. It's a natural process for her."

In the final stretch of the campaign Michelle was nothing if not real, hugging reporters instead of shaking hands, often tossing her shoes off to go barefoot. At a Fourth of July picnic in Butte, Montana, she demonstrated her facility with a Hula-Hoop in a $79.50 sundress from the Gap. On the eve of the election at rallies in Pueblo, Colorado, she was hugging her kids in a striped T-shirt and purple jeans. The nonchalance and accessibility of her style matched her person-ality. And yet she wasn't afraid to admit to a passion for handbags, manicures, and designer belts. There was confidence and femininity in what she picked out to wear, but also surprise. She kept everyone guessing with her wardrobe choices, right up until the triumphant appear-ance in Grant Park on election night, when she walked out before thousands of people with her husband and her two daughters dressed in a fiery red and black embroidered silk dress by the designer Narciso Rodriguez—Rodriguez as surprised as everyone else to see her in one of his gowns. It was a provocative choice not only because it wasn't the stereotypical boxy St. John

"I come here as a mom whose girls are the heart of my heart and the center of my world—they're the first thing I think about when I wake up in the morning, and the last thing I think about when I go to bed at night. Their future— and all our children's future—is my stake in this election." —MICHELLE OBAMA AT THE DEMOCRATIC NATIONAL CONVENTION

suit favored by Washington wives, but also because it was difficult to read on television. The flash of red embroidery on the front of the dress was slightly obscured by a cummerbund-style belt and a black sweater that looked as if it had been shrugged on at the last minute for warmth, a gesture many read as too casual for the occasion. One blogger said the dress looked like a "lava lamp" and respondents in an online USA Today poll expressed their dislike by a margin of

Making her debut as mom in chief at the Democratic Convention, Michelle Obama flaunted her glamorous image in a Maria Pinto–designed sheath dress (*opposite*). The designer encouraged Michelle to wear vibrant colors like turquoise and periwinkle, as seen in the sketches above, to highlight her skin tone as well as her confidence. *Following pages*: Michelle's election-night dress symbolized the incoming First Lady's willingness to take risks.

two to one. All the same, the dress signaled Michelle's willingness to take risks. It confirmed her determination to go her own way, hew to her own style. Up on the podium in Grant Park on election night her clothes bespoke the character beneath: she was fiery, she was opinionated, she was vital, and she had a current of her own. She was no docile political spouse. She had used her smarts to escape Chicago's humble South Side. She had hauled herself into the Ivy League and eventually into a turbo-charged career. And now, as one of the most powerful female African American role models ever, she was a pivotal voice in her husband's campaign. In her rather brilliant lava lamp Michelle personified a twenty-first-century postfeminist ideal, one that unapologetically embraced the serious and the frivolous, the surfaces and the depths, the style and the substance. It was a night of triumph, and it ushered in a new level of visibility and influence that would culminate three months later in her star turn on the world stage of her husband's inauguration.

A CASE FOR PASTE

For those who worried that Michelle Obama might be wearing real diamonds in broad daylight on inauguration day, take note: The brooch she fastened at her neck like a collar was actually a Victorian glass paste sash pin. The use of glass paste in jewelry stretches all the way back to the Egyptians and the Romans, but the craft didn't become popular until the early eighteenth century when the increasingly prosperous French and English urban middle classes were looking for a less-expensive imitation of the elaborate diamond jewelry worn by royalty. Paste, as it is known (or strass, after Georges-Frédéric Strass who was appointed jeweler to Louis XV in 1734), was made of hand-cut lead glass faceted to resemble real diamonds. These faux stones were then backed by metallic foil and set in precious metals like sterling silver and gold to give them the brilliance of real stones. French and English royals commissioned fine jewelers to create paste versions of their elaborate hairpins, shoe buckles, necklaces, and dangling earrings

to wear while traveling so they could dupe highway robbers. In those days these styles were hardly considered cheap imitations. Glass is more malleable than diamonds and less costly, so craftsmen were able to create more extravagant designs, which made paste popular even among people who could afford real gems.

Today the most valuable vintage paste jewelry is either English or French and dates from the eighteenth century through about 1850—what is known among collectors as "the Age of Paste." Although the word *paste* is still used to define other imitation jewelry through the nineteenth century and even up through the 1940s, the eighteenth-century pieces are coveted by collectors for their soft luster. These five Art Deco brooches, from the collection of vintage jewelry dealer Carole Tanenbaum, are dated from 1910 to 1940. They may be more contemporary than the Victorian pin Michelle Obama wore, but they boast the same intricate detail and luster that makes paste so popular.

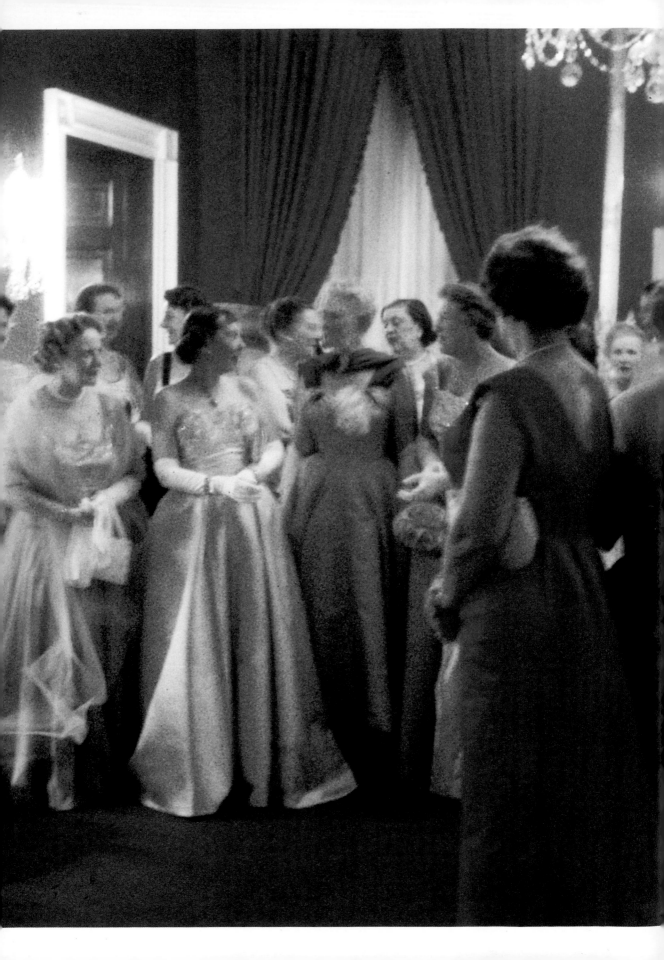

2 STYLE VERSUS SUBSTANCE

Every First Lady makes an impression, whether she means to or not. Some arrive at the White House already well versed in the sartorial requirements of the job—what Lady Bird Johnson referred to as "the harness of hairdo and gloves"—and embrace the style-setting authority of the role with gusto, as Jackie Kennedy did in 1961. Other First Ladies resent the expectation, or from insecurity or ambivalence they struggle with the language of imagery, failing to grasp why what makes them feel comfortable should be any of the public's business. Although she finally found an eight-days-a-week groove in Oscar de la Renta pantsuits, Hillary Clinton spent her first term in the White House wrestling with how much influence the First Lady's appearance carries. In her memoir, *Living History,* she confessed she was slow to comprehend that her appearance was no

Mamie Eisenhower (*second from left*), wearing her favorite shade of pink, receives guests in the White House Red Room for a state dinner honoring Supreme Court justices in 1958.

longer solely a representation of herself. "I was asking the American people to let me represent them in a role that has conveyed everything from glamour to motherly comfort."

Whether they are popular or unpopular, politically visible or hidden in the background, overtly stylish or uninterested in clothes altogether, our First Ladies highlight the ongoing evolution of American women. The purview of the job itself makes them symbols. They have the privilege or the burden of shaping their times through the speeches they give, the causes they support, and, most subtly, in the style they exhibit.

It is not a responsibility all First Ladies have embraced uniformly or with unalloyed enthusiasm. Some do cheerfully become fashion trendsetters, influencing everything from hairstyles (Frances Cleveland's shaved neck, Mamie Eisenhower's bangs) to colors (Harding blue, Reagan red) to hats (Dolley Madison's turbans, Jackie Kennedy's pillbox).

Others downplay style, or dismiss it outright, as if their devotion to policy and the gravitas of governance precluded an interest in anything so frivolous as fashion. Frugal, recession-savvy Rosalynn Carter famously flouted the fashion commandment that says Thou Shalt Not Neglect to Cough Up for a New Dress When Your Husband Is Elected President and wore the same limp frock to Jimmy Carter's inauguration that she had worn both times he was sworn in as governor of Georgia. It augured the style quotient of an administration in which the most famous fashion statement was her husband's decision to confront the high price of home heating oil by wearing a cardigan.

Even when they hide in plain sight, as Laura Bush did for most of her time in the White House (her Incurious George hosted only six state dinners in eight years), First Ladies are inevitably scrutinized. More so today than ever we are eager to hear what they think, what they're like, what their strengths and weaknesses are.

The First Ladies are symbols not just of power but also of an administration's psychological subtext, its emotional undertone. The most influential among them embraced the authority and influence that comes from being the feminine face of an administration.

Well before she reached the White House, Michelle Obama had signaled by way of her appearance not just her understanding of the charismatic aspects of the role but also how she might expand and employ it. On the campaign trail, she stressed that if her husband were elected she would be Mom in Chief. She tailored her image accordingly. It was politically wise to align herself with the long tradition of women who have embraced the role of First Lady as caretaker. But in her dress Michelle dropped hints that she would not be a caretaker in the grandmotherly manner of, say, Barbara Bush, or those meek, stick-to-their-knitting types in the nineteenth century who were happy to have the men ruling the world. With her flounced, floral print dresses, ballet slippers, and gaudy brooches, she gave the caretaker tradition a postfeminist twist, mixing frivolity and glamour. Mother her family as she might, she was not averse to baring her buffed arms, lest people forget the prospective Mom in Chief had strengths of her own, reservoirs of confidence, a warrior's resolve in the face of obstacles. Time and again what she wore underscored the point that she was not reluctant to go against the grain of female archetypes—whether they be the subordinated spouse or the adamant glass-ceiling smasher or the Washington Political Woman stuffed into her mannish suit.

But perhaps the most remarkable aspect of Michelle Obama—and really it is the essence of her style—is her innate ability to finesse the differences between what Eleanor Roosevelt observed was the "person" and the "persona"—the private self and the projected public image. The easy, almost effortless way in which Michelle Obama carries herself suggests not only that she has mastered the art of blending person and persona, but also that

she has resolved one of the contradictions that have plagued working women in America for the better part of a century: the mistaken but deeply entrenched belief that style and substance define two mutually exclusive paths, and that a woman has to choose one or the other.

You can see this contradiction played out in the two approaches that First Ladies have taken throughout history, some based in style, others in substance. The first approach, being more traditional, has a longer lineage. It runs from Dolley Madison to Jackie Kennedy and includes First Ladies who used style and image to advance their husbands' agendas and to cultivate their own influence. The other line follows the course of twentieth-century feminism. It runs from Eleanor Roosevelt to Hillary Clinton and comprises those First Ladies who broke with the traditional limits of the role and threw themselves into the political fray, testifying at congressional hearings, challenging conventions, and championing causes.

Given her widespread reputation as one of the most stylish women ever to inhabit the White House, you might think that Michelle Obama automatically belongs in the Madison-Kennedy lineage. A triumph of style over substance. But her background and activism argue differently. No one can claim that Michelle Obama doesn't know what it's like to work, or entered marriage because she didn't get an education and lacked economic power of her own. It is plain she has learned as much from the example of Hillary Clinton as from the example of Jackie Kennedy, if not more.

In some sense what makes her exceptional is that she seems so at home in both camps. So at home that the whole debate about style and substance suddenly seems passé, an anachronism of the gender wars, a false dichotomy enforced by male chauvinists or women at war with themselves. The fact that Michelle Obama does not see style and substance as an either/or choice is a powerful indication that the underlying assumptions about women's

roles and images have changed. Embodying the confluence of substance and style, she has reconciled the long-standing antagonism between them. She has, in some sense, made them one and the same.

To understand this extraordinary synthesis it helps to look back at how the office of First Lady began and how it has been shaped by the evolution of image making and the struggle for women's rights.

POLITICIZING STYLE

It may be hard to imagine today, but from the earliest years of the American nation, the dress and style of the First Lady has been a politically charged issue. Reluctant to call attention to herself or to be associated with the flashy trappings of royalty, Martha Washington wore homespun clothing. According to some historians, to highlight her frugality she wore dresses woven from the remnants of silk stockings and slipcovers. Her white muslins and satins evoked a kind of classical Roman style and referenced the idea that the new republic was modeled on the ideals of the republic fashioned in ancient Rome. But the image of the First Lady became a full-fledged political symbol when Dolley Madison came to the White House in 1801 as the part-time hostess for the widower Thomas Jefferson, and then eight years later as "Lady Presidentress" and wife of James Madison, the fourth president, elected in 1809.

Dolley Madison was the first First Lady to embrace high style and use it to her political and personal advantage. She understood that even in a young, raw, and self-consciously democratic nation, political leaders would still be drawn to the symbolism

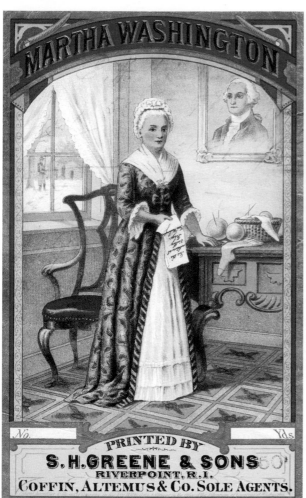

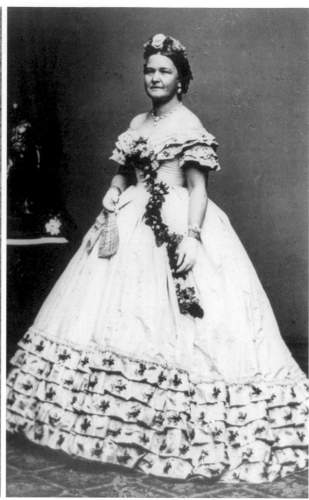

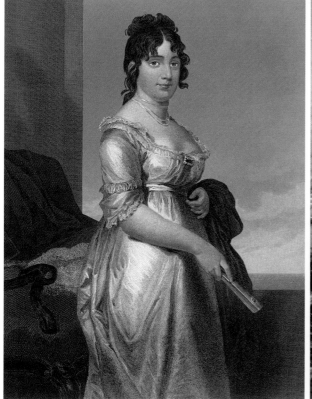

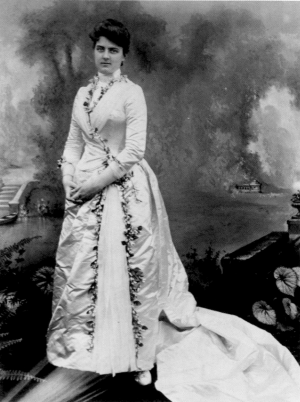

of aristocracy. Queen Dolley, as she came to be known, used the White House as her court. She entertained lavishly. She hired the architect Benjamin Henry Latrobe to restructure the interior of the executive mansion. She chose pieces of furniture to reflect the republican spirit of the mansion—not too fancy, not too foreign. She invited artists, writers, and politicians to her "Wednesday drawing rooms"—weekly receptions that became Washington's hottest ticket. To fill the public spaces she had created in the White House, she devised events that became national rites and ceremonies, from the first inaugural ball to the first Easter egg roll. All of these social innovations enhanced her husband's effectiveness because they provided occasions for people to gather and socialize. Dolley loved people and was adept at maneuvering her husband into the right political circles and social circumstances. She also loved fashion and became a trendsetter long before she arrived at the White House. She emulated the slinky silhouette and plunging neckline favored by France's Josephine Bonaparte. She stuck colorful feathers in her hair. She bought fine European silks and twisted them into turbans—her most influential fashion statement. Josephine Bonaparte, in turn, copied her by adopting the turban. Soon women wanted to know what Dolley was doing and wearing. Her look underscored her husband's burgeoning power.

"Her style mixed a kind of democratic inclusiveness and personal warmth and charm with these really lavish clothes," says Catherine Allgor, a professor of history at the University of California at Riverside and the author of *A Perfect Union: Dolley Madison and the Creation of the American Nation*. "They weren't court costumes, she could never have been in Europe in a court, but they were almost like a fantasy of what an American queen would look like—satin and ermine and feathers and jewelry." Like Michelle Obama two hundred years later, Dolley achieved flair and elegance without snobbery. She dressed according to her own taste, writing

Ladies first; (*counterclockwise from top left*) Martha Washington was known for her homespun look; Dolley Madison mimicked Josephine Bonaparte's plunging necklines; Frances Cleveland was topic A in the press on her wedding day when she wore a white satin gown with a fifteen-foot train; Mary Todd Lincoln was criticized for overindulging in fashion at a time when the country was ravaged by civil war.

to her sister Anna, "I take and use only that which is pleasing to me." It's widely believed that the term "First Lady" was coined by President Zachary Taylor, who in his 1849 funeral eulogy for Dolley Madison said: "She will never be forgotten because she was truly our First Lady for a half-century."

By the time Mary Todd Lincoln arrived at the White House in 1861, the context in which women's finery was viewed was drastically different. Born in Kentucky, Mrs. Lincoln was an educated, feisty, and politically involved First Lady who studied astronomy, read Shakespeare, and spoke fluent French. She hardly lacked for substance. And she had the heart of a fashionista. She splurged on dresses made of expensive European silks at a time when the country was convulsed by the Civil War. She tried to justify the extravagance, writing: "People scrutinize every article that I wear with critical curiosity." One season she had her seamstress, a former slave named Elizabeth Keckley, sew up sixteen ball gowns in the hoop-skirt style favored by Empress Eugénie of France. Perhaps what seemed to her contemporaries an excess of vanity and self-absorption derived from the fact that as a westerner she felt insecure among Washington's East Coast establishment. Mrs. Lincoln made it worse for herself, misreading the mood of the country, seemingly blind to the danger of an image out of sync with the times. During her husband's campaign for a second term, Mary Todd was derided as a "coarse, vain, unamiable woman." And the press went after her clothes, denouncing her "absurd costumes" with a vicious glee that makes the most biting fashion criticism of today seem tame.

Twenty years later, the context that had crossed up Mary Todd Lincoln had shifted again, and the country was ready for a First Lady with a glitzy closet and a glossy image that women might emulate. The telegraph relayed news faster, and railroads expanded the reach of newspapers. More women were reading, and newspapers were dedicating space to topics of interest to them. In 1886

Making a flap: Grace Coolidge was the trendsetter of the early 1920s, a time in America when women looked to the First Lady for fashion tips. Coolidge inadvertently made the color red popular when she posed for her official White House portrait in a long crimson dress (left). One of the most physically active First Ladies, she was the first to wear shorter skirts (top right) and to appear in moving images (bottom right).

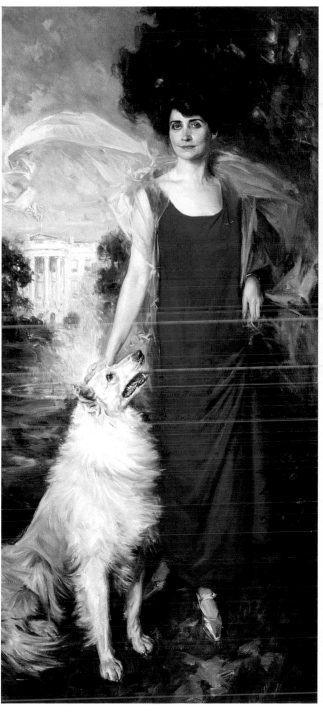

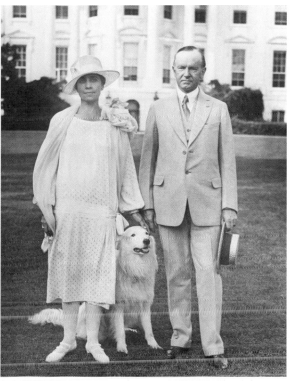

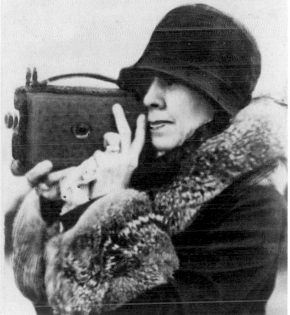

topic A was Frances Folsom, the twenty-one-year-old bride of the forty-nine-year-old bachelor President Grover Cleveland. The story of their courtship was endlessly intriguing. The president had known his young bride since she was an infant, even becoming her guardian when her father, a friend of Cleveland's, died suddenly in an accident when Frances was eleven. But Cleveland waited until Frances graduated from Wells College to propose. The intrigue meant that "Frankie," as she was nicknamed by the press, was all over the papers, the Brangelina of her day. Her wedding—the first in the White House—was considered the closest thing in presidential history to a royal wedding. Impressed by Frankie's popularity and poise, manufacturers slapped her image onto advertisements for everything from soap to underwear. Women copied what she wore and imitated her close-cropped hairstyle, shaving the back of their necks. They even mimicked her regal pose in photographs. It was the first time a First Lady's image and name had been commercialized on a mass level and may have augured the beginning of the split between the "person" and the "persona."

Women were afforded a more realistic glimpse of a First Lady's lifestyle when Grace Coolidge arrived in the White House in 1923. Although she never spoke in public, because her husband did not allow her to give any speeches or interviews, she appeared in newsreels, sporting the radical new fashions of the day. She wore sleeveless flapper dresses, showing off glimpses of arms and legs that First Ladies had never revealed before. Her style and energetic personality (her favorite pastime was hiking in the Black Hills of North Dakota) reflected the changing social and political landscape of the 1920s, particularly for women who had won the right to vote.

"She came to the White House at a time when there were more women seeking higher education, more women putting off marriage, moving into the cities, getting jobs and supporting themselves,"

says Carl Sferrazza Anthony, the historian of the National First Ladies Library. "She was a college graduate. She had worked as a teacher before she got married. And for the first time you started seeing her in independent newsreels. She was always moving, so she became a real person to the public. There was a lot of physicality to her, she was always laughing and reaching out to people."

Although she had no interest in politics, Grace's energy and enthusiasm helped to offset the social handicap of her husband, whose lack of personality and personal graces earned him the nickname "Silent Cal." Her schedule was always booked with public appearances. She rode in parades, volunteered for the Red Cross, raised money for the deaf, and received countless guests at the White House. One such visitor, Will Rogers, called her "Public Female Favorite No. 1." She was often compared to Dolley Madison because they both understood the power of style as a means to connect to the public and to convey—or in some cases offset—the emotional tenor of their husband's administration.

For most of the twentieth century style remained the primary way that First Ladies were able to exert influence. The mystique of the office received a tremendous boost with the advent of color television in the early 1960s. TV made Jacqueline Kennedy one of the most influential style icons of the twentieth century. Feminism had not yet taken hold, and despite the fact that she was educated and well read, Jackie was part of a generation of women who believed their primary responsibility was to care for their family. She may have been incredibly young when she arrived at the White House but she was wise to the cultural moment and the impending changes in values. Nowhere were these changes more clearly expressed than in matters of style and taste

Jackie loved clothes, and in the early 1960s, fashion was the first expression of rebellion for a generation eager to challenge the traditional values of their parents. (Little did they know that the ensu-

ing cultural upheavals—civil rights, integration, Vietnam—would forever change America.) Jackie wanted to elevate American taste by reintroducing the idea of American excellence to the world. The White House became her stage. She invited famous musicians like Pablo Casals to perform at the White House and invited writers like Saul Bellow and Thornton Wilder, poets like Robert Lowell, and painters like Mark Rothko and Franz Kline to mingle with other artists in the East Room. She knew about art, poetry, dance, and music, and she showcased the arts when she entertained. She wanted to prove that they were important, that style had a place in the White House and in American history. She employed experts in every field to help her but ultimately relied on her own ideas about how a First Lady should look, entertain, and decorate.

She initiated a complete restoration of the White House, setting up the Fine Arts Committee for the White House, enlisting American antiquities expert Henry Francis du Pont to lead the charge, and tracking down historical pieces of furniture and paintings. Not satisfied with merely restoring the White House, Jackie also engaged experts around the world to restyle her surroundings. Raymond Loewy, the industrial designer who created the Coca-Cola bottle, redesigned the interiors of Air Force One, Stéphane Boudin of the prestigious French interiors firm Maison Jansen assisted in the redecoration of the White House's West Wing and state floor rooms, and French-born chef René Verdon was brought in to revamp the White House kitchen.

But it was Jackie's own personal look—perhaps her most significant legacy—that was the essence of her mystique. She knew fashion (she was probably the first First Lady to read magazines like French *Vogue* in the private quarters of the White House), and she knew the importance of appearance. As Nancy Tuckerman, Jackie's roommate at Miss Porter's School in Farmington, Connecticut, and her social secretary for her last eight months in the White House,

told me, Jackie had filled the margins of her textbooks with sketches of dresses she wanted to wear. She continued the habit with long letters written to Diana Vreeland, her mentor and friend, who was then the fashion editor of *Harper's Bazaar*, asking for help in devising a wardrobe of "terribly simple, covered up clothes."

Once in the White House, she enlisted an American designer, Oleg Cassini, to help craft her image. As a former Paramount Studios costume designer, Cassini understood how to visualize Jackie as if she were in a moving image or a tableau—he understood how to create a persona. He envisioned her as a sphinx, exuding mystery and power without ever speaking. Cassini approached the job as a film director would: imagining a character in close-ups or from afar. "I always thought of her as part of a painting, a quadro," Cassini wrote in his book *A Thousand Days of Magic.* "I thought of how she would look with other people. I wanted her to stand out—that was the trick."

When she traveled she embraced the style of the countries she visited. On a trip to Paris with her husband to meet with Charles de Gaulle, she wore clothes by the French couturier Hubert de Givenchy and charmed the French president with her command of his language and her grasp of French history. In India with her sister, Lee, Jackie wore brilliant shades of hot pink and marigold, colors indigenous to the country. She boated down the Ganges draped in lotus garlands, a red tilak dot on her forehead. She greeted crowds in Udaipur from the back of an open car using the traditional *namaste,* and she took a train to the Taj Mahal

"There have been some great wives in the White House—like Abigail Adams and Dolley Madison—so great that you can't think of their husbands, presidents, without thinking of them. It looks as though we are having another one now." —ROBERT FROST ON JACQUELINE KENNEDY

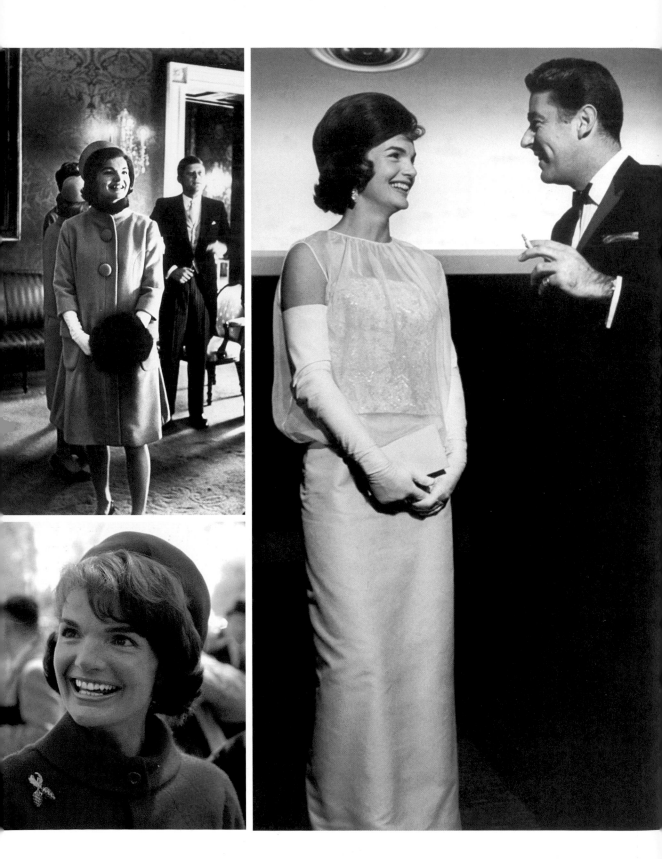

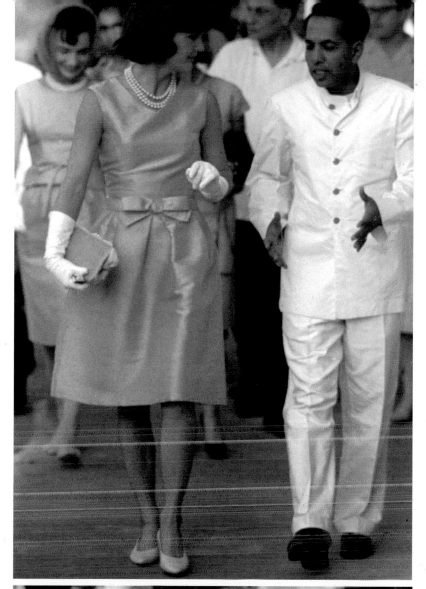

Jacqueline Kennedy, the first First Lady to appear on color television, used bright hues to set herself apart. On a trip to India, Jackie wore pinks and oranges, the colors symbolic of the country. She even wore garlands of lotus blossoms and held a silver encased coconut to her forehead, a Rajasthani mark of luck and respect, upon arrival at the Jaipur Airport. *Opposite:* Oleg Cassini chose a camel coat for Jackie for her husband's inauguration (*top left*), so that she would stand out in the crowd of fur coats, and she wore white later that evening (*right*). She wore a red bouclé suit on a trip to Canada in 1961 (*bottom left*).

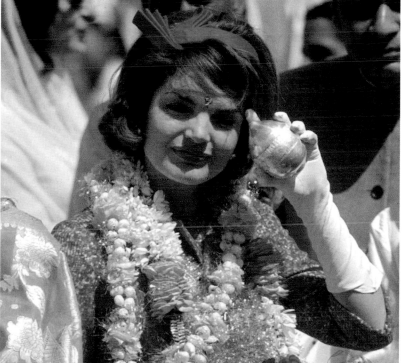

and posed in front of the glorious monument in a vivid green paisley dress.

The press gobbled it up, featuring Jackie in a way that no other First Lady had ever been covered. Her youth and her feeling for fashion made her a subject of endless fascination to reporters and photographers. Even her kids were subject to it, despite Jackie's enormous efforts to keep them out of the spotlight. Nancy Tuckerman remembers hundreds of letters pouring into the White House about John F. Kennedy Jr.'s hairstyle, which Jackie let grow long in front like an English schoolboy's. Many of the letters were from concerned Americans who felt that if Jackie let the bangs grow any longer, her son would go blind. There were Jackie Barbie dolls, cutout dolls, and games. There was even a Flintstones character created in her image, Jackie Kennelrock.

"Jackie Kennedy put a little style into the White House, and into being First Lady of the land and suddenly 'good taste' became good taste. Before the Kennedys, 'good taste' was never the point of modern America at all." —DIANA VREELAND

Ultimately the public persona Jackie created was substantive in its historical references. She exposed Americans to a very sophisticated, exclusive, and almost exotic kind of style with her taste for things like eighteenth-century French furniture and Schlumberger jewelry. Her taste was elitist, but the simplicity of her style made it accessible. The fashion critic Hebe Dorsey summed up Jackie's influence best when she wrote, "Jackie's style . . . helped to break down a certain Puritanism that had always existed in America and which insisted that it was wrong to wear jewelry, wrong to wear fancy hairdos, wrong to live elegantly and graciously, wrong to wear tailored clothes."

Most First Ladies haven't been as successful as Jackie at navigating the political implica-

tions of appearance. It is a constant challenge to work out what it takes to look good without looking too good to be taken seriously. In many ways the First Lady has come to serve as a reflection of our own conflicted feelings about appearance. "Modern politics is mostly psychological and so how we feel and what we think comes from these symbols," says Allgor. "If our president had lived an incredibly rich lifestyle and had jets and so on, wouldn't that say something about him? Absolutely."

From Jackie right up to Michelle Obama, every First Lady has been conscious of the public's complex and changeable attitude toward appearance. Paradoxically, we want our leaders to project a democratic spirit, but we also want them to be glamorous and alluring. The country has turned against First Ladies who looked too rich or self-indulgent or seemed deaf to the economic conditions of ordinary Americans. Much has been made of Michelle Obama ordering clothes online from J.Crew and mixing high-end designers like Thakoon Panichgul and Narciso Rodriguez with lower-priced clothing from H&M, Talbots, and Target. But she isn't the first to use this formula to reassure Americans. Mamie Eisenhower had her mail-order hats, and Barbara Bush wore fake pearls from Kenneth Jay Lane and mixed her Arnold Scaasi dresses with off-the-rack clothes from Evan-Picone, ordered by phone from A&S.

Nancy Reagan, on the other hand, ran into trouble. Steeped in the royal ambience of Hollywood, she was excoriated for extravagance when she wore a $10,000 glittering white couture gown to her husband's inauguration in 1981. The pampered social-climbing image was exacerbated when she accepted a donation of $200,000 worth of White House china and had the redecorated private quarters featured in the upscale shelter magazine *Architectural Digest*. Questions were raised about her failure to pay taxes on the expensive gowns she received as gifts from designers like James Galanos and Adolfo. Even though she was the product of a generation that

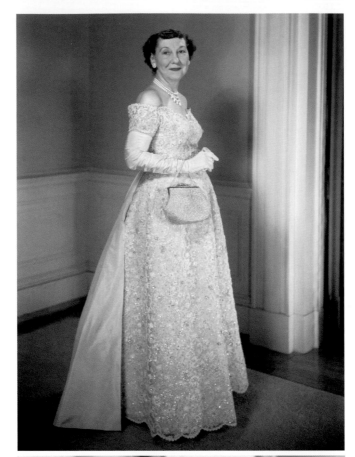

Color can carry symbolic meaning and nowhere more boldly than in the White House. Some First Ladies adapt their favorite color as a signature. Mamie Eisenhower (*top*) wore pink so often (and decorated her bedroom entirely in pink) that the Textile Color Institute issued a shade called First Lady Pink. Nancy Reagan (*right*) made red—a color associated with power and intensity— the symbolic color of her husband's administration.

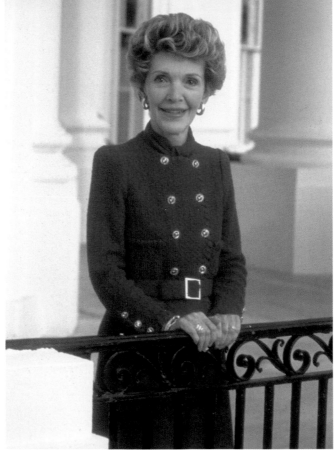

believed women of her stature had to look good at all costs, her style gave political opponents an opening. "Remember, she came in during a really bad recession in 1981 and she became a symbol for the Democrats to use and turn her into a caricature. That's a danger," says Carl Sferrazza Anthony.

But Nancy Reagan also seemed caught between warring paradigms of what a woman's role in the culture and society should be. In the 1980s the modern ideal of American womanhood was that of a powerful, boardroom-bound superwoman. Feminists were contemptuous of Nancy's old-fashioned stand-by-your-man attitude. "She has not advanced the cause of women at all," complained Betty Friedan to *Time* magazine. In some ways what made Nancy Reagan seem regressive and reactionary was the erosion of the traditional role itself.

THE GLOVES COME OFF

While many First Ladies of the twentieth century were content to play the part of caretaker, some set out to redefine the office. The archetype, born of necessity and a kind of historical precocity, is Eleanor Roosevelt. The wife of Franklin Delano Roosevelt blazed the trail for future generations of politically active First Ladies, and she did it famously, looking like—well, how to put it nicely?—looking like she couldn't have cared less about style. She cared about style enough to go on epic shopping sprees when it mattered, like the week before her husband's first inauguration when she bought herself a blue velvet evening gown designed by the New York retailer Arnold Constable. But Eleanor also prided herself on her thrift, often wearing dresses she bought

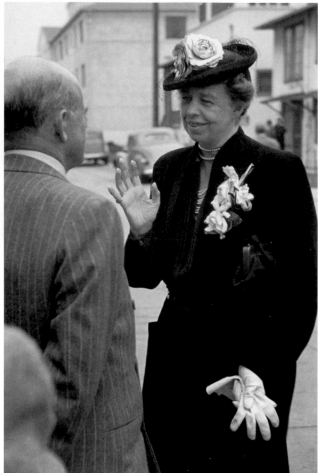

With the rise of feminism, First Ladies added political activism to their traditional hostess duties. Eleanor Roosevelt (*right*) was the first First Lady to officially serve as her husband's "eyes and ears" on the road. She was also a prolific writer (*above*), penning newspaper columns and books and adapting a workaday wardrobe. Mamie Eisenhower (*bottom*) was probably the last full-time hostess in the White House. *Opposite:* Betty Ford (*top left*) and Rosalynn Carter (*bottom left*) openly embraced political issues as well as more practical drip-dry clothes. Pat Nixon (*top right*) followed her own agenda while accompanying her husband on diplomatic tours and was the first First Lady to wear pants publicly. Lady Bird Johnson (*bottom right*) took caretaking to a new level with her Keep America Beautiful campaign and used bright colors to convey her message through her appearance, too.

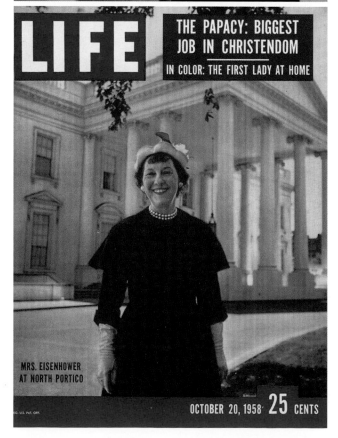

LIFE

THE PAPACY: BIGGEST JOB IN CHRISTENDOM

IN COLOR: THE FIRST LADY AT HOME

MRS. EISENHOWER AT NORTH PORTICO

OCTOBER 20, 1958 25 CENTS

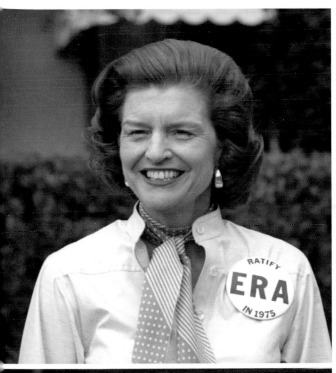

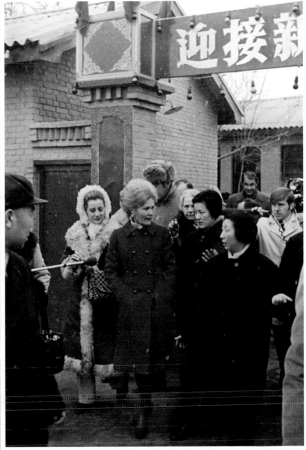

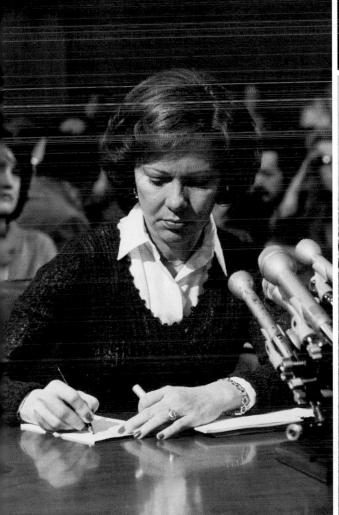

off the rack for $5 or $10. Her signature touch, if you could call it that, was a hairnet. She was physically awkward at five foot eleven and had buckteeth, but in her case beauty was as beauty did. She transformed the role of First Lady into a semiofficial position by taking over some of her husband's duties. Confined to a wheelchair, Franklin Roosevelt depended on Eleanor to mingle and press the flesh with everyone from coal miners in West Virginia to U.S. servicemen in the South Pacific. She was, in a sense, his avatar, politicking in a way that he could not, his eyes and ears reporting back after around-the-world inspection tours.

She entered the White House during the depths of the Great Depression—a time when appearance was the last thing on anybody's mind. And, at forty-eight, she already had a robust résumé. She had been a teacher at the Todhunter School in New York City, a businesswoman running the Val-Kill crafts factory in Hyde Park, and a political activist copublishing and editing *Women's Democratic News*. Her political activism was, in many ways, formed by her lifelong determination to help people living on the margins of society. She was particularly determined to fight poverty and racism. She also fought for women's rights. In the White House she established in the Green Room the first First Lady press conferences, began a weekly newspaper column called "My Day," and even took a job as the host of a radio show. She also supported the cause of the working woman, insisting her husband appoint women to government jobs and going so far as to bar male reporters from her own press conferences. She was appointed deputy director of the Office of Civilian Defense during World War II and became the first First Lady to hold a government position.

For all the inroads she made, many Americans were not ready for a First Lady who worked outside the White House or espoused such freethinking ideas. In that way Eleanor Roosevelt was one of the most controversial First Ladies of the twentieth century. She

received a staggering amount of mail—more than 300,000 letters in 1933 alone. Typical of many was the correspondent who scolded her to "stay home and personally see that the White House is clean."

After Eleanor, for much of the latter half of the last century, the role of the First Lady was in flux, shifting uncertainly between the traditional obligations of the wife and mother who worries about home and family, and the new assignment of the working woman who has professional qualifications that match or outstrip her husband's.

Many First Ladies of the modern era happily emulated the traditionalists of the nineteenth century. Mamie Eisenhower famously said she did not get out of bed before noon and preferred housewife duties to any professional work. In restoring the White House, Jackie Kennedy acted as a kind of national homemaker and softened the public impression of her as nothing but a society blue blood. Even Lady Bird Johnson's Keep America Beautiful campaign was the caretaker role writ large.

It wasn't until the early 1970s, when Pat Nixon arrived at the White House, that the idea of the politically involved First Lady—or at least the idea of a spouse who has something to contribute to the diplomatic success of state visits—would not instantly arouse controversy. Pat Nixon was careful to maintain a low-key "homemaker" image and made a point of telling the press that she did her own laundry. She cared less about creating an image for herself and more about making the White House accessible to the public. Foreshadowing the Obamas, who refer to the White House as the "People's house," she often said the White House belonged to "all people." She made this idea a reality by installing ramps for the physically disabled, creating brochures for tourists, and printing them in four languages for foreign visitors. She also traveled abroad extensively on "personal diplomacy" trips to places like Peru, where she visited towns destroyed by earthquakes, and China

and Africa, often maintaining an itinerary completely independent of her husband's.

Betty Ford had the most down-to-earth approach to the position of any First Lady before her. She was an ex-dancer who had studied under Martha Graham, wore a mood ring, and made no secret of her past problem with painkillers. She loved to entertain but would also venture out of the White House to grab lunch at McDonald's or shop for shoes. She speculated about her kids' sex lives and even joked about her own. She publicly discussed her battle with breast cancer with an unabashed candor that raised the profile of the disease in the media. But behind her spontaneous nature and candor was an emphatic belief in equal rights. She told Barbara Walters she agreed with the Supreme Court's decision on *Roe v. Wade* and she lobbied tirelessly for the Equal Rights Amendment.

Pat Nixon, Betty Ford, and subsequent First Ladies were subject to the social forces of the culture at large, where women were crusading for equal rights, equal pay, and places in corporate boardrooms. The women of the feminist movement viewed the role of the flattering hostess as a dereliction of duty in the battle against a sexist society. They saw the "harness of hairdo and gloves," as Lady Bird Johnson had called it, as the trappings of the system they were determined to remake. To be preoccupied with your appearance was not just trivial, it was also a betrayal of your depth as a woman. The polarization of substance and style reached a point in the 1970s where women in college who wore makeup were stigmatized for colluding with the forces of male oppression. Style was buried under the rush for equality, and fashionistas looked like a traitorous fifth column in the battle for substance.

The cause of feminism and women's rights had a dramatic impact on the still-unofficial office as professionally accomplished

women arrived at the White House. Like Rosalynn Carter, Hillary Clinton was surprised to discover the public's mother-hungry desire for traditional feminine roles. Meeting those needs is still very much a part of the First Lady's job, no matter how much the priorities of women have evolved. "The White House serves three functions," says Ann Stock, who served as the social secretary to Hillary Clinton from 1993 to 1998. "It's a private home, a priceless museum and the center of power. All those roles play into the public perception of the First Lady and she can do anything she wants provided she fulfills this very traditional role as caretaker first."

Rosalynn Carter famously placated the traditionalists by bringing a sewing machine to the White House when Jimmy Carter swept into Washington in the aftermath of the Watergate scandals. Then she got to work, convincing her husband to appoint a commission on mental health. She campaigned for her husband in 1980 while he stayed home to deal with the hostage crisis. In the fall of that year Congress passed and funded her Mental Health Systems Act. She became the first First Lady to sit in on cabinet meetings and travel abroad officially, delivering policy reports to her husband upon her return. Her activism was not only a product of the times, but also a necessary outlet for her sharp political mind. "I could never sit and drink coffee and talk about babies and clothes," she told *Time* magazine in early 1977. Like many women of her generation, Rosalynn underestimated the importance of image in her position. "Image became a nuisance that wouldn't go away," Carter wrote in her memoir, *First*

"Image became a nuisance that wouldn't go away. I thought that if I were working productively and accomplishing something worthwhile, the image would take care of itself." —ROSALYNN CARTER, IN HER MEMOIR, *FIRST LADY FROM PLAINS*

Lady from Plains. "I thought that if I were working productively and accomplishing something worthwhile, the image would take care of itself."

The fashion choices among these politically minded First Ladies—the cloth coats, drip-dry pantsuits, and on-the-go shirt-waist dresses—reflected the antifashion moment as well as their own ambivalence about embracing style. Any attention to appearance was deemed a distraction from their political efforts. Pat Nixon was the first First Lady to publicly wear pants. (They weren't allowed on the Senate floor until two decades later.)

By the time Hillary Clinton joined her husband in the West Wing as the head of the President's Task Force on National Health Reform in 1993, the issue of whether the First Lady should work had become a cultural flash point. Her predecessor, Barbara Bush, though beloved in some circles, seemed an out-of-touch anachronism because she didn't have a career. And yet to her chagrin, Hillary was discovering that her professional qualifications had alienated parts of the public attached to the traditional role of the First Lady as the nation's hostess. Questioned during the campaign about her desire to continue working while her husband was in public office, Hillary famously snapped: "I suppose I could have stayed home and baked cookies and had teas, but what I decided to do is fulfill my profession, which I entered before my husband was in public life."

Hillary later admitted to a group of reporters gathered for an off-the-record lunch at the White House that she didn't "get this whole image creation thing." By not getting it, she confessed, she had let other people define her. When Hillary first arrived at the White House, she had sought Jackie Onassis's advice, traveling up to New York City to have lunch with the former First Lady. Clinton had been criticized for the hat she wore to her husband's inauguration. Some said it looked like a flying saucer landing on her head.

Although she did her fair share of hostess duties, like decorating for the holidays (*top*), Hillary Clinton seemed more comfortable in her West Wing office and in the requisite business attire (*bottom left*). Michelle Obama, on the other hand, has steered clear of any official government role (*bottom right*).

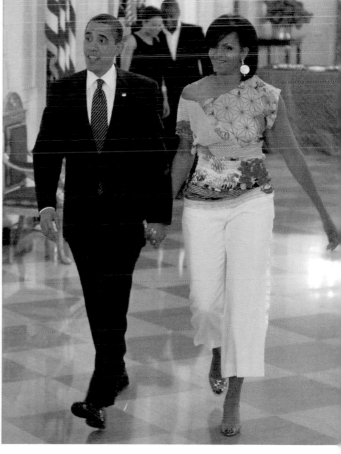

When Hillary suggested to Jackie that maybe she should hand herself over to fashion consultants, the style icon was horrified. "You have to be you," she reportedly told Clinton.

But Clinton lacked the innate sense of style that Jackie so famously possessed. She'd been formed in the generation that saw style and substance as antithetical—style a sideshow to professional accomplishment. A professional woman could not afford to worry about what she was wearing. Hillary's famous inability to settle on a hairstyle and her occasionally awkward wardrobe choices were telling signs of how difficult it was for her to reconcile the guise of domestic responsibilities with the guise of the professional woman. Always erring on the conservative side of fashion, she often ended up looking frumpy in covered-up evening dresses or long, to-the-knee jackets worn over pants. In retrospect there is something almost touching about her insecurity about what to wear and how to navigate the baffling contradictions of the day.

In one of her first big interviews as First Lady, Hillary told the *New York Times* she couldn't understand why people were surprised that the job required her to balance work and motherhood: "I'm still always a little bit amazed at how big an issue this is for people because if they will just stop and think, this is what women do. Eventually, I expect, it won't be a subject for a lot of comment." But of course the issue of the work/family balance would continue to be controversial a decade and a half later when Michelle Obama would suffer the same chorus of disapproval from women who felt she should not abandon her high-powered career for her husband's campaign. Learning from Hillary's experience, Michelle cleverly co-opted the criticism by talking honestly about her own struggles balancing work with family responsibilities. On the campaign trail she often talked openly about how she felt "duped" by the feminist promise of having it all. "As a mother, wife, professional, campaign wife, whatever it is that's on my plate, I'm drowning. And

nobody's talking about these issues," she told a group of women at a fund-raiser in Austin, Texas, in the summer of 2007.

As Catherine Allgor points out, the position of First Lady has become a focus of our deep-seated anxieties about women, gender roles, politics, and power. "In Dolley Madison's day, people are worried about her in a very direct way in terms of political power—we don't want petticoat politics, we don't want women meddling," Allgor says. "By the time we get to Hillary [our anxiety] is not just about political power which it was, it's also 'Is she the kind of woman we want our mothers to be or our daughters to be? What kind of woman is she? How is she balancing home and work?' So it's become even more of a focus of gender roles, and the First Lady is the repository of all of our craziness about it."

Hillary broke much of the ground for Michelle Obama. "Because Hillary was the first First Lady who had a career she had to take the hit for it," says Allgor. "So by the time Michelle comes around we've grown up a little bit. We're OK with this now. We got that out of our system. And Michelle has the advantage of having young children so she is allowed to be a mom."

Indeed, by immediately defining her role as Mom in Chief, Michelle Obama dissolved many of the old anxieties the public might have harbored about her involving herself in policy making. She embraced the traditional role of White House caretaker by planting the kitchen garden and telling the world her first and main concern was her kids. In doing so she freed herself from the corset of etiquette that restrained so many of her predecessors. She has already demonstrated that there is no meaningful difference between substance and style; substance *is* style, and style is substance. She has shown that if you follow the rules, you can break the rules. As First Lady she is writing a new kind of protocol: you can wear flats with cocktail dresses; you can exit Air Force One in shorts; you can touch the queen.

THE BODY POLITIC

For a while it seemed as if the phrase "the body politic" referred not to the 136 million or so Americans who voted in 2008 but to the physical person of the First Lady. First there was the New Arms Race controversy. Or perhaps it should be known as the New Racy Arms controversy. Should Michelle Obama have appeared in Congress without covering her sculpted biceps? The public was divided. Then on a family vacation to the Grand Canyon she exited Air Force One in hiking shorts. Commentators professed to be scandalized. Hiking shorts at the Grand Canyon on a sweltering summer day may be acceptable for millions of Americans visiting one of the nation's hottest national parks, but for the First Lady? You would have thought she'd turned up in Riyadh without a headscarf.

Like her sculpted bare arms, Michelle's sculpted bare legs were problematic for many people who saw them as an affront to traditional female modesty, a projection of a threatening independence, visual evidence of her power and strength, and a dramatically different approach to the role of First Lady. Nothing about muscular arms and legs said *hostess* or *caretaker*. This First Lady might be Casual Michelle, but she is also forthright Michelle, say-it-like-it-is Michelle. Her husband might be the president, but that wouldn't stop her from telling him to pick up his socks.

Of course this fascination with the physicality of the First Lady is nothing new. Americans have been obsessing over their leaders' physical attributes for centuries. "When we had the whole flap with Michelle Obama's arms, I wanted to reassure her that she was part of a very long tradition of the fascination and the obsession with the body of the ruler," says Catherine Allgor, professor of history at the University of California at Riverside. "This fascination is a very old, royal thing and it got carried into the republic and it got fastened onto not just men but women." Dolley Madison was criticized for wearing low-cut dresses. Mary Todd Lincoln was dubbed "weak-minded" for exposing her cleavage.

Sometimes the public is criticizing a perceived lack of propriety, but at other times the public is processing an image that clashes with a perhaps subconscious idea of how a First Lady should look. Hillary Clinton posed for a photo before her first state dinner in 1993 in Donna Karan's "cold-shoulder" dress. She got a lot of flack for wearing a trendy dress—out of step with her substantive identity. But even the most stylish First Ladies have inadvertently raised the public's proverbial eyebrow by revealing too much.

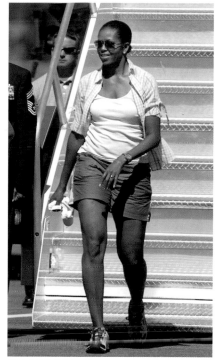

When Michelle Obama descended Air Force One in hiking shorts on her way to a vacation in the Grand Canyon with her family (*top*), a furor erupted over the idea that the First Lady would wear something so "inappropriate." But when Hillary Clinton vacationed with Chelsea and Bill in Martha's Vineyard in August 1993 (*above*), nobody bothered with her bare legs.

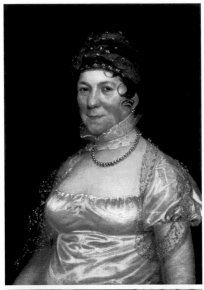

Dolley Madison's plunging necklines often raised eyebrows (*top*) and Hillary Clinton elicited a few remarks when she wore Donna Karan's bare-shoulder dress (*above*) to her first state dinner in February 1993.

Jackie Kennedy's iconic sleeveless shifts were deemed "incorrect for church" in 1961. Over a century earlier, Frances Cleveland infuriated the Women's Christian Temperance Union by baring her shoulders. They called it "an evil influence on other young American girls."

"The rules of the game change once you become First Lady; you are not a private citizen anymore," says Ann Stock, former White House social secretary to Hillary Clinton. So even when she goes hiking with her kids in the Grand Canyon, Michelle—or any First Lady, for that matter—is expected to dress the part of First Lady, not of a camera-clad, T-shirt-and-shorts-wearing American vacationer. Yet here is Michelle Obama, once again dressing for herself, not for the job. Does anybody remember Hillary Clinton wearing shorts on vacation in Martha's Vineyard? Nobody cared because she didn't have a body to brag about. She didn't appear in any way an Amazonian superwoman. Like "sleeve-gate," "shorts-gate" is another example of Michelle Obama's willingness to take risks.

The right to bare arms: When Michelle Obama revealed her sculpted biceps in Congress in February 2009, she prompted *New York Times* op-ed columnist David Brooks to write, "Put away Thunder and Lightning." But when Jackie Kennedy wore a similar sleeveless shift to her husband's State of the Union address in January 1963 (*above*) it was no big deal—perhaps because her arms didn't convey the same message of strength and power.

DOES ANYONE STILL WEAR A HAT?

Oscar de la Renta, the nonpartisan Seventh Avenue designer who has dressed both Hillary Clinton and Laura Bush, explains how he helped to eliminate the steadfast inaugural tradition of wearing a hat to the swearing-in ceremony:

“ **IT'S A VERY FUNNY STORY** and no one picked up on it, but when I dressed Hillary Clinton for the second inauguration I made an evening dress for the balls and a dress and a coat for the swearing-in ceremony. It was a wonderful color like a melon and we did it quite early because I was leaving for Paris to work on my collection there. Three or four days before the inauguration, I get this telephone call from the White House—from Capricia Marshall who was then the social secretary— and she says we forgot the hat. And I said, what hat? And she goes on, saying, Well, you know every First Lady for the inauguration always wears a hat. I said, Why don't you send me three or four hats that Mrs. Clinton likes and I will make a hat here in Paris in a color that will go with what she is wearing? We only had three or four days before the inauguration so she sent it right away.

Twenty-four hours later the hat arrived. You remember those hideous hats that she wore for the first inauguration? Three or four hats arrived and this particular hat is in the package with a tag that says this is Mrs. Clinton's favorite hat! So I called Capricia back to say that I would make a hat and send it to her, but that I thought she should tell Mrs. Clinton that she represents the modern American woman and she should break with tradition and not wear a hat. She has wonderful hair, and she doesn't need a hat.

The day of my show in Paris was exactly the same day as the inauguration. The day before the inauguration, the day we were preparing my show, I get this telephone call from the White House and I said, 'What's going on now?' And I hear this voice on the telephone that

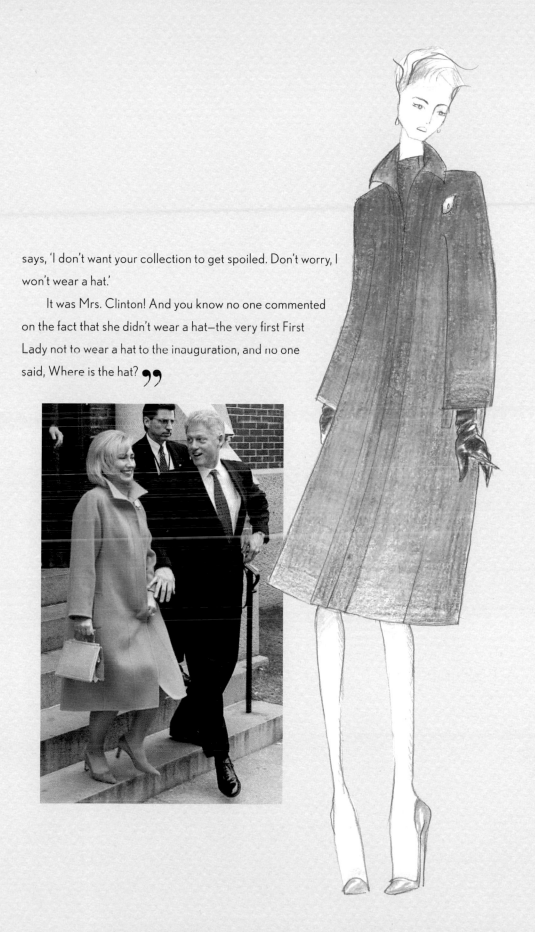

says, 'I don't want your collection to get spoiled. Don't worry, I won't wear a hat.'

It was Mrs. Clinton! And you know no one commented on the fact that she didn't wear a hat—the very first First Lady not to wear a hat to the inauguration, and no one said, Where is the hat? **99**

DRESS CODES

Arnold Scaasi, the designer who has dressed five First Ladies—from Mamie Eisenhower to Laura Bush—reveals the four crucial points to keep in mind when creating the wardrobe of a public figure.

66 DISCRETION

You have to be very understanding of these women because most of them—in fact all of them—have been thrown into the center of the public eye having never been quite there before. They might have been socially prominent or even in government, but they have not been the First Lady of the first country of the world, where they are photographed every day of their lives and where their picture appears in millions of newspapers, on the Internet, and on television all over the world. So you have to be cognizant of that and be understanding of their role and understanding of *their* understanding of their role. It's not always obvious. Although I adore her, Laura Bush did not really understand what she was going to be thrown into when she left Texas to go to Washington. It took her a while to get used to it and to realize what her position meant and what her role meant to the public.

EXCLUSIVITY

When I was dressing Mamie Eisenhower I'd go to the White House, and I would bring fabrics and clothes to fit. I had done a cut-velvet fabric with big cabbage roses in wonderful colors—pink, turquoise, and apricot. She loved the pink and we did a strapless dress for a state dinner. So the president and the First Lady came down the grand staircase—she was in the beautiful pink cut-velvet ball gown—and at the bottom of the stairs was another lady in the same dress in apricot! Mamie of course was a wonderful sport. The next morning she called me and said, 'Mr. Scaasi, I don't want you to get upset. I just want you to know that there was another dress like my dress that I wore last night.' She said, 'Don't be

upset. We were photographed together and it was great fun. But I know the newspapers are going to call you and ask you all sorts of embarrassing questions. Don't even think about it.' And that was very sweet of her.

FIT

For women who are larger than a size ten a dress has to fit somewhere on the body. That's my major credo, because otherwise it makes you look bigger. I met Barbara Bush at a state dinner that the Reagans were giving. I literally bumped into her, and we started talking. We had a lot of friends in common—she was the wife of the vice president then—and I said, 'You know a lot of our friends think I should be dressing you,' and she said, 'Oh, I think that's a very good idea.' She had on this big flowing caftan in printed chiffon, so I had no idea what she was like underneath it and I was surprised when they said she wanted to come to my salon. So she came to choose some clothes and then we took the measurements and she was like a large size twelve, whereas in her clothes she looked much bigger. We really changed her look just by fitting the clothes.

COLOR

You want the First Lady to stand out and it's much easier to stand out in color. Because she's going to be photographed, you want the color to be strong. **99**

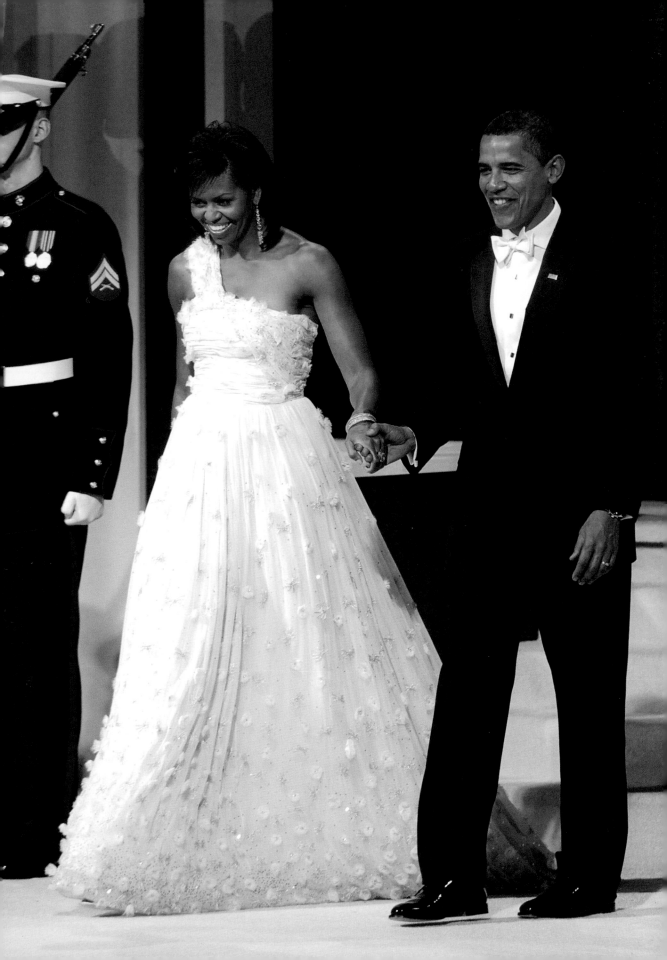

3 THE DRESSMAKERS' DETAILS

Every dress tells a story, whether it's the romance and promise of new beginnings in the pristine white of a wedding dress or the symbol of extinguished light and loss in the black lace of the widow at a Victorian funeral. Sometimes the story is in the dress, and sometimes the dress is in the story. Who can forget Monica Lewinsky's blue shirtwaist number from the Gap on which for a while the fate of the forty-second presidency depended? The sexy midnight blue satin slip Lady Diana wore to a Metropolitan Museum gala following her divorce said "Who needs a stodgy prince?" Just as the miniskirt will forever symbolize the sexual freedom of the 1960s, the footloose flapper dress evokes the power and freedom women felt when they earned the right to vote. And how about the cone-bra dress Madonna wore in the early 1990s? Part medieval chastity belt, part dominatrix gear, it was

a perfect expression of the radical change in sexual mores in the era of AIDS. Even the mere silhouette of a dress can recall a time and place: the absurdly shaped pannier dress instantly summons images of the extravagant court of Versailles and the spoiled young queen, Marie Antoinette. Some dresses evoke an entire nation—a consummate example being the brightly colored saris of India.

Few dresses tell as much as the First Ladies' inaugural gowns on display in the Smithsonian's National Museum of American History in Washington, D.C. Two rooms on the second floor of the museum long known as "the nation's attic" contain twenty-four glass-encased dresses along with artifacts ranging from Abigail Adams's yellow leather slippers to Nancy Reagan's pricey red-bordered White House china. Each dress reveals the period in which it was made. Lined up they show the evolution of the First Lady's look and the way fashion figured in it. The petite black-and-white-striped silk taffeta hoop-skirted dress punctuated by hundreds of tiny purple flowers belonged to the tiny shopaholic Mary Todd Lincoln. The volumes of fabric, which engulf the faceless and impressively small mannequin, speak to the controversial First Lady's extravagance. Towering over poor Mary Todd, in stark contrast, is Eleanor Roosevelt's drab, long-sleeved, almost colorless rayon dress from the 1945 inaugural reception, a testament to her self-conscious desire not to call attention to herself. Grace Coolidge's cool velvet-trimmed black and gold lace flapper dress looks as modern and sophisticated now as the energetic First Lady must have seemed back in the early 1920s when she shocked her public by revealing her bare arms and flashing more leg than was the custom of the time.

Short of meeting the First Lady herself, a close look at an inaugural dress—or a gown worn to an important occasion—may be the only chance to study the trappings of an often-charismatic persona. What's striking is the discontinuity of the various periods—how

Dress codes: While Hillary Clinton (*top*) and Laura Bush (*left*) both chose covered up, long-sleeved gowns for inaugural night, Michelle Obama's ivory chiffon gown revealed more than just her elegant neckline and sculpted arms. *Page 58:* Making an entrance with her husband at the Commander in Chief's Ball on January 20, 2009, the new First Lady looked more like a blushing bride than a mom in chief.

little connection one time has with another. Some dresses are so far ahead of their time they seem truly timeless. Jackie Kennedy's simple lemon yellow sari-style dress, worn to her first state dinner for Tunisian president Habib Bourguiba, looks like something that could carry an actress down the red carpet at the Academy Awards ceremony today. Other dresses seem fusty or hopelessly tied to their time and place and have no currency today. But we can't know where fashion will be in fifty years or how these artifacts will strike our eyes. It's interesting to think what Michelle Obama's frothy white inaugural gown will look like next to Laura Bush's stiff sheath of red lace twenty years—or two hundred years—from now. How will it hold up? Will it seem as fresh and innocent and promising as it did on that historic night when she wore it? Could it possibly still convey the intense excitement and anticipation it stirred up in the winter of 2009?

The dress! The dress! Not since Jackie Kennedy stepped up to the Capitol podium in her pillbox hat and fur-collared cloth coat in 1961 had there been such intense focus on a First Lady's inaugural outfit. This dress, the one-night-only, glamorous, historical inaugural gown, would be the dress that would tell the biggest story, setting the new administration on its course. Every detail—the neckline, the color, the fabric, the fit—would be deconstructed by a million different critics from Hyde Park to Honolulu to Hanoi. This was the dress that every designer wanted to make. This was the dress that instigated what can only be called a kind of covert global sweepstakes involving veteran Seventh Avenue pooh-bahs frantically faxing sketches, desperate publicists, misplaced messages, unanswered e-mails, lost FedEx boxes, all-night embroidering marathons, a twenty-six-year-old Taiwanese designer, and a Svengali-like retailer named Ikram.

While the rest of the world speculated about the dress in the days immediately following the election, the future First Lady went

about her business, seemingly aloof to all of the obsessing over her wardrobe. "Stay out of my closet," she seemed to be saying as she prepared for her big move to the White House. Too late, the cameras were already tracking her. They captured her bundled up against the bitter midwestern winter in a swingy wide-collared black coat and chic knee-high boots on her way to dinner at Spiaggia, a favorite Chicago restaurant, with the president-elect. They were waiting for her as she emerged from a workout at a local gym, hiding behind a baseball cap and dark glasses. She seemed more determined than ever to show the world that she was not going to follow a formula, she was going to dress as she pleased. If anyone had any doubts on this subject, the new First Lady certainly made a point of demonstrating her position when she paid a visit to the White House to glean some last-minute advice from Laura Bush. Towering over Laura, who had chosen an unremarkable brown dress for the occasion, Michelle wore a snug, sexy crimson dress that left little doubt as to who was now in charge. That dress spoke volumes about the new First Lady. It said: I'm in charge of my body (only a woman with washboard abs could wear that dress); I'm in charge of my family, my husband (who looked frankly kind of small and sheepish next to her); and I'm in charge of this big white house now, too.

But that crimson dress, however powerful in the moment, was just a minor distraction. The dress that everyone cared about was the inaugural gown. And even the future First Lady's seeming indifference to the details of her wardrobe—particularly her inaugural gown—couldn't deflate the public's interest. Journalists, bloggers, and fashion insiders fed the First Lady fashion sweepstakes fever, wagering on who would dress her. Those who weren't dressing Michelle were frantically faxing sketches to her. Those who were making clothing for her kept mum, sworn to secrecy, presumably by the First Lady and her fashion Svengali. As the big day neared, the speculation intensified: Would she wear traditional jewel tones

or something signifying a fresh start, like winter white? Would she take the dreadful economy into consideration and choose something reasonably priced from Talbots or J.Crew? Or would she break with protocol completely and wear a pricey dress by a European designer?

The guessing game was endlessly intriguing, not just for the mystery or the history surrounding the moment, but also for the fact that at five foot eleven—standing nearly shoulder to shoulder with her husband—Michelle Obama would be the first First Lady to bring the physical stature of a supermodel to the post. Unlike her predecessors Hillary Clinton and Laura Bush, who were insecure about fashion and so played it safe by asking Seventh Avenue stalwarts like Oscar de la Renta to tell them how to dress, Obama had confidence in her style, and her track record for taking fashion risks meant that she was likely to choose a relative newcomer. But she would not address fashion directly, because to do so would be to risk appearing frivolous and unconcerned about more pressing issues like unemployment or health care. The effect of style in some ways is like the effect of charm: when you call attention to it, it disappears; it can lose all its potency in an instant. But when you deny it, or dismiss it, or disparage its significance, it comes on twice as strong.

So as the inquiries flooded in, Michelle's press secretary, Katie McCormick Lelyveld, stuck to the reasoning that like any other professional mom moving to a new city, the incoming First Lady was preoccupied with settling her daughters, Sasha and Malia, into their new school. Fashion was "on the back burner," not a priority, she said. McCormick Lelyveld even hinted that Mrs. Obama might choose her inaugural outfit at the last minute.

It was a shrewd cover story but proved a little threadbare on closer inspection.

Back in November, roughly ten days after the election, the

Decoding color: At the traditional preinaugural White House meet-and-greet (*top right*), incoming First Lady Michelle Obama was hard to miss in a sleek, crimson Maria Pinto dress that screamed "I'm in charge now!" Meanwhile, her predecessor Laura Bush took a more subtle approach in a muted shade of brown. For the same occasion in 1992, both Barbara Bush and Hillary Clinton (*bottom right*) played it safe with conservative cobalt blue outfits.

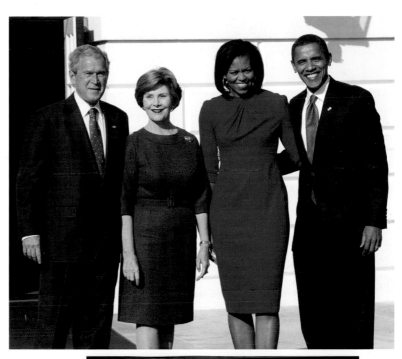

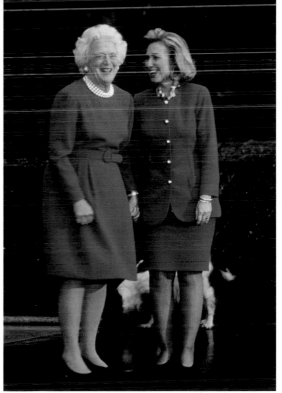

BEHIND THE SEAMS

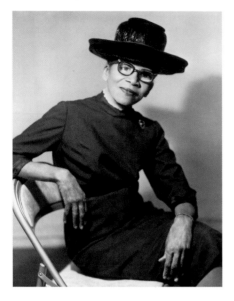

Ann Cole Lowe is not a name that resonates in the showrooms of New York's Seventh Avenue, unlike Arnold Scaasi's or Oscar de la Renta's. But Lowe, an African American dressmaker from Grayton, Alabama, was a key player in the history of First Lady fashion. Her name even appeared in the *National Social Directory* in 1968. Lowe dressed Jackie Kennedy before Oleg Cassini did when she made the young debutante's ivory silk and taffeta wedding gown in 1953. The daughter of a dressmaker, Lowe learned how to sew as a young girl. When she was sixteen her mother died and Lowe took over her work—finishing four ball gowns for the wife of the governor of Alabama. By the 1950s, Lowe's trapunto stitching technique had become a favorite of New York society women with names like du Pont, Lodge, Rockefeller, and Auchincloss. In 1961 Lowe briefly opened a shop on Madison Avenue called Ann Lowe's Originals. Although she had health problems, Lowe continued to design through the 1970s. Despite the fact that she created one of the most photographed dresses of the 1950s, Lowe never got the recognition reserved for most designers of First Lady fashions.

incoming First Lady had begun planning her inaugural day wardrobe. Her consigliere was forty-one-year-old Ikram Goldman, an Israeli-born retailer whose North Rush Street store, Ikram, was a favorite shopping destination for Michelle and other prominent Chicago businesswomen like former White House social secretary Desirée Rogers, senior adviser to the president Valerie Jarrett, and Ariel Capital Management president Mellody Hobson. They relied on Goldman to furnish them with fashion-forward clothes that would enhance their personal style. Goldman's expertise lay in matching the clothes to the personality—she would never sell a customer something that didn't completely capture her essence. She would never force a boldly printed Moschino dress on a client who only wore black Jil Sander suits. And yet Goldman was incredibly persuasive, nudging her customers to try clothes from an unknown designer or to venture beyond their comfort zone with a bold accessory. She was the ultimate personal shopper for women confident enough to recognize the critical role style played in their professional identity.

A fixture in the front row at fashion shows in New York and Paris, Goldman had learned her trade as a saleswoman at Chicago's beloved Oak Street boutique Ultimo, where she honed her expert eye and learned how to lavish personal service on her clients. When she opened her own place in 2001, Goldman designed it to look more like a fashionable woman's closet than a fancy department store, with wrought-iron racks stuffed with designer clothes and long tables piled high with accessories. Women typically do not venture into Ikram for a plain black skirt or a pair of pleated pants. Shopping at Ikram, as one devoted client explained it, is about the promise of a whole new wardrobe, even, in some cases, a new persona. To further accommodate her customers, Goldman trained her

"Ultimately, such a huge force in fashion becomes fashion."

–NARCISO RODRIGUEZ

sales staff to offer tailoring services and to help style outfits with trendy accessories from designers like Tom Binns, Azzedine Alaïa, and Jimmy Choo.

It wasn't unusual for specialty stores such as Ikram to go the extra mile for their clients, ordering them unique pieces or hand-picking looks from the runways with specific women in mind. One such client, Michelle Obama, became a favorite of Goldman, who not only began buying clothes for her, but also began fund-raising for her husband's campaign. It was Goldman who introduced Michelle to the work of lesser-known designers like Jason Wu, Toledo, and thirty-four-year-old Thai-born designer Thakoon Panichgul. And as Michelle's public appearances during the campaign increased, Goldman began discreetly stockpiling runway looks and custom-made dresses for her "special client." At first, the designers didn't have a clue as to who that "special client" might be. But by August, when Michelle Obama began flaunting a bit more of her inner fashionista, wearing Azzedine Alaïa's black perforated belt (the one her husband refers to as the *Star Trek* belt) to town hall meetings or showing up to the vice presidential debate in Panichgul's funky upholstery-chintz-printed dress, the designers' in-boxes quickly filled up with praise from friends and clients who had recognized their trendy clothes on the candidate's statuesque wife.

Unlike other First Ladies who consulted directly with designers to create gowns for special occasions and even socialized with them, Michelle Obama maintained a distance from the process. Apart from Rodriguez and Toledo, whom she had met at fund-raisers in Chicago and New York, she didn't personally know the designers who now dressed her. As the go-between, Goldman commissioned the clothes and then orchestrated fittings that were independent of the designers, a process that afforded the First Lady complete freedom. In many ways, this was the most democratic statement

on her style: she eschewed special "relationships" with designers, which might imply preferential treatment, discounts, or favors, because she wanted to approach fashion the way any woman with a keen interest and not much time would. No big deal. But more than anything, Michelle Obama seemed determined to hold on to her individuality. While some First Ladies—or any woman thrust into a high-profile position—might feel overwhelmed by the public scrutiny, Michelle was confident in her own taste. She knew what she liked, and she knew what looked good on her. She was, after all, someone who had gone to the same Chicago hairstylist and trainer for over a decade. So when it came to Michelle's wardrobe, Goldman certainly made suggestions, but ultimately it appeared that the First Lady called the shots.

Having a retailer broker her wardrobe choices also threw a proverbial veil over the unavoidable question of how much all these clothes would cost and who, ultimately, was paying for them. Presumably Ikram would pay the designers, and the First Lady would pay Ikram. The arrangement allowed not only for privacy but also meant, potentially, that some of the more expensive pieces could be purchased at cost—substantially less than the retail price.

Typically, Goldman did not give much direction to designers when soliciting ideas for Michelle Obama. "You know she likes to wear color, so give me something that she will like," Goldman told Panichgul in the late fall when she called him to ask for sketches for the inaugural swearing-in outfit. For that particular order, Goldman had suggested color, but not too bright, something low-key to reflect the somber economic climate. Panichgul, who was known for his edgy romanticism, a style that played to the First Lady's proclivity for feminine flourishes, tried to follow this direction. But because of time constraints, fabric choices were limited. Anything custom-ordered would have to be from a mill that could work fast. He chose an elegant black and magenta rose-printed silk jacquard

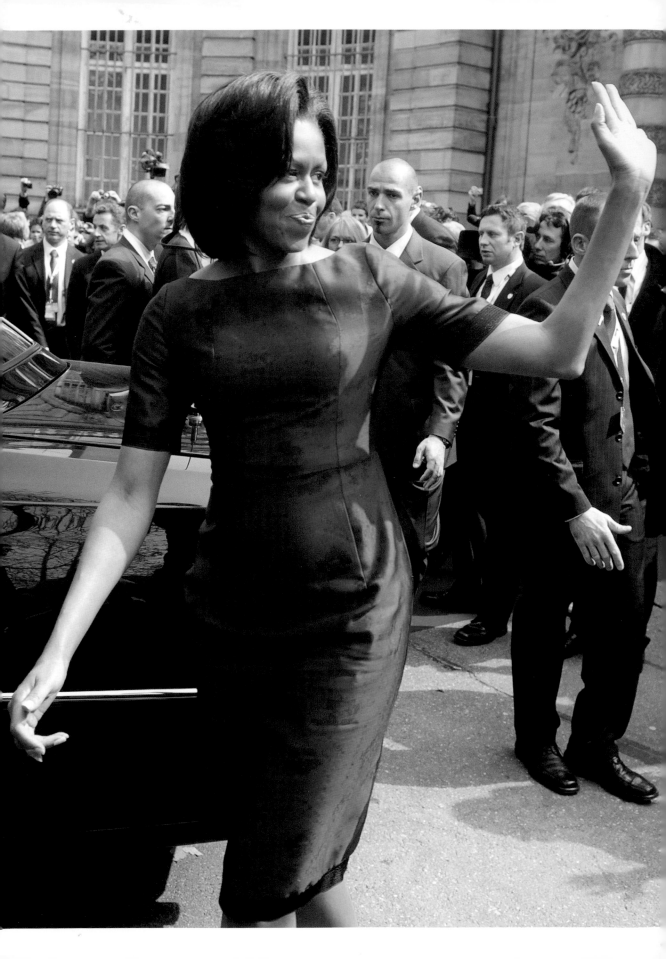

"She is someone with authority and style that people can look up to. It's about women who are real and confident and in a position of power."

–THAKOON PANICHGUL

Michelle Obama waves to the crowd in Strasbourg, France, as she arrives at the Palais Rohan wearing a fitted magenta Thakoon dress that was originally designed—along with a matching coat—for her husband's inaugural ceremony. The fabric (*left*), a reversible silk jacquard, was inspired by a digital poppy print.

for a coat with a dress cut from the reverse side of the same fabric. In the excitement of the moment, Panichgul did not factor in the weather—particularly the biting cold temperatures in the capital in January. He lined the coat in a satin silk he thought would be warm enough, but it wasn't—a fact that probably eliminated it as an option right away. His backup plan was a white tweed coat and dress trimmed in black grosgrain ribbon. He thought the graphic look of black trim on white tweed would make a statement in a quieter way, and he added pleating detail around the collar to highlight the First Lady's elegant neckline.

Rodriguez, another designer Goldman contacted, imagined a slightly more austere and modern look for the incoming First Lady. His sleek, minimalist designs highlighted her athleticism and confidence. Rodriguez submitted sketches for the swearing-in ceremony and was asked to produce two of them—a sculpted, tulip-shaped camel hair coat with a matching skirt and a lavender wool and silk coat with a sleeveless plum dress. Rodriguez, who liked the "sexy austerity" of the first outfit, had envisioned the First Lady in something tailored but not uptight.

Meanwhile, Toledo, who had also been called, was inspired by the majesty of the occasion. She envisioned the First Lady in a color that radiated optimism and charm and a fabric that had depth and was difficult to define, so she ordered a special wool lace from the Swiss mill Forster Rohner AG for her now-famous lemongrass design. She had seen a swatch of the fabric—called Etch lace—and begged the mill to produce it for her as fast as possible, in less than two weeks.

"At first they said no, but we pushed and pushed," Toledo remembers. Once the order was in, Toledo's production person would check in with the UPS truck every morning to see if the fabric had arrived. Because of snow and construction on their street, they wanted to make sure they got it. Time was running out, so

Thakoon's take: Sketches of the two outfits designed by Thakoon Panichgul for Michelle Obama to wear to her husband's historic inaugural ceremony. The reversible black and magenta jacquard (left) was not warm enough. And the second option, a white tweed coat and dress trimmed in black grosgrain ribbon (right), had graphic appeal but probably would not have stood out against the Capitol podium.

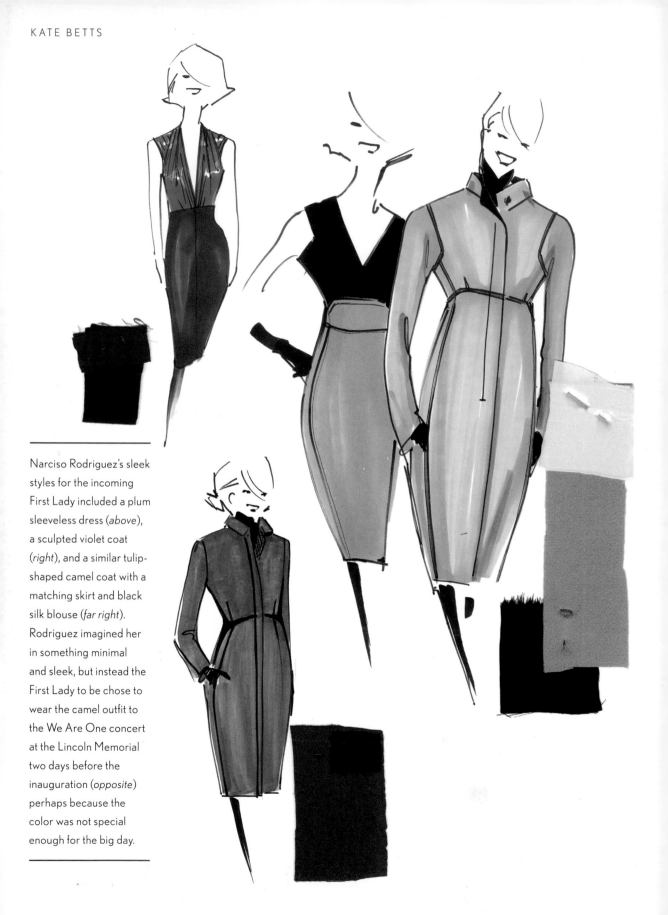

Narciso Rodriguez's sleek styles for the incoming First Lady included a plum sleeveless dress (*above*), a sculpted violet coat (*right*), and a similar tulip-shaped camel coat with a matching skirt and black silk blouse (*far right*). Rodriguez imagined her in something minimal and sleek, but instead the First Lady to be chose to wear the camel outfit to the We Are One concert at the Lincoln Memorial two days before the inauguration (*opposite*) perhaps because the color was not special enough for the big day.

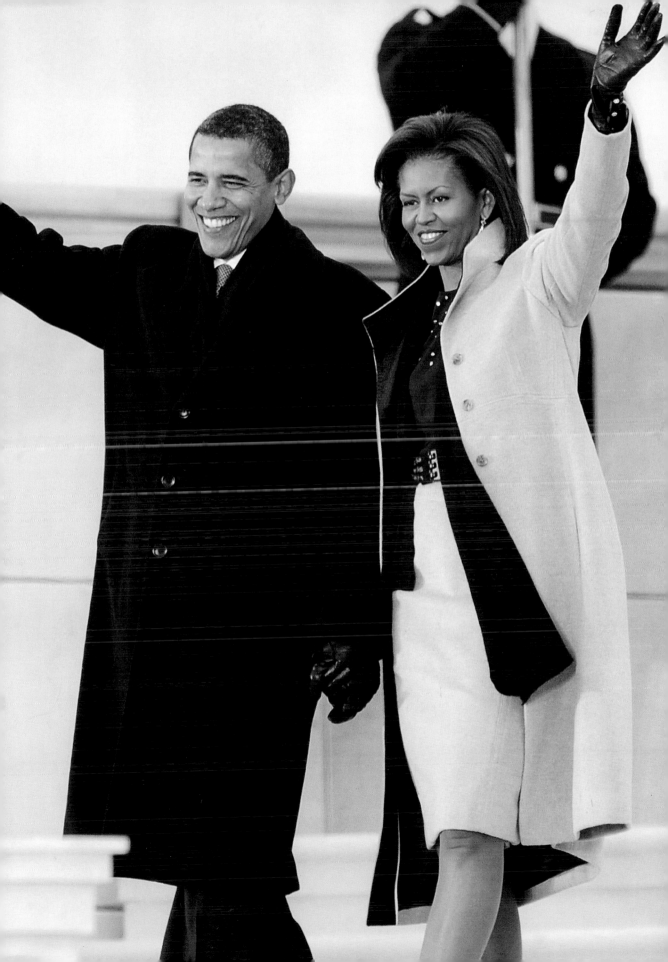

"I knew it was right. I knew it. I knew better than she probably, because I took into consideration so many things that nobody else would." —ISABEL TOLEDO

Toledo asked two seamstresses to work through the Christmas holidays in her Midtown New York studio. Over the weekend, Toledo and her husband, Ruben, cut most of the lace pieces so they would be ready for the seamstresses to sew on Monday morning. Ruben's eighty-four-year-old father, Vitelio, who had been trained in a tailoring shop in Havana and worked as Toledo's head cutter, worked on the rest of the pattern. This was not just any coat and dress; four layers of fabric had to be cut and stitched and quilted together. The layers, including a thin veil of pashmina for warmth, were the first imperative for Toledo. "I knew it was right. I knew it. I knew better than she probably, because I took into consideration so many things that nobody else would," said Toledo in retrospect. "The one thing she requested was that it keep her warm, and layers do that."

A mere ten blocks away on West Thirty-seventh Street another designer, Jason Wu, was also hard at work on a dress for Goldman's "special client." Wu had only been in business for a few years, but buyers had taken note of his soft, sophisticated evening dresses, and that's probably why Goldman asked him to sketch up a few ideas for the inaugural gown. The only caveat was that it had to sparkle. The project, as it was called, was to remain top secret, and he had only two weeks to complete it. Luckily Wu, a twenty-six-year-old native of Taipei, Taiwan, who was educated in the United States and had been running a designer doll business since the age of sixteen, in addition to his three-year-old fashion business, kept several seamstresses on hand in his third-floor studio. Like Toledo, Wu also envisioned something very specific for the First Lady. She had already ordered a few dresses from him through Goldman, but she had not yet worn them. One, a white raw silk sleeveless dress embroidered with black rosettes, had been featured in his fall 2008 runway show. This order was different, though, and Wu knew he only had time to produce one dress, so it had to be right. He didn't envision a traditional bright blue or

Michelle Obama's inaugural ceremony outfit, the now-famous lemongrass wool lace coat and dress were designed with the weather in mind. Isabel Toledo lined the custom-made Swiss lace in silk radzimir to give it a slight sparkle and pashmina for warmth.

What not to wear: New York designer Peter Soronen sketched this gold brocade dress—inspired by a vintage Dior design—but ultimately the First Lady chose something softer and more contemporary for her inaugural gown.

red inaugural gown with covered-up long sleeves, as seen on other First Ladies. This gown had to be young but also appropriate. For Michelle Obama, the first African American First Lady, Wu wanted to strike a balance between the traditional and the new.

Goldman also solicited sketches for an evening gown for the inaugural festivities from Peter Soronen, a forty-two-year-old New York designer who had once worked as a pattern maker for a Chicago uniform company and was now designing constructed gowns and cocktail dresses with built-in corsets. His dresses were sold at Ikram and worn by celebrities like Jennifer Hudson and Sarah Jessica Parker. Michelle Obama had worn a cotton brocade dress of Soronen's to the Democratic convention, and so he thought he had an idea about the kind of silhouette she liked. He submitted two sketches to Goldman, a classic streamlined gown with a fluted skirt in gold brocade and a version in the same fabric with a fuller skirt that was inspired by a vintage Dior dress. Both designs played to Michelle Obama's statuesque glamour and retro femininity, but Goldman never asked Soronen to produce either of the gowns. Instead, she called Wu and told him she liked his sketch and to go ahead and make the dress. Wu ordered twenty yards of ivory silk chiffon and began the tedious process of sewing two thousand coin-sized organza flowers and millions of tiny Swarovski crystals onto the panels of ivory chiffon that would become the skirt of the gown. His was still a small and relatively unknown operation, so he didn't have the kinds of connections with suppliers that bigger Seventh Avenue labels had, the kinds of connections that could get custom fabric orders or beadwork done quickly. In the interest of time, he did all of the beadwork in-house—on the tables in his Manhattan workrooms—instead of sourcing them out to embroiderers in India.

When the dress was finished, Wu decided to hand deliver it to Ikram in Chicago because he had been on a losing streak—losing

things like FedEx boxes. This was not the time to take that risk. Wu canceled his Thanksgiving plans and flew to Chicago with the dress on his lap. Goldman made a point of always remaining vague about when or where the First Lady would wear the clothes she commissioned, and she forbade designers from talking about the work they were doing for her. Presumably the First Lady did not want fashion—or the "*f*-word" as one of her staff members would later refer to it—to overshadow the more important messages of her husband's historic presidency. In political terms, fashion was useful as a communication tool, to convey the First Lady's individuality and to grab the attention of young women who responded to aesthetics in an image-obsessed culture.

On Wednesday, November 26, Wu brought the dress to Goldman's store and went back to his hotel room, mission accomplished. He flicked on the television and landed by chance on the Barbara Walters special. There was Michelle Obama in the white and black raw silk dress that he had made several months earlier. This was a good sign, he thought. The next day, on the way back to New York, the airline lost Wu's luggage.

Then on the evening of January 20, Wu's luck returned. He had spent all day watching the inauguration on CNN at his office. Everyone was watching it. "We were paralyzed," Wu said. "We had never really paid attention to the inauguration, but this was different, it had never been covered like this before. Not to my knowledge." That night he continued the inaugural-watching marathon with friends at his Midtown apartment. They ordered pepperoni and mushroom pizza and zapped around to find the best coverage. Wu wasn't even sure he was watching the right channel because the festivities looked more like a rock concert to him than an official ball. Then the president and First Lady were introduced at the Neighborhood Ball, the first of ten balls that evening, and Michelle Obama floated out onto the stage at the Washington Convention Center in a

Approval rating: Michelle Obama gives designer Jason Wu a thumbs-up at the ceremony where she donated her ivory chiffon inaugural gown to the Smithsonian National Museum of American History's "First Ladies at the Smithsonian" exhibit in March 2010.

frothy ivory-colored one-shouldered dress worthy of a prom queen or a blushing bride—a dress that she would later say made her feel luscious. As she moved, the folds of ivory chiffon fluttered under the sparkling crystal embroidery like a blanket of freshly falling snow. That dress told the story of a new beginning.

"I thought, Oh my God, that's my dress," Wu remembered. Within ten minutes CNN was calling, and his e-mail in-box was flooded with congratulatory messages from as far away as Sydney, Tokyo, and Taipei. "It was really, really crazy, like nothing I would

have ever expected. There was no precedent. Not even Reagan. We all experienced it for the first time ever. It will be hard to repeat this experience ever again for a long time."

Instead of choosing a big-name Seventh Avenue designer to create her inaugural wardrobe, Michelle Obama had gambled on a new generation of talent. The gesture clearly demonstrated that she was not going to follow any rules when it came to fashion. The fact that the designers she chose were the sons and daughters of immigrants—even first-generation Americans themselves—was significant, too. A new and historic administration required new ideas, new faces. Everything about Michelle Obama's inaugural wardrobe would speak to new beginnings. And for designers like Wu and Toledo—both relatively unknown and both working independently of the great luxury behemoths that dominate the fashion industry—the chance to dress the First Lady on inauguration day would catapult their names into newspapers, magazines, and Web sites around the world. The street outside Toledo's studio became so mobbed with cameramen the police were summoned. Wu became so famous in his hometown of Taipei that his mother found she could keep tabs on him by watching the local news every night. People camped out on the street in front of his studio for a week. He had to take his name off the buzzer on the door downstairs.

The inaugural gown would not be Wu's last for Michelle Obama. He would continue to make one-of-a-kind dresses for her in brilliant shades of fuchsia, lime, and teal—dresses that would appear on the cover of *Vogue* and travel to Buckingham Palace, Moscow, and Rome. His fashion shows would fill up with important magazine editors, department store buyers, and socialites. His store orders tripled. His company's revenues quadrupled. He moved to a nine-thousand-square-foot showroom. And still the designer had yet to meet his most important client. But that didn't seem to bother Wu; in fact, it presented a new kind of design challenge. "You can get what this woman

is about without having to meet her," he said. Indeed, her personality and style proved to be so forthright, so real, that he felt he knew what Michelle Obama would like without even knowing her. Of course when he finally did meet the First Lady more than a year later—at the official ceremony where she handed over the famous dress to the Smithsonian National Museum of American History—she gave him a heartfelt hug.

For Toledo, a veteran of the fashion business who had at one time designed for Anne Klein, the attention meant that her work, once deemed arty and experimental, would get its rightful place alongside other First Ladies' inaugural gowns and ensembles in the annals of American fashion history: the Smithsonian Institution. Even Narciso Rodriguez, whose two outfits never made it to the Capitol podium on January 20 but were worn instead in the days leading up to the inauguration and later in the White House, continued to be astounded by Michelle Obama's immeasurable influence. "I don't think there's any designer who isn't thinking about her in some way or another," he said. "Ultimately, such a huge force in fashion becomes fashion."

For Panichgul, Michelle Obama inspired a new way of looking at fashion. Tired of dressing size 0 models and celebrities who seemed to aspire only to a surgically enhanced standard of beauty, he welcomed her intellectual vitality as emphatically as he applauded her confidence in young, unproven American designers. He recognized in her someone who knows what she likes and is self-assured enough to stick to her opinions and ideas. She would not be swayed by a fashion system or any anachronistic Washington protocol. "She is someone with authority and style that people can look up to," he said, several days before the inauguration. "It's about women who are real and confident and in a position of power, as opposed to the celebrity thing, which is so false."

Even her physical stature was inspiring to these designers.

"Her body is the body of a modern woman today," Panichgul added. "She wears dresses that are tight to the body, but she's not a size four, and it looks good on her. The way that she wears clothes is so powerful, with such confidence. That's a concrete visual thing." Certainly there was nothing fake or timid about Michelle Obama as she glided across the stage at the first inaugural ball in those sweeping layers of embroidered ivory chiffon, sharing an intimate moment with her husband while looking to all the world like a strong, powerful woman with her own ideas about how to lead. Her husband's campaign had promised change, and on that inaugural stage the new First Lady promised her own kind of change—a new etiquette that would transcend race and fashion and the stodgy protocol of her position.

For these American designers, the support from their most famous and elusive client would prove to benefit them in many ways, not merely financial. Dressing Michelle Obama would give them name recognition, yes, but she would also give them a new kind of inspiration, something they hadn't seen in a long time, if ever. Her height, her realness, and her intelligence would empower them and unite them. Instead of focusing on fashion insiders or celebrities, they would find a common ideal in the first African American First Lady. It was beginning to dawn on all of these designers that what they had on their hands was a new American icon.

Jason Wu's sketch for Michelle Obama's inaugural gown details the draped shoulder, Swarovski crystal embroidery and the organza flower embroidery as well as the dress's train, which proved a little unwieldy at times during the ten inaugural balls the First Lady attended.

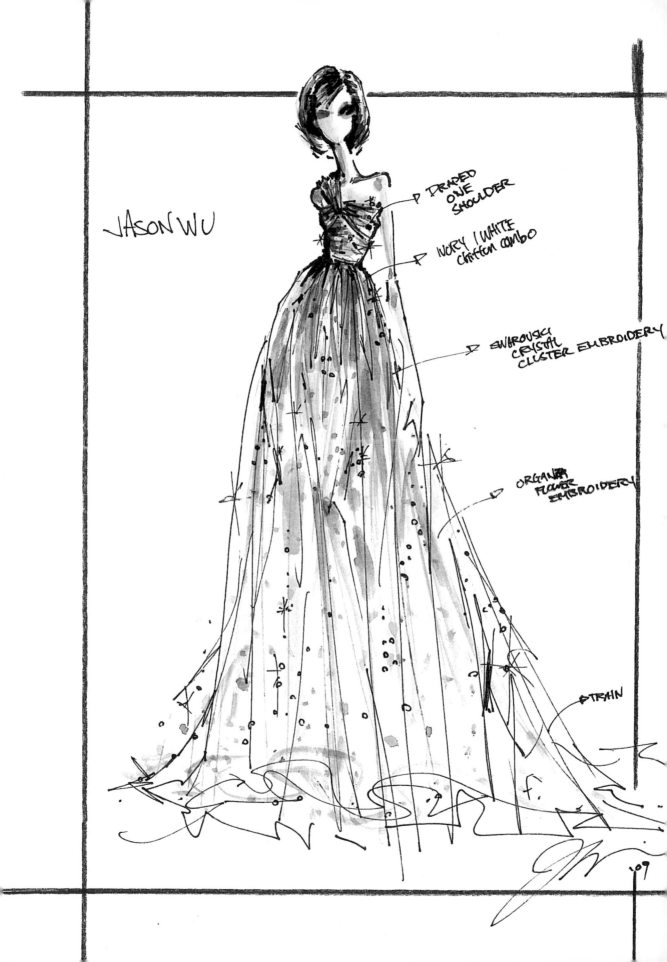

JASON WU

▷ DRAPED
ONE
SHOULDER

▷ IVORY / WHITE
CHIFFON COMBO

▷ SWAROVSKI
CRYSTAL
CLUSTER EMBROIDERY

▷ ORGANZA
FLOWER
EMBROIDERY

▷ TRAIN

'09

THE PERSONAL SHOPPER

Ikram Goldman, owner of Chicago's Gold Coast store Ikram, is the First Lady's connection to rising fashion stars like Jason Wu and Thakoon Panichgul. Despite her high-profile client, Goldman has maintained an air of mystery, even when sitting front row at fashion shows. The elusiveness is not part of Goldman's pitch. By all accounts she's an extremely affable salesperson with a keen eye for fashion and a mother-henlike devotion to her clients. Part of that devotion includes avoiding all discussion about her relationship with the First Lady.

Goldman got her start in fashion working as a salesperson for one of Chicago's legendary retailers, the late Joan Weinstein, founder and former owner of Ultimo on Oak Street where for thirty years Windy City shoppers discovered designers like Giorgio Armani, Jil Sander, and Yohji Yamamoto. Weinstein was one of the first American specialty boutique owners to venture to Europe to buy clothes in the mid-1970s. In one famous story, Weinstein went to see an up-and-coming menswear designer by the name of Giorgio Armani in his studio on Milan's via Borgonuovo and advised him to make his draped power suits for women, too. Similar stories have been told about her first meeting in a Paris attic with Thierry Mugler and her first order for John Galliano's Russian Aristocrat collection in 1995.

"If you look it, you'll become it" was Weinstein's mantra, and she repeated it constantly to her salespeople and her customers. "We didn't sell pieces, we sold wardrobes," says Jesse Garza, a New York–based wardrobe stylist who was the creative director of Ultimo from 1987 until 1995. Inside Ultimo's dressing room, Weinstein's salespeople were taught to sell a total look—the dress, the bag, the belt, and the shoes. "Joan challenged us to be stylists, not salespeople. She set the stage in the boutique and there was a cast," says Garza, who cringes when he remembers his

own look at the time, a Flock of Seagulls–style haircut and a Byblos jacket with linebacker shoulders.

In addition to Garza, another starring member of Weinstein's "cast" was Ikram Goldman, a young salesperson who had moved to Chicago from Israel and had an eye for fashion. Weinstein quit the business after bringing in venture capitalists to help her expand in 1999. Two years later Goldman, who had become one of Weinstein's top salespeople in her ten-year career at Ultimo, opened her own shop a few blocks away, on North Rush Street. Goldman's boutique quickly became a popular shopping destination among Chicago women who favored more avant-garde labels from Europe and Japan. Goldman also introduced her clients to a raft of new American names that were beginning to gain notice at New York Fashion Week—names like Rodarte, Maria Cornejo, Thakoon Panichgul, and Jason Wu.

Ikram Goldman, owner of the eponymous Chicago boutique, has been the point person for the First Lady's White House wardrobe, contacting young designers like Thakoon Panichgul, Jason Wu, and Sophie Theallet and ordering clothes for every kind of occasion.

Mellody Hobson, president of Ariel Capital Management and a faithful client and old friend who has known Goldman since she was sixteen and shopped at Ultimo, emptying pockets full of change onto the counter, says the retailer always buys with a person in mind. "She'll say 'You won't believe what I got for you in Paris,'" says Hobson, who, on the day I met her in her twenty-ninth-floor office overlooking Grant Park, was wearing six-inch-high Christian Louboutin platform pumps. "She'll say to me 'You're getting this,' even if I protest and say I don't like the color or something. She'll say, 'Sorry but you're getting this.' I trust her implicitly."

The designers trust Goldman, too. "Ikram is so respectful of her designers," says Panichgul. "She really loves what we do and she really loves having her designers come up with things that are different for Michelle and she doesn't really dictate at all." That said, Goldman certainly has a look. "It's not a store for somebody who doesn't know fashion," adds Panichgul. "It's a very avant-garde store, and if you shop there regularly you have to understand fashion. Ikram knows the designers, she knows what she likes and she knows exactly what works for Michelle."

FROM RUNWAY TO REALITY

When it comes to fashion, Michelle Obama knows what works for her. And she knows clothes well enough to be able to make adjustments so that even tricky runway looks can fit her perfectly. For example:

1 The famous Narciso Rodriguez "lava lamp" dress from election night originally had an entirely different neckline and transparent straps, both of which the First Lady altered to achieve a more conservative look.

2 Jason Wu's cocktail dress originally appeared on the runway in chartreuse. The First Lady had it made in teal instead and without the embroidery around the border and wore it on her first trip to London.

3 And when she accompanied the president to Oslo, Norway, to collect the Nobel Peace Prize, she wore Calvin Klein's flocked velvet dress but had the hemline altered to something more traditional.

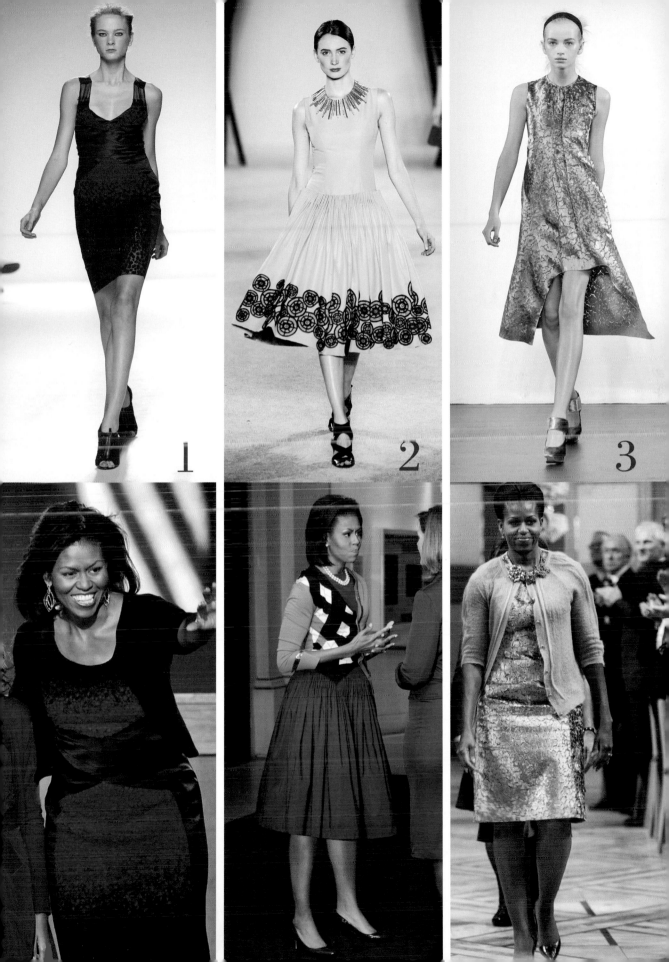

1

2

3

4 THE EVERYDAY ICON

Anyone who takes a few minutes of each day to consider his or her appearance confronts a crucial question: Are you dressing to fit in, or to stand out? Are you following the crowd or striking out on your own? Fashion magazines are always filled with snooty directives like "It's all about pants!"—the bruising subtext being that if you don't wear pants this season, you're out of step, your children will creep away from you in shame, and Prada store employees will howl with laughter. Absurd as it sounds, a lot of the multibillion-dollar fashion business capitalizes on the fear of not fitting in. Designers make their money manipulating consumer tastes with seemingly random changes of direction. Red this season, blue the next. Skinny jeans today, bell-bottoms tomorrow. It's no surprise that so often the women with real style are the ones who disobey the imperial edicts and wear what they want to.

The First Lady and the president stroll across the South Lawn on their way to Marine One and, eventually, Camp David for the weekend in March 2009.

Michelle Obama could easily have chosen a wardrobe that allows her to fit into the drab landscape of Washington, D.C. Instead she wears clothes that make her stand out, clothes that identify her as someone with individual style, not a fashion follower. In many ways she personifies the difference between fashion and style, between the desire to fit in and the natural inclination to stand out.

The question of whether to fit in or stand out goes way back to our nation's early days. It reflects a contradiction that's been in the American character since the beginning. We were founded in the spirit of self-determination and freedom and by nature disdain the trappings of monarchy. There was no place in the new democracy for European class distinctions. Then again, from the Puritan times onward we have been suspicious of too much self-expression, viewing an excess of individuality as sinful self-indulgence, an affront to the egalitarian spirit de Tocqueville summed up so brilliantly when he said that Americans would rather be equal than free.

As the nation developed, so did its national style, sharpening the contradictions of fitting in and standing out. The vocabulary of self-expression became increasingly personal and complicated for women as they won civil rights and professional gains, and as they rejected clothes that constrained their freedom or emphasized their helplessness. It's no coincidence the corset disappeared around the time women won the right to vote in 1920, or that burning your bra became one of the first symbols of 1960s feminism.

As women flooded the workplace in the late 1960s, style was looked on as a liability that might compromise professional standing, or highlight a woman's sexuality at the expense of her expertise. Images of Michelle Obama in her casual cardigans, jeans, baseball cap, and sneakers are striking in part for showing how much the strictures of earlier generations have been relaxed. The white gloves and girdles of Mamie's and Jackie's day seem like relics of an ancient civilization. Now we have Casual Friday, which lasts all week. The old

rules have been washed away. The power-dressing decrees in John Molloy's book *Dress for Success*, which came out during Nancy Reagan's reign and preached a gospel of floppy bow ties, gray suits, and linebacker shoulders, just seem silly, and yet it was only twenty years ago that most executive women on Wall Street and female members of Congress wouldn't dare wear pants to work.

> "Style ain't nothing but keeping the same idea from beginning to end." –AUGUST WILSON

Women in positions of authority—from Washington to Wall Street—have always struggled with being intensely scrutinized when it comes to their appearance. Betty Spence, the founder and president of Equal Voice and the National Association for Female Executives, wittily calls the attention "skirtiny." Women want to project a feminine image, without losing their standing in a masculine world, but under the pressure of skirtiny they have often stifled the urge to stand out. It's never occurred to millions of professional women that style might be a useful tool, a sign of an aesthetic intelligence and sophistication that could actually enhance their effectiveness, not hinder it. Too often women have accepted the conventional wisdom that paying an inordinate amount of attention to clothing is a flaw in character that denotes frivolity, a lack of gravitas.

As we've seen, this has especially been the case in the nation's capital. Indeed it may be the staid backdrop of Washington that makes Michelle Obama seem so vivid. Fashion plays a role in the culture of the capital, mostly in the sense that it is conspicuously absent. Washington is, generally speaking, a style wasteland governed by a code of conformity. Where New York City says stand out, Washington says fit in. Where New York and Los Angeles are full of forty-year-olds trying to look twenty-five, Washington is full of twenty-five-year-olds trying to look forty. In Washington being older is considered a virtue, of course, because it implies serious-

ness. And maybe dull clothes are the only attribute that people who despise one another's political beliefs can share. Why let what you are wearing exacerbate your differences? Whatever the reason for the code, it exerts a powerful effect, and people find it convenient to conform to it. Men wear a predictable array of power suits in shades of blue and gray. Expressions of individuality are confined to a risqué tie or an argyle sock.

The code is even more severe for women—especially those who work on Capitol Hill. Worried that their views on health care reform or the budget won't be taken seriously if they are dressed too fashionably, they go out of their way to depersonalize their outfits. They cling to a threadbare uniform of boxy blue suits, vanilla-colored panty hose, and sexless square-heeled pumps. An adventuresome woman in Washington might tiptoe into designer label land with a St. John suit or an Akris Punto dress from old-school stores like Rizik's on Connecticut Avenue or Saks Fifth Avenue and Saks Jandel in Chevy Chase.

Once in a while a powerful Beltway player will throw caution to the winds and veer away from the dowdy government look. In the early 1970s Congresswoman Bella Abzug made zany hats her trademark, largely on the advice of her mother, who shrewdly told her that a smart hat would differentiate her from the secretaries. When she was secretary of state Madeleine Albright set the city abuzz by pinning a different gaudy brooch to her chest every day. She used the pins to telegraph her feelings. Unhappy with the pace of negotiations for peace in the Middle East, she wore a pin in the shape of a turtle or a snail. If she was in a foul humor, she wore a pin in the shape of a crab. Pins shaped like hot air balloons signified "high hopes." Ladybugs meant she was in as fine fettle as a secretary of state could expect to be. It was her way of having fun with fashion, but it also proved useful—a way of making a point without saying anything. And for Washington it created a veritable fashion

tsunami. Deputy assistant secretaries and administrative assistants scrambled to get into the Albright Pin Club. They ransacked the shelves of places like the Tiny Jewel Box, a popular vintage jewelry store.

Some violators of the capital fashion code have been punished for reasons that speak as much to the subtlety of image as to its power. Although she was more fashion conscious than most women in the West Wing, Condoleezza Rice had established a conservative image consistent with her responsibilities as secretary of state. Her wardrobe attracted little attention until 2005, when she marched across the tarmac at Wiesbaden Army Airfield in a severe black military-style coat and a pair of black stiletto boots. The boots were cool, but on Rice they seemed out of place and inauthentic, a weird turn away from what she had given people to expect. "Dominatrix!" wrote Robin Givhan in the *Washington Post*, applauding Rice for leaving the matronly Beltway look at home. But in the context of the Bush White House, Rice's boots seemed more militant than feminine, and bloggers compared her to the trigger-happy, leather-coated insurgents of *The Matrix* and its sequels. To prevent future U.S. foreign policy debates from playing out in the pages of *Vogue*, Rice slipped back into her sensible pumps.

More than in most cities, professional dress in Washington functions as a kind of corporate camouflage—a team jersey, easy to put on, useful in the way it can minimize differences among people and create a feeling of solidarity. It's always the safe choice.

What's amazing is how quickly and thoroughly Michelle Obama seems to have repudiated the safe choice. As the Obamas settled into the White House following the inauguration, she made it clear she was not going to be coerced by the dress code of the capital. No boxy blue suits. No East Wing uniform of stiff shantung jackets in innocuous noncolors like puce. She was going to do something few First Ladies have dared to do in the White House: dress

Stand-out style: Michelle
Obama resisted
Washington D.C.'s dull
dress code from day one.
Showing up at the Capitol
for the president's first
joint session of Congress
in a sleeveless dress
signaled her willingness
to go her own way (*top*).
Stepping out to lunch
in a turquoise tweed
coat (*bottom right*) or
at the National Prayer
Service in a dress with
an unusual print (*bottom
left*), the new First Lady
uses her appearance to
send a powerful message
of independence and
confidence.

for herself. As the first African American First Lady she was starting a new chapter in the history of the White House and bringing a new style with her. Nothing about it would be by the book. Unlike Laura Bush and Hillary Clinton, who both came to the White House after stints being a governor's wife, Michelle didn't own a wardrobe full of "safe" choices. And she made it clear from her early forays into the public eye as First Lady that she would not be wearing any uniform but her own.

The day after the inauguration, at the National Prayer Service in Washington's National Cathedral, Michelle turned up in an unusual floral-printed Tracy Feith dress—looking as exotic as an orchid in a field of dandelions. The following day she made a splash when she met Mayor Adrian Fenty and his wife, Michelle, for lunch in a tweed coat the color of the Caribbean Sea. She even appeared at her husband's first joint session of Congress in a sleeveless dress by Narciso Rodriguez, a sight that launched a chorus of outrage in the blogosphere. One blogger said the First Lady looked like she was going out to a club. Even fashion magazine editors were agog: "Oh my God," Cindi Lieve, the editor of *Glamour* e-mailed the *New York Times*, "the First Lady has bare arms in Congress, in February, at night!" As if to reiterate the point that she would follow no fashion ordinance but her own, the First Lady chose another sleeveless sheath—this one by Michael Kors—for her official portrait. Not only did the portrait flaunt her enviable sculpted arms, but it also radiated strength and independence. She was consistent, confident, and almost radical in her elegance and her ease.

This bold decision to shun the Washington power uniform and go headlong into her own style is all the more unexpected, given the precedent of Michelle Obama's race. It's likely a five-foot-eleven African American woman would stand out in the White House no matter what she wore. But it takes a special measure of self-confidence to brush off the city's uniform. As a newcomer to

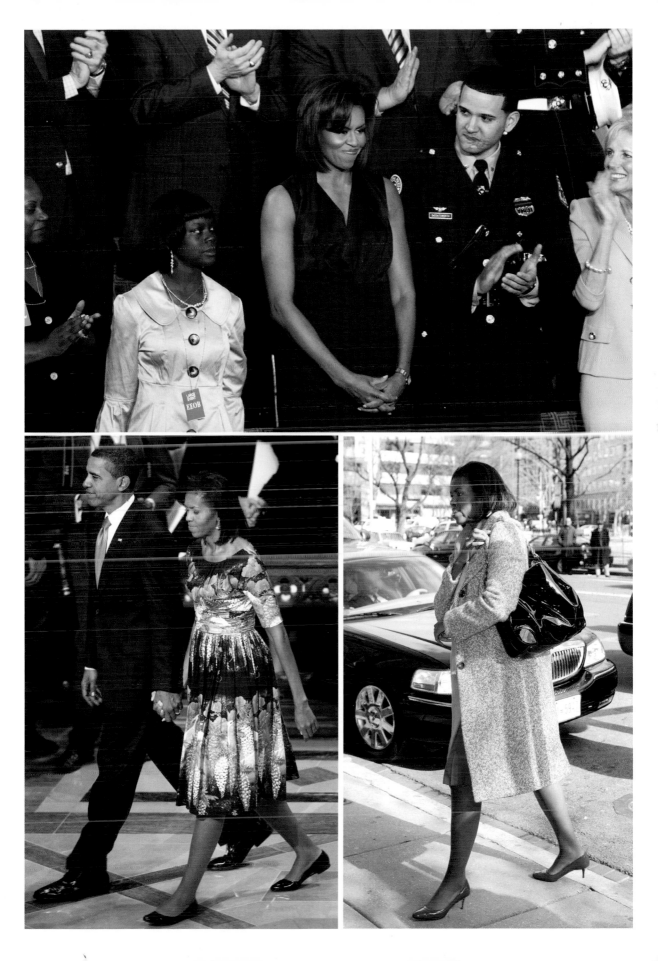

the city, and a leading advocate in an administration aspiring to change long-entrenched policies and practices with controversial new approaches to the environment, health care, and the country's economic troubles, wouldn't it have been more politic to adopt the Washington dress code, rather than flout it? Smarter to play it safe, look for stylistic ways of showing how she could fit in? This is not to say she should have resigned herself to a puce shantung jacket and some panty hose until the midterm election results were in.

But the fact that she didn't play it safe makes you wonder how she came by such self-confidence, or whether her idea of the protective coloration of clothing is different than it is for those of us who are more cautious about dress codes. Perhaps the precedent of her race is what ultimately gave her license to express her independence and self-possession. Not only did the First Lady refuse the less risky route, but she also turned the whole fit in/stand out two-step inside out. She's made "safe and predictable" seem like a liability and the stand-out, wear-what-you-love choice an asset. She seems to have harnessed the power of an idea that the iconic designer Karl Lagerfeld articulated not long ago: "The thing about fashion is you can use it to hide, but it's only magic when you use it to express who you really are." In wearing what she loves and what she wants, Michelle Obama has not just repudiated the conventional Washington uniform. She's also dumped the whole stuffy etiquette behind it.

"The thing about fashion is you can use it to hide, but it's only magic when you use it to express who you really are." —KARL LAGERFELD

THE NATURAL

One photo taken on a brisk Sunday afternoon in March 2009 shows the First Lady and the president returning to the White House from Camp David. They amble across the South Lawn holding hands. The president is wearing a windbreaker and a pair of khakis. The First Lady is in a black trench with a black patent leather bag slung over her shoulder. One could almost picture oneself in their place. They look comfortable and confident, not overwhelmed by their circumstances. Or so we imagine. In that photo, and in many others, the president and the First Lady project something Americans have not seen for a long time in public figures and certainly not in the White House: a natural sense of style. What you would never know from the appearance of the First Lady is how much effort had gone into looking so effortless; nor would you know what a keen, cutting-edge sense of fashion she has.

In choosing little-known designers such as Wu, Toledo, and Panichgul, in mixing their clothes with pieces from the Gap and J.Crew, the First Lady has spurned the conventional choices and the orthodox ideas. She wears her principles on her sleeve. Not for her the trends of the moment. Be who you are and don't apologize, she seems to be saying.

Not long after that South Lawn saunter with her husband, she showed up at Fort Bragg to read to a roomful of kids. She wore a cardigan and pants. When one of the kids asked her what she does to relax, she said, "Click on some nonimportant TV and veg out." Over and over again, she emphasized the same idea. Be who you are. Wear what you love. Could she make such a proclamation if she were secretary of state? Probably not, but it's hard to say. Certainly when she was planting her new White House kitchen garden, nobody thought to cry out, "Dominatrix!" when she pushed

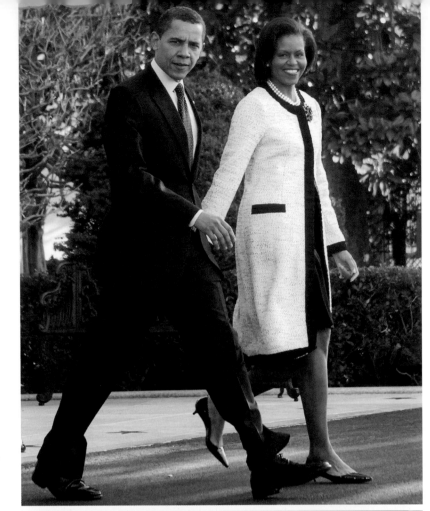

The pageantry of
Michelle Obama's first
official trip to Europe
captured the public's
attention like few former
First Ladies' trips had. She
left the White House for
London in a conservative
tweed Thakoon coat
(*top*) and did a quick
change aboard Air Force
One the next morning,
disembarking at Stansted
Airport broadcasting
her message of optimism
and renewal with a bright
yellow Jason Wu dress
(*right*).

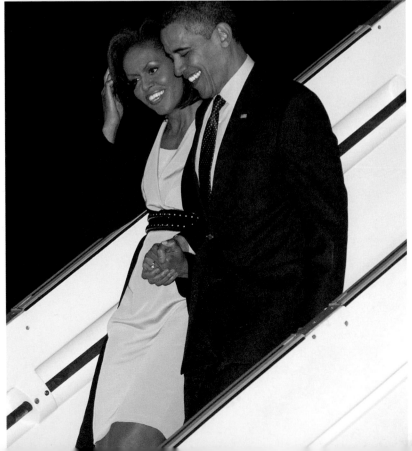

the shovel into the South Lawn dirt with her lug-soled black patent leather Jimmy Choo boots.

STYLE OF COURSE encompasses more than what you wear. Style is just as much what you do and how you do it. Nothing drove this idea home more than Michelle Obama's remarkable European tour in April 2009, when she and the new president stormed the great capitals of Europe. It was the First Lady who captured the crowds and who seemed to breathe new life into what it means to be an American. It was the First Lady who seemed to restore the enthusiasm for America that had been lost during the previous administration. As one Paris-based designer, Azzedine Alaïa, had said, her realness and her openness had "made America something that people admire again."

Even as the Obamas left for London, people were commenting on Michelle's crisp white tweed coat—presumably the appropriate uniform to wear to meet Europe's heads of state. But Michelle had something more surprising in mind. She disembarked Air Force One at Stansted Airport north of London the following morning in a bright lemon yellow dress, and with the British press skirtinizing her every move, promptly assumed the mantle of Michelle the Conqueror. Conveyed by motorcade to Buckingham Palace for an appointment with Her Majesty Queen Elizabeth II of the House of Windsor, she wore a simple black cardigan. A cardigan to meet the queen, Monarch of the Commonwealth, Supreme Governor of the Church of England? It put Oscar de la Renta around the bend. "You don't go to Buckingham Palace in a sweater," he scoffed. Then as she was leaving the private quarters at the palace—Michelle in her black

> "Style is about how you put it together, not how someone else tells you how to put it together." –JENNA LYONS

101

cardigan and the queen dressed in a powder puff pink dress, white gloves, pearls, with her pocketbook slung over her left arm—apparently she never goes anywhere around that palace without her pocketbook in tow—Michelle Obama did something that no one ever does. Something no one would apparently even ever dream of doing. She touched the queen. She touched the queen! All friendly and familiar, she draped her left arm over the queen's back, resting her long manicured fingers in the area of Her Majesty's thoracic vertebrae. Half of England nearly had a stroke.

What was she thinking?

Maybe she wasn't thinking. If, as I heard later, she was overwhelmed by the unlikeliness that someone from her background might one day be having an audience with the Queen of England, she certainly wasn't paralyzed by the majesty of the moment. And of course it's possible she didn't think twice about the breach of protocol because, well, as her many campaign appearances had established, she was hands-on, a toucher, a hugger. And from the get-go, much of her appeal has come from her spontaneity, her willingness to improvise at even the most heavily scripted events. Touching, hugging, were natural extensions of who she was.

And what was the queen thinking? How did the Supreme Governor of the Church of England feel? She seemed rather charmed. After all, she had initiated the gesture, gently tapping Michelle on the back. No icy glares like the one Her Majesty had given George W. Bush back in May 2007 when he winked at her after blundering a welcome address on the South Lawn. This time around, maybe the queen found the protocol burdensome herself and was refreshed by American informality. Or maybe she wanted to send a broader message about America and its new administration to the world: for the first time in eight years, it's okay to "touch" us again.

A few days later, Air Force One skipped across the channel from London to France and a Group of 20 summit meeting in the

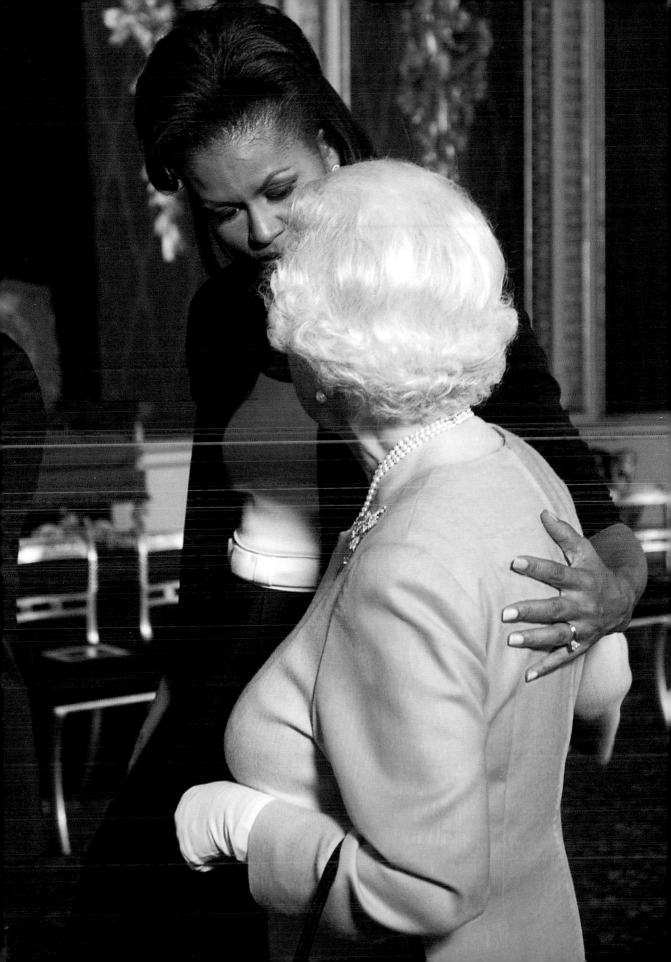

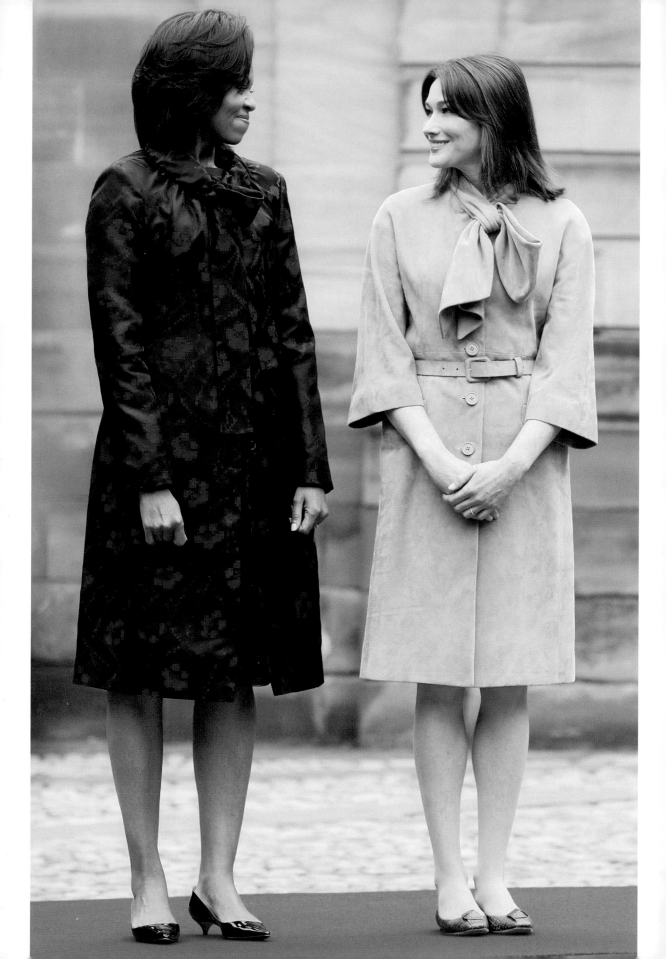

Alsatian capital of Strasbourg. There on a red carpet in the court-yard of the baroque Palais Rohan, before a ceremony marking the sixtieth anniversary of the North Atlantic Treaty Alliance, the Obamas were met by the French President Nicolas Sarkozy and his wife, the cat-eyed former fashion model Carla Bruni. Newspapers were billing the meeting as the "style summit" and "the fashion face-off," echoing the "style wars" between Nancy Reagan and Raisa Gorbachev back in 1985. But this time, the First Ladies were on French soil, and the stakes were much higher for America's new First Lady. Everyone knows that natural style doesn't translate in France, where women would never do something as outré as kicking off their shoes. As a result, it can be hard for Americans to look very glamorous in France, and you'd think a former hospital administra-tor from the South Side of Chicago might be overshadowed by an habitué of the haute-couture runways known for slinky hips and a list of male conquests like Mick Jagger and Eric Clapton. But it was just the opposite. On the runway of international relations Bruni's demure gray Dior coat looked more like Capitol Hill–style camou-flage than high French fashion. As a former model, Carla is a pro at morphing into whatever you want her to be. That day in Strasbourg she was dressing for the role of France's First Lady. Michelle can only be who she is. Her bright, snug magenta Thakoon dress was irrefutably unique, not something any woman could wear with such confidence. Beyond their outfits what was remarkable—what even photographs plainly convey—is how natural and graceful the First Lady of the United States seemed beside the First Lady of France. The woman who had made a living on the runway suddenly looked as if she was just going through the motions, almost robotically, while her American counterpart seemed completely natural, born to the stage.

From Strasbourg it was on to Prague, and then after five days on the road, she returned to the White House to see what had grown in her garden while she was away being hailed as an icon. If as the

Michelle Obama caused an international stir when she touched the queen (*page 103*), but Her Royal Highness didn't seem to mind. Unfazed by all the hoopla surrounding her seemingly unconscious gaffe, Michelle moved on to France where she met Carla Bruni in Strasbourg (*opposite*). Bruni may have more experience with fashion, but it was America's new First Lady who was the model of easy elegance on the runway of international relations.

European press proclaimed, Michelle Obama was an icon, she was not an icon of high style with the traditional aristocratic airs. She was down-to-earth, without pretensions. She wore fashion in a way that suggested she knew it, loved it, but was not beholden to it.

THE LOST ART OF STYLE

Part of the impact Michelle Obama has had on the fashion world has to do with the fact that real style has been drained of substance by the machinery of celebrity culture over the past decade or so. Fashion has increasingly had less to do with taste and art and self-expression and more to do with money, sales, and fame. Fashion has become something that glitzy people can employ to mask their lack of style.

Though they are often confused, style and fashion are not the same. One of fashion's greatest revolutionaries, the fiery and fiercely independent Coco Chanel, defined the difference when she famously declared, "Fashion fades, only style remains the same." A few decades later, another iconic French designer, Yves Saint Laurent, reiterated the idea when he proclaimed, "Fashions fade, style is eternal." Saint Laurent and Chanel shared not only a vision but also a determination to create clothes that would transcend trends and retain their vitality and relevance long after the designers themselves were gone. They broke the rules to create iconic looks for the women of their time. Chanel's legacy of course remains her renowned nubby tweed suit, shrugged on like an easy cardigan and as coveted today in the malls of Dubai and the mansions of Beverly Hills as it was when she reintroduced it in Paris in 1954. (Not surprisingly, the French were somewhat blasé about the Chanel suit at first—what ensured its success was, *quelle hor-*

reur, the enthusiasm of the American market.) Much as Chanel had taken menswear staples and adapted them for women, Saint Laurent followed suit, offering women stylish outfits based around pants just as women were marching off to work in large numbers in the 1970s.

Fashion designers have always looked to style icons to inspire them, emblematic figures from Hollywood, society, royalty, the arts, and occasionally even politics. They have found ideas in figures as diverse as Cleopatra, Josephine Baker, Ella Fitzgerald, Ché Guevara, James Dean, Grace Kelly, Andy Warhol, Frida Kahlo, and even, strange as it might seem, the Supreme Governor of the Church of England, aka the queen. What a dinner party that would be! Some icons are established through marriage: Lady Diana (prince), Babe Paley (media mogul). Some make it on the strength of their work (Audrey Hepburn). What they all share is an outsize charisma, a consistent, unchanging look that pegs them to an idea, an aesthetic, a single-minded obsession. So Cleopatra becomes a symbol of female power; Grace Kelly, untouchable beauty; Greta Garbo, mystery; Lauren Bacall, sexy wit; James Dean, wounded rebellion; Andy Warhol, the mechanization of art. As every icon is an image that reflects some aspect of the spirit of the times, imagery is the medium of an icon's influence. And just as style icons shaped their day, they in turn have been shaped by image makers and the changing way images have been transmitted. This evolution can be traced in how the drawings of Charles Dana Gibson at the turn of the century gave way to the manufactured black-and-white glamour of Hollywood studios in the 1940s; or how the still-life tableaux of society swans in *Vogue* in the 1950s yielded to the fractured jump-cut video of MTV fly-girls in the 1980s.

"I think Michelle Obama is an icon. She has perhaps even surpassed Jackie O. because the world is bigger now than it was then." —THAKOON PANICHGUL

Capturing the moment:
(*clockwise from opposite,
top left*) Audrey
Hepburn's gamine style
made her a Hollywood
icon in the 1950s;
Dorothy Dandridge was
the first African American
actress to be nominated
for an Academy Award
for Best Actress; Ella
Fitzgerald was known
as "the First Lady of
Song"; Josephine Baker
personified exotic flapper
style in Paris; Greta
Garbo's mysterious
aura elevated her to
icon status; Babe Paley
was high society's high
priestess in the 1960s;
Frida Kahlo represented
the exotic life of the artist;
the Gibson Girl, drawn by
illustrator Charles Dana
Gibson, was the first
style icon of the twentieth
century.

Working women:
From Diane Keaton's
androgynous look in
Annie Hall (*below*) to
Diane von Fürstenberg's
sexy wrap dresses (*bottom
right*) and Madonna's East
Village tough chic (*right*),
style icons of the 1970s
and 1980s were working
women determined to use
appearance to emphasize
their independence.

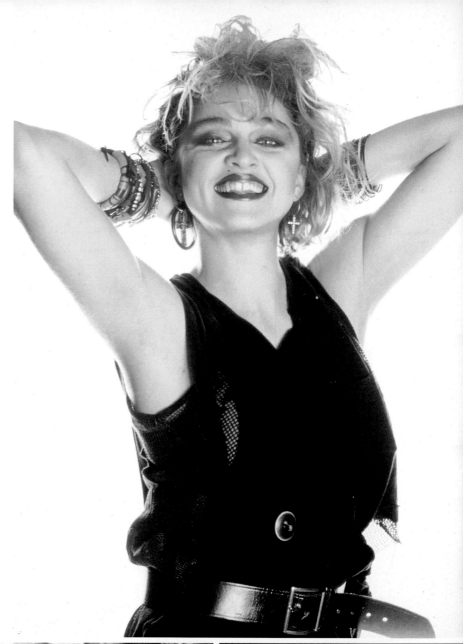

Smart and stylish: As an anchor on the *Today* show in the late 1970s, Barbara Walters (*above*) represented the synthesis of style and substance, as did Diana Ross (*above right*), whose music defined the decade and who used style to reinvent herself. Today's style icons, Mary-Kate and Ashley Olsen (*right*), are products of Hollywood who have translated their success on the small screen into a fashion enterprise.

When I was growing up in the early 1970s I remember my mother talking about style icons, women who had careers but were also glamorous. My mother was particularly impressed by the British writer Lady Antonia Fraser, who wore the draped jersey dresses of the English designer Jean Muir and was one of literary London's "it girls" in the late 1960s. There were others—female photographers, musicians, women who, like my mother, were part of a generation on the cusp of feminism, fighting for their place in the professional ranks with men but also still struggling with how the role of house and home affected their identities. When I was old enough to buy my own clothes, the style icons were out-and-out careerists like Barbara Walters, delivering the somber news of Vietnam every morning on the *Today* show in a buttoned-down shirt with patch pockets and epaulettes. My friends and I were not even teenagers yet, but we idolized Walters, wanted to be her, intuitively sensed the glamour in her drive to work hard and get noticed. The style icons of that era were independent working women, like Diane Keaton in *Annie Hall,* or Meryl Streep in *Kramer vs. Kramer,* or Diane von Fürstenberg on the cover of *Newsweek* in her wrap dress in 1976. Or they were performers like Diana Ross and Carly Simon and Joni Mitchell, who told you who they were and how they saw themselves, not just in their lyrics but also in their style. Working women with the glamour of their own identities: we studied them, we modeled our clothes on their clothes, we adopted their postures, hoping the substance they so obviously possessed would rub off on us.

Nowadays it seems like there's no time for real style to take root or make a difference. The rise of the Internet and video Web sites like YouTube has made fashion so ubiquitous and disposable that anyone can become "iconic" overnight. Like music, we sample style—try it on and discard it just as quickly. Click, you're Victoria Beckham in a little bit of lingerie. Click, you're a housewife in Orange County carping about a catfight. Click, you're a thirteen-year-old

blogger from Chicago named Tavi texting from the front row of the haute-couture shows in Paris. The user-generated images flash up on the screen faster than you can say Louboutin and disappear before you can get the cursor on "refresh." The result is that people with real style have been eclipsed by a seemingly endless parade of fleeting and forgettable jerry-rigged fashionistas riding their notoriety as reality TV stars, *Project Runway* contestants, and brilliantly vapid sex-tape stars like Paris Hilton, who stand for little beyond their own craving for celebrity.

For designer Isaac Mizrahi—a fashion changeling who has segued from runways to reality TV—the missing ingredient in these overnight sensations has been a certain level of sophistication. "Fashion has become just about the newest, hottest whatever," Mizrahi told me one day, sitting in his West Chelsea loftlike studio just before he was to rush off to film a video for his daily blog. "Style has more to do with education and knowledge and smarts. Someone like Victoria Beckham is a fashion icon because she knows how to change it up and listen to the right people and buy the craziest dress that costs the most and be noticed for that. That's fashion." But it's not style.

The result is that in the past ten years many American designers and the consumers who follow them have shifted their focus from style to fashion, from creating a consistent, enduring look to embracing any wacky development that comes down the runway. Miley Cyrus, Emma Watson, Mary-Kate and Ashley Olsen, play the part of fashion's poster girls—adolescent or

"One of the lessons that I grew up with was to always stay true to yourself and never let what somebody else says distract you from your goals. And so when I hear about negative and false attacks, I really don't invest any energy in them, because I know who I am." —MICHELLE OBAMA

adolescent-looking celebrities whose enormous fashion influence comes not from their innate, consistent sense of style but from the mere fact that the media lavishes so much attention on them.

The rise of the Internet also means that the quality of the "style" image has been downgraded. Where once 1940s Hollywood studios hovered over their stars—manicuring their images, controlling when and how they appeared in public—today there is no mystique. Any recognizable figure is captured on digital film (or even by camera phone) at any hour of the day for all to see—walking their dog on a Malibu beach, biting into a burger at a trendy Los Angeles bistro, or strolling in SoHo. They may be wearing the latest fashion—the handbag of the moment, the must-have matchstick jeans—but their clothing says more about the savvy of their stylists than their own sense of style. "Iconic" celebrity style today is based on an inauthentic fabrication: professional stylists are hired to choose clothing and jewelry, designers lend them product or give it away for free, and the media sets its sights on those celebrities with the highest commercial value. The result is that style is not measured in behavior or substantive talent anymore, but rather in how many magazine covers an actress or an "icon" can land and how many eyeballs their image can capture in the blogosphere.

For the celebrities, parading on the red carpet in the latest Givenchy or Versace is just part of the job. And any actress with a good stylist can play the game. Poise, grace, and savoir faire don't really matter. It helps to have the height of Nicole Kidman or the sample size of Victoria Beckham. And it certainly doesn't hurt to be a former model like Cameron Diaz or Sharon Stone. But landing the cover of *Vogue* or *Harper's Bazaar* or *Elle* does not depend on an actress's inherent sense of style. It depends on her box office draw, the release date of her next major movie, or the number of copies she can sell on newsstands.

I know because when I was the editor in chief of *Harper's Bazaar* I had to navigate the tricky world of celebrity managers, stylists, and publicists. "Does she sell magazines?" was the deal maker or breaker when choosing a celebrity cover. I also worked at *Vogue* in the 1990s when supermodels like Linda Evangelista, Christy Turlington, and Claudia Schiffer appeared almost every month on the magazine's cover—in fact, they came to epitomize the magazine in that era. But the rise of celebrities and magazines like *InStyle* and *Us Weekly* toward the end of that decade made cover models obsolete. Even if Evangelista or Turlington knew how to bring the clothes to life and embody an ideal of sophistication, they couldn't compete with the commercial appeal of a Jennifer Aniston or a Julia Roberts.

Thakoon Panichgul, one of Michelle Obama's favorite designers, started out working as a fashion writer when I was editing *Harper's Bazaar*. (Nobody knew he wanted to be a designer, but he was taking courses at night at Parsons School of Design in Manhattan.) Michelle Obama wore one of his dresses when she met with Carla Bruni in Strasbourg, as we have seen, and he was one of the designers Obama's fashion consigliere Ikram Goldman consulted early on. Thakoon is typical of many young designers whose budgets are sorely taxed, making special gowns for Hollywood face cards, and whose ideals about how fashion ought to work have been tattered by the experience. He missed the style icons of yore, women who weren't afraid to make mistakes, women who dressed to stand out. Now that Hollywood had co-opted the fashion business, it was rare to see a woman with real style. For designers like Panichgul, fashion had been reduced to a celebrity gambit. "It was just about getting the clothes on a celebrity. It wasn't real. It was all fake," he said one afternoon in his studio in lower Manhattan. "It was all superficial, and people got paid and the celebrities didn't even buy the clothes and your object was to get the picture published in those tabloid

magazines that fed the celebrity culture even more. I just felt that was a machine that was going to self-destruct."

THE EVERYDAY ICON

The machinery of celebrity may be on the brink of destruction or it may not, but it doesn't seem like something that could be dismantled overnight by the arrival of a new First Lady. You have to wonder how much of the infatuation of young designers with the Obama brand reflects their longing for a fresh start, or is just a respite from their own sense of jadedness about the industry. Business is business, and fashion has always been a business, ready to commercialize style or the next hot product. The frenzy about Michelle Obama in some sense can be seen as another instance of fashion's relentless pursuit of the latest, newest look of the moment.

Then again, Michelle Obama could never have made such an impression based on just the disenchantment of a bunch of young designers and clotheshorses. Dramatic cultural changes, from the ascent of the professional woman to the breakdown of dress codes, prepared us for her arrival. The culture as a whole is more casual, and women have achieved more independence and authority in the workplace. They no longer have to dress like men in order to compete with them. As women's ambitions have evolved, so have the faces that represent them. Michelle may have the glamour of a Jackie Kennedy, but as a style icon she speaks to a multicultural, postfeminist, wireless world.

The fashion business has exploded. You can buy a Prada handbag in any major city in the world. The now-global industry has been subdivided into dozens of tribes and is no longer domi-

nated by monolithic influences such as Seventh Avenue, or Paris, or the hot label of the season. The once mighty social hierarchy that governed fashion is also gone. The industry used to dictate to women en masse, now it tries to cater to women as individuals. Those snooty fashion magazine directives coercing everyone to look the same—"It's all about pants!"—have morphed into more inclusive declarations like "It's all about personal style!" Technology has made style more accessible and diverse. Any individual can be a fashion arbiter on social media and shopping Web sites like polyvore.com, where users tag their favorite products and share them with friends in virtual showrooms. Even designers who once made their name on Seventh Avenue tending to the *Social Register* have turned their back on the idea of falling in line behind one archetypal style icon or one universal look. Oscar de la Renta, who at age seventy-seven has dressed his share of First Ladies and society swans, now sees fashion in a different light.

"The old kind of icons don't exist today, there are no references like that," he said, sitting pashalike in his Seventh Avenue showroom overlooking New York's garment district, an office he has inhabited since 1965. "If you go on the street and ask three hundred people, probably there's not even one person who knows who Grace Kelly is. That's not really where we are today. What is important to a woman is to project her own sense of individuality—who she is—which Mrs. Obama does in an extraordinary way."

Of course Mrs. Obama could not have achieved this sense of individuality in her style had not the women of Hillary Clinton's generation blazed the trail. Hillary's generation struggled to sort out how a professional woman should dress, with an eye for clothes that would help them hammer at the glass ceiling. The solution many women adopted was to subvert their femininity in an almost comic version of menswear, a kind of professional equivalent of overalls and tool belts. Michelle Obama's generation assumed the workplace was sufficiently comfortable with women in business to

"What is important to a woman is to project her own sense of individuality—who she is—which Mrs. Obama does in an extraordinary way."

—OSCAR DE LA RENTA

allow them to define professional attire for themselves. Contemporary professional women don't look back to past avatars of style for inspiration; they are eager to forge ahead on their own. The key word of this generation is *self-definition*.

Icons by their nature evoke emotions in us. Beyond her intellect, beyond her support for ever-so-worthy causes—from military families to children's nutrition—Michelle Obama evokes some deep response in many people that invites them to feel better about themselves, to take pride in what they are, limitations notwithstanding. It's a reaction that does not depend on age, politics, race, clothing, class, or nationality. "She's kind of amazing in the fact that she's really drawing people from both ends of the spectrum," says J.Crew designer Jenna Lyons, who has created custom-made outfits for Michelle and her two young daughters, Sasha and Malia. "She's just young enough that she's still connected to girls who are twenty-five or twenty-six and sophisticated enough that she's connected to older women, too. That's incredibly unique."

In bringing style back down to earth, Michelle Obama may have stripped a few gears out of the machinery of celebrity. Certainly a lot of designers have embraced a new view of what style means and see their work in a more realistic context. "Because she is not a size four and because she's a mother and she's constantly moving with her kids and her family, there's a real agenda," says Panichgul. "This is not just another premiere."

But in a way it is another premiere, a more serious sort of premiere. The premiere of a new era: an era defined by women who have grown weary of the increasingly disposable cycles of fashion, a postfeminist era of women who embrace fashion but set themselves apart from the crowd by wearing what pleases them. And for many

designers—especially the younger ones who don't have the largesse of financial backers to help them play the fashion game—this message is more inspiring than the celebrity posturing. As Panichgul says, "Clothes are now going to be about women in their everyday lives as opposed to women on the red carpet."

Even sticklers for Washington's dreary dress code are responding to the new First Lady's individuality. Michael Kors has spent his fair share of time making personal appearances at Washington stores, including a few of his own. "I used to dread going down there because everyone was so conservative," he says. "They would be wearing panty hose in hundred-degree weather!" But on a recent trip to Washington Kors noticed women in bare legs and sandals, a look the First Lady has made popular there. "She's letting women know that the word *appropriate* has changed. She isn't afraid to make a mistake, and to be stylish you have to be willing to make a mistake."

To be stylish you have to be willing to stand out.

An exercise in style: For practical purposes—or perhaps to show off her own svelte silhouette—Michelle Obama wears a sleek red pantsuit over a sequined J.Crew tank top as she exercises with Olympians, Paralympians, and schoolchildren at Washington, D.C.'s River Terrace School as part of her Let's Move! initiative.

THE CONTINUING INFLUENCE OF JACKIE

With her meticulous style Jacqueline Kennedy elevated America's taste. But her look was never static; she evolved over time and continued to be copied long after she left the White House. **Michael Kors** talks about how her "props"—big sunglasses, sleeveless dresses, and three-strand pearl necklaces—are as relevant today as they were in 1961.

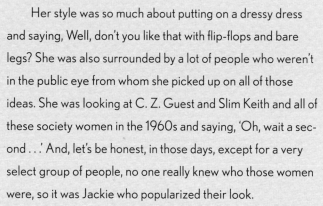

66 **THE SIMPLE TRUTH IS** people are alway a product of their time. And Jackie Kennedy is still influential to designers because when she came along she really blew the dust off of the past. For the first time you had a First Lady who was bare legged at church in flat sandals. I think she's really the first person who took us into modern times, and that's why we keep referring back to her style. She had the elegance of the past and then she had this kind of easiness that was so modern. She was also the first woman who made everyone realize that style is not necessarily just about the dress, it's about the woman. It's not necessarily what she wore, but how she wore it. She understood that.

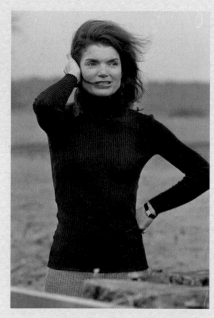

Her style was so much about putting on a dressy dress and saying, Well, don't you like that with flip-flops and bare legs? She was also surrounded by a lot of people who weren't in the public eye from whom she picked up on all of those ideas. She was looking at C. Z. Guest and Slim Keith and all of these society women in the 1960s and saying, 'Oh, wait a second . . .' And, let's be honest, in those days, except for a very select group of people, no one really knew who those women were, so it was Jackie who popularized their look.

I'm always influenced by the fact that she understood the yin and yang of style. For example, if she wore something romantic, then she tempered it with something butch. If one piece of her look was over-the-top, then something else was streamlined. It was always this weird give-and-take, and I

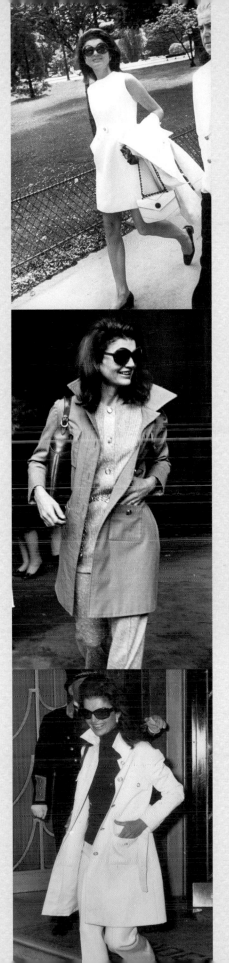

The "Jackie look" or "props" include, from top, the sleeveless dress; the streamlined trench coat, oversized sunglasses, and Gucci shoulder bag; and cropped pants. *Opposite*: The ribbed turtleneck and jeans were also a part of her windblown, natural look.

think to this day that is what makes fashion applicable for most women. When you look at something, you want it to be at the same time new and invigorating, but you also want it to be familiar like an old friend. You want it to be the best of both and I don't think that goes away. That's why the way she dressed through all the years is still so right for today.

She also stayed current, whether it was the 1950s, 1960s, 1970s, or 1980s she did the best thing for her style in each decade. She did the working-woman, Faye Dunaway-*Network* look better than Faye Dunaway in the 1970s. She did the strong-shouldered, chic adult in the 1980s, she did glamorous jet set in the late 1960s, and she did fresh, sporty young mom in the early 1960s. She was a chameleon, but she was always herself.

We live in such a tabloid society today and she was really the first tabloid creature. She was the first television pop celebrity. Without television we wouldn't have had the Kennedys, so she knew what was telegenic and how to play to the camera. She knew what made a good picture. Even today if you want to look glamorous when you get off a plane you're going to grab Jackie's props. You still see it today, that's why anyone we think is stylish today, whether it's Kate Moss or Mary-Kate and Ashley Olsen or Angelina Jolie, they're all stealing from Jackie still—the big sunglasses, the sleeveless dress, the cropped pants, the carefree flip-flops. Her influence just doesn't go away. 🙶🙶

NO SHRINKING VIOLET

Even before she got to the White House, Michelle Obama had a penchant for petals (*clockwise from top left*): She wore a floral printed chiffon Maria Pinto gown in 2004; at her husband's first debate in 2008 she channeled the retro housewife look in a cabbage-rose-printed Thakoon dress; wearing Moschino with Jill Biden at a rally in August 2008; arriving in Mexico in May 2010 in a festive dress by Tracy Reese; welcoming sailors home at Norfolk Naval Base in a sleeveless Talbots dress; another Talbots favorite covered in cabbage roses.

Had she wanted to fit into Washington's conservative dress code, Michelle Obama would have abandoned her beloved floral prints upon arrival at the White House. It takes a certain kind of moxie to wear a bold floral print. Even the most intrepid style icons have shied away from them—Jackie Kennedy famously disliked prints and instructed Oleg Cassini never to use them. She wanted to keep her style as simple and streamlined as possible. But right from the get-go, from even before she joined her husband's campaign efforts, Michelle Obama made floral prints one of her most recognizable signatures—not the demure rosebud kind, but everything from giant cabbage roses to more abstract black and white flowers. They certainly make a feminine statement, but they also make a friendly statement—setting her apart while softening her image.

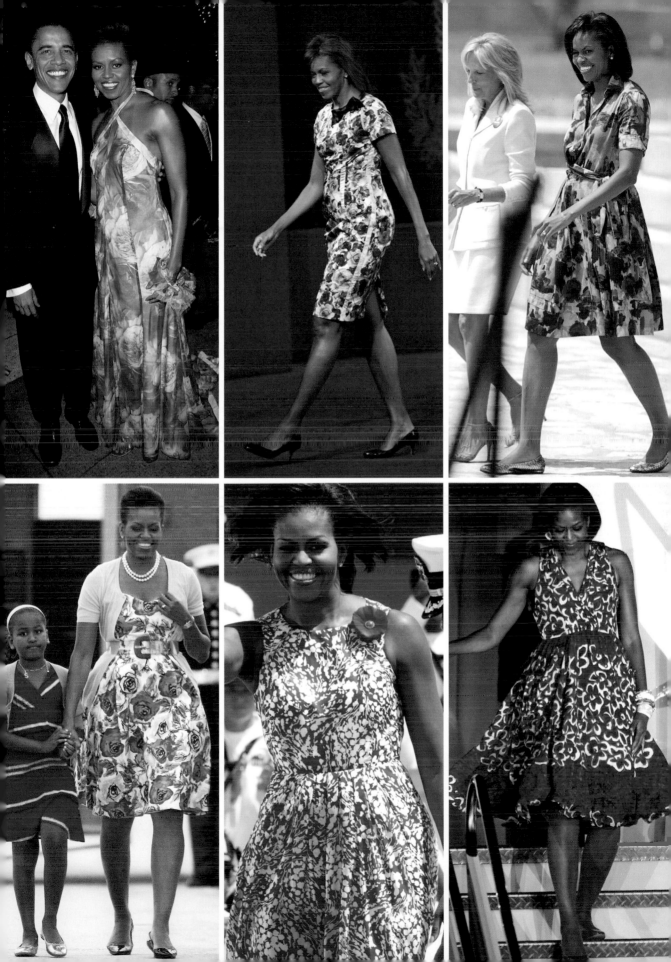

THE TEN COMMANDMENTS OF FIRST LADY STYLE

Nobody tells this First Lady what's "appropriate." She under-stands implicitly that the most critical tenet of style is freedom. "That sense of independence and that strength of character is what all designers and women around the world are looking at and thinking, 'That is inspiring,'" says Narciso Rodriguez. Let's say the First Lady did have a style manifesto—a sartorial Ten Commandments of sorts—here's how it might read:

#1 Don't talk about fashion; let the clothes speak for themselves. The *F* word is seldom heard in the East Wing, and yet the First Lady is not shy about flaunting her love of avant-garde designers like Junya Watanabe and freely admits to magazines like *Vogue* that she loves fashion. The message: women should dress to make themselves feel good and forget about whether or not they are fashionable.

#2 Never be afraid to wear color, but save black for those eternal moments. Nobody has demonstrated a bolder use of color than Michelle Obama. She wears every shade beautifully—from lemon yellow at Rome's Capitoline Hill to coral pink at the Kremlin. She even layers on contrasting colors but she reserves her simple, somber black outfits for more formal occasions like meeting the queen and posing for official portraits. Don't forget date night: she often chooses a black cocktail dress for evenings out with the president.

3

Always wear the same heel height. Perhaps she's afraid she'll tower over her husband if she wears high heels, or maybe she just wants to be comfortable. Whatever the reason, Mrs. Obama has consistently chosen one- or two-inch heels—preferably by Jimmy Choo. It's a look that has legs: designers have already abandoned sky-high platforms in favor of kitten heels or flats.

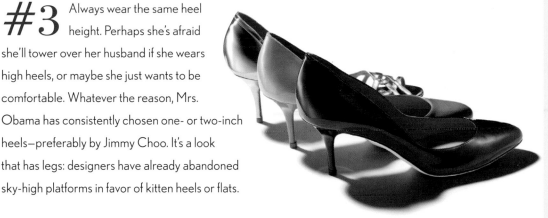

4

Look chic even in the vegetable garden. When Michelle Obama planted the first White House kitchen garden in March 2009 (only Eleanor Roosevelt had previously planted a garden, her Victory Garden, in 1944), she underlined the importance of healthful eating while also inadvertently calling attention to her approachable attitude. With her chunky sweater and her cool Jimmy Choo boots, she seemed determined to keep the style quotient up even while digging up dirt. A pair of graphic Puma sneakers replaced the boots when spring arrived, proving that true style never takes time off.

5

Create surprises. From the kooky Junya Watanabe cardigan on her first official trip to London to the controversial "lava lamp" dress on election night, Michelle Obama is not afraid to have fun with fashion. "For a lot of First Ladies in the past dressing became very formulaic and cookie cutter," says Michael Kors. "She's really stepping outside the whole ball game when she says, 'You know what? I actually like this and some of you might enjoy it, too, and some of you might be indifferent, but I'm doing it and if there's a reaction so be it.'"

#6

Make accessories your signature. We know she loves brooches and she has worn the black Azzedine Alaïa belt her husband nicknamed the *Star Trek* belt so often she finally broke out a version in white. But Michelle Obama told *Ebony* magazine that her favorite accessory is her husband. "Barack and I—as partners, as friends, as lovers—we accessorize each other in many ways," she said. "The best thing I love having on me is Barack on my arm and vice versa."

#7

Get your daily workout. She claims she's always been a closet jock, but Michelle Obama let exercise fall by the wayside when she had her first child. Then four months after Malia was born, the "aha" moment struck: Michelle began working out every day at 4:30 A.M. The routine changed her approach to maintaining her energy and shape in a hectic juggling act of family, career, and campaign. Her trainer of twelve years, Cornell McClellan, has also trained friends of Michelle's like the designer Maria Pinto, who attests that the one-and-a-half-hour workouts are "hard-core."

#8

Support young designers. The First Lady has almost exclusively championed little known American designers. For an event at the White House she even chose a bright red dress by MDLR, a line designed by Oscar de la Renta's son, Moises. Seventh Avenue's establishment types voiced their concern early on in the administration, telling the trade newspaper *Women's Wear Daily* that she should be choosing clothes by marquee names like Ralph Lauren and Calvin Klein. But the First Lady has her own agenda. Fashion's proverbial second row should move up now.

#9

Keep it real. Not for nothing has the budget-conscious First Lady chosen looks by mass-market retailers like H&M and Target. She even wore a sweater from the Gap to lunch with Nancy Reagan. It's a recession, so let's dress the part. Choosing to wear clothes that represent a wide range of price points is also a canny way of connecting with constituents.

#10

Think globally. Although the majority of the designers Michelle Obama wears are American, once in a while she'll throw on an Azzedine Alaïa dress (for the Nobel Banquet, for example, or for a photo op in front of the White House Christmas tree), or a Moschino suit (for the president's health care address to the joint session of Congress). As the First Lady she's expected to wear American designs, but once again, Michelle Obama is writing her own rules. Fashion is a global business now, so why not dress accordingly?

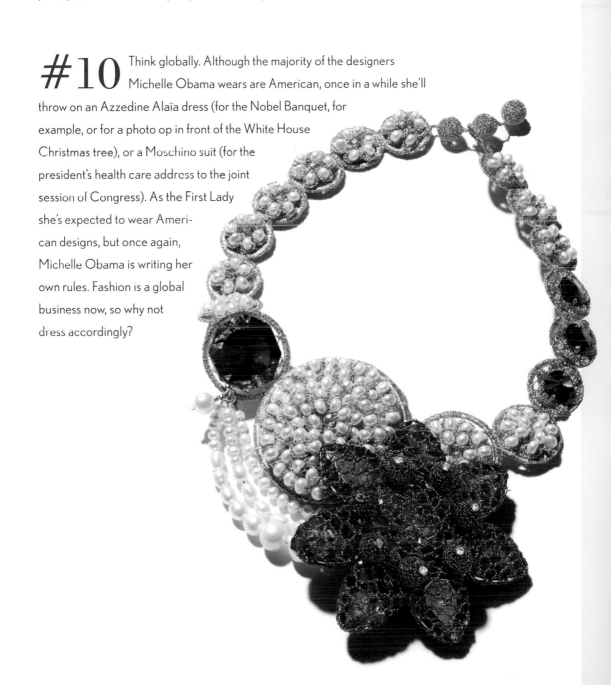

MICHELLE'S REACH

First Lady summits are often the most scrutinized moments in global diplomacy. The clothes each spouse or female head of state wears are carefully chosen for the message of formality and respect they impart. But every First Lady has to also consider how her outfit will look in a group shot. You have to wonder whether Michelle Obama consults with other First Ladies beforehand. Did Mexico's Margarita Zavala know, for example, that when she paid a state visit to Washington with her husband in May 2010, she would find herself sprinting around a gymnasium with a bunch of elementary school kids as part of the First Lady's Let's Move! initiative?

MEETING THE QUEEN OF ENGLAND IN APRIL 2009.

Some designers felt that wearing a cardigan to meet the queen was a breach in protocol, but maybe it wasn't a break in protocol at all. If the First Lady does it, who is to say the cardigan isn't now the height of fashion? Besides, Michelle actually looked quite formal in her black and white satin Jason Wu dress and matching opera coat.

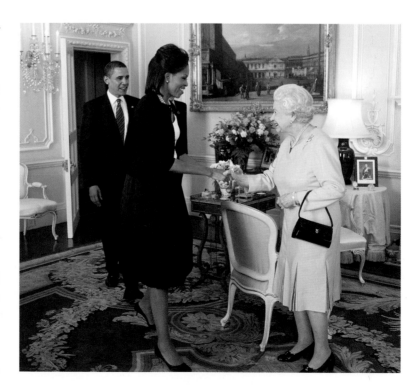

WITH FIRST LADY OF THE CZECH REPUBLIC, LIVIA KLAUSOVÁ IN PRAGUE IN APRIL 2009.

The crisp white Moschino blouse and enormous bow that Michelle Obama wore touring Prague was whimsical and graphic, balancing the serious tone of her husband's visit with a little levity.

GREETING MEXICAN FIRST LADY MARGARITA ZAVALA IN MAY 2010.

When dignitaries visit the White House, chances are the First Lady is going to put them to work. She engaged Mexico's First Lady in her favorite cause. After their official arrival on the South Lawn, Michelle ditched her cherry red Calvin Klein coat and invited Zavala to join her in some games with kids at a local school as part of her health initiative, Let's Move!

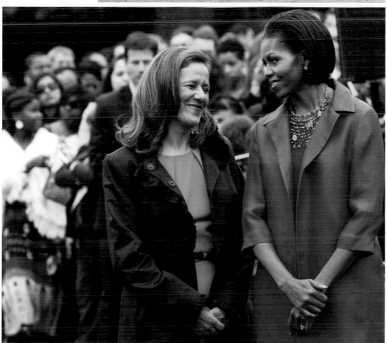

WITH FIRST LADY OF GHANA ERNESTINA NAADU MILLS IN JULY 2009.

Michelle Obama's simple cotton dress by New York–based French designer Sophie Theallet makes her stand out—but not in an ostentatious way— next to the traditional African print dress of the First Lady of Ghana. The unfussiness of Theallet's cotton dress could very well speak to the humility the First Lady felt returning to a country that had so moved her on a previous visit with her husband.

WITH CARLA BRUNI AT THE GROUP OF 20 SUMMIT IN PITTSBURGH IN SEPTEMBER 2009.

While Carla played it safe in a conservative black dress at the Pittsburgh summit, Michelle played up her fashion sense—and, obviously, her sense of humor—with a pastel pleated animal-print Thakoon dress.

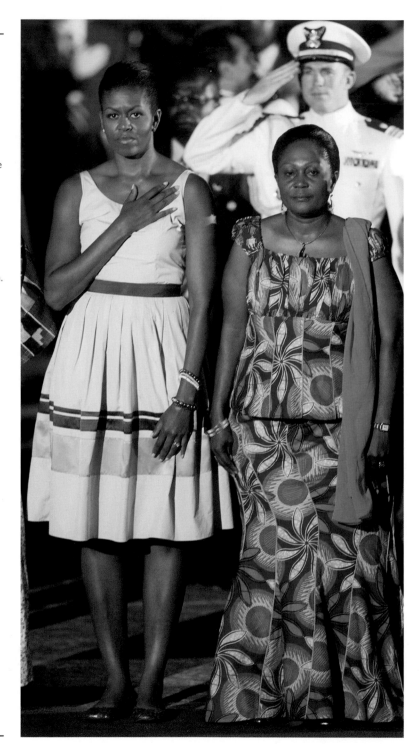

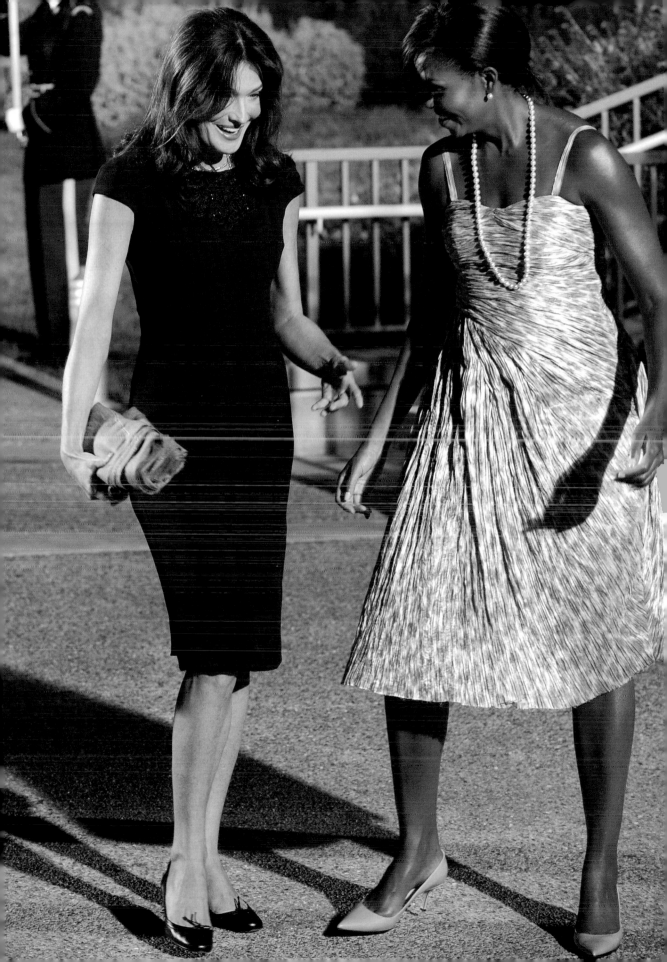

5 WELCOME TO THE WHITE HOUSE

To watch Michelle Obama in action is to understand not just the power of style but also its inherent substance, its intellectual vitality, the way style conveys the essence of a person, her views, her principles, her cares and concerns. One September day—Indian summer 2009—I abandoned the New York Fashion Week shows in Bryant Park to make a trip to the White House. To promote Chicago's ill-fated 2016 Olympic bid, the president and the First Lady were throwing one of those meticulously staged pieces of capital theater that have been filling out the White House schedule since the dawn of the Republic. We had not heard much from Michelle Obama since she had moved into the White House, but in many ways we didn't need to because she expressed herself through her appearance. The event to promote Chicago's Olympic bid was one of many telling examples of

how the First Lady used style to convey her message of confidence, optimism, and strength.

Alas, Mercury must have been in retrograde that day. The e-mail from the White House press office warned that members of the press would not be admitted a second after 12:30 P.M. For a while it looked as if the Acela Express I took from New York wouldn't even make it to Washington. I got a taxi driver who didn't know the Southeast gate of the White House from the Northwest one. When I got out of the cab it was twenty-five minutes past twelve o'clock, and there was a line outside the White House security gate that was moving as slowly as one of those blockbusting queues outside a Prada sample sale.

When I got onto the grounds just under the deadline, I knew I needed some fashion show finesse because I had no idea where to go. (It's not as easy as the Salahis, those gate-crashing reality TV characters, made it look.) I trailed a cluster of earnest-looking women up to the West Wing, past the presidential limo, past a briefing room, and into a small courtyard where about thirty cameramen and journalists had been corralled. Because photographers are experts at creating visual images, anyone with a camera usually knows where to go and gets a prime perch. A harried-looking young woman with official White House credentials slung around her neck emerged from the Palm Room, barking that people with photographic equipment would be let in first. Follow the equipment! Here was one fashion rule that applied to politics, too. And just like veteran runway reporters and editors who earn their front row seats through their longevity and influence, White House correspondents measure their power by hierarchical positioning.

I scurried in behind a bulky guy with a video camera as he and his fellow linemen lumbered through the Palm Room, past a glass door with a view down the Center Hall of the White House, and out through the Rose Garden. We were shown past immacu-

Returning from Norway where her husband collected the Nobel Peace Prize, Michelle Obama wears the same Narciso Rodriguez coat and dress she wore to the We Are One inaugural concert in January 2009. Her tendency to repeat outfits underscores her down-to-earth, everyday attitude. *Page 132:* The First Lady wears a J.Crew blouse and cardigan to a panel discussion about healthy meals in schools in Alexandria, Virginia.

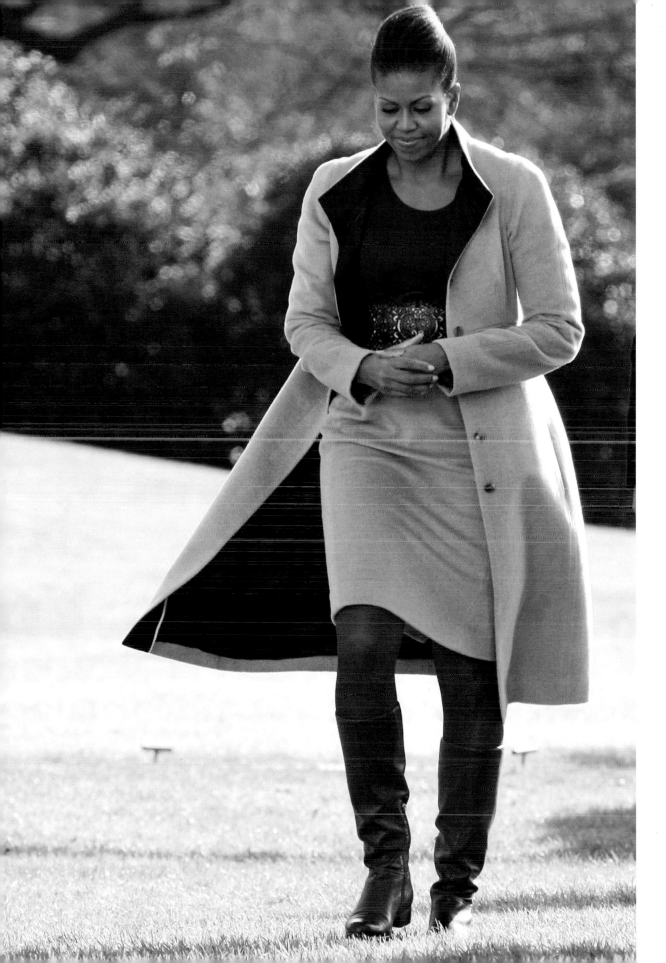

lately groomed flower beds, and onto the muddy South Lawn, where bleachers were set up for the press behind a white rope. When the cameramen were shepherded out to bleachers farther from the podium I realized I had lucked into the ultimate front row seat.

There was something surreal about standing before the towering columns of the South Portico, a feeling of déjà vu brought on by the fact that this iconic tableau—this overfamiliar backdrop of newscasts, this stage set of so many American moments—was an actual place. Brilliant red geraniums punctuated the painted white Aquia sandstone facade of the mansion. Military cadets in starched white uniforms and Secret Service agents in dark suits hovered around a fern-splashed podium. A big blue athletic mat and balance beam had been set up for a demonstration by Olympic and Paralympic hopefuls. The slightly soggy lawn was filled with White House staffers and delegates from the U.S. Olympic team. Movers and shakers from Chicago were so numerous one reporter joked that the South Lawn looked like Chicago's City Hall. Education Secretary Arne Duncan and top adviser David Axelrod mingled with Olympians like the gymnast Dominique Dawes and volleyball gold medalist Bob Ctvrtlik. More impressive even than the West Wing's big-shouldered *machers* were the East Wing fashion plates. Desirée Rogers, at that time the First Lady's glossy social secretary who would later come under fire for not policing the door at the state dinner that the Salahis crashed, picked her way across the grass in a pair of killer lizard stilettos and a sleek pencil skirt, thumbing her BlackBerry. (It takes more than one barrage of partisan clucking and tut-tutting to wear the chic out of the fashionista.) Even the First Lady's assistant looked like runway material in a pair of high-heeled Mary Janes and a snug tartan dress. It was as if the First Lady's follow-your-fashion-bliss example had intoxicated her staff. I was reminded of what Narciso Rodriguez had said: ultimately such a huge force in fashion becomes fashion.

Around 12:40 twenty-eight kids from Sousa Middle School were ushered out of the East Wing, across the grass to the judo mats. Some were in wheelchairs; others were using walkers. They wore T-shirts emblazoned with the sunny and impressively unsuccessful slogan of Chicago 2016, LET FRIENDSHIP SHINE. Looking rather awestruck by their surroundings, they sat erect or stood up straight and folded their hands in front of them, looking like they were trying out for jobs as White House military cadets.

After a bit of scrambling as handlers took their official spots around the podium, a voice boomed over the public address system. "Ladies and gentlemen, the president of the United States." Several Sousa Middle School kids marched stiffly out of the Diplomatic Room door followed by the president and the First Lady, or as they were known to the Secret Service, Renegade and Renaissance. Watching them approach the podium it was hard not to think that Renaissance was the bigger star. Dressed in full-on mom-in-chief regalia—a bright blue cardigan cinched over an acid green T-shirt with a purple-studded belt—she looked as regal as the columns of the portico behind her. Her floral print silk skirt billowed gracefully in the wind as she lined up alongside Chicago Mayor Richard Daley, special adviser to the president Valerie Jarrett, six-time Olympic medalist Jackie Joyner-Kersee, Paralympic medalist April Holmes, and several Olympic Committee members. What struck me was how fashionable she seemed without looking in the least bit "fashionable," if *fashionable* means a supermodel just off the Balenciaga runway in Paris or one of those glossy social-

> "There is a true family unit there. That takes nurturing. It doesn't just happen. I think she is setting that bar. You can have it all, but you do have to find balance and there is a way to do it in a calm way." —JENNA LYONS

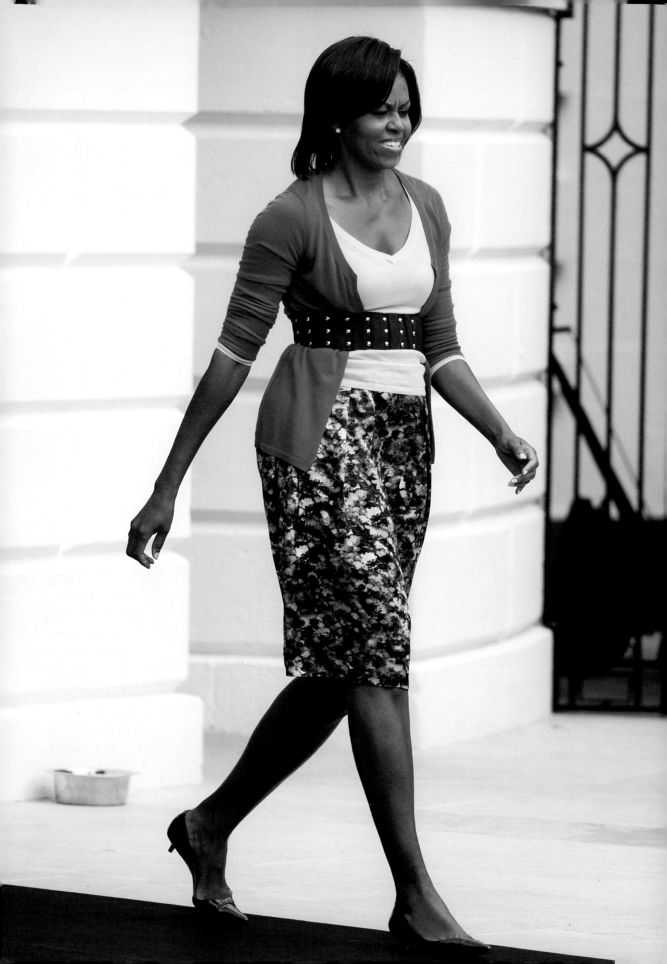

ites waltzing out of Neiman Marcus after a spree with a personal shopper. She had the look of almost any forty-five-year-old mother of two (albeit a statuesque and carefully groomed one) picking up her kids after basketball practice or browsing the aisles at Target. And perhaps that was the point. She did not want to come across as some idealized icon on a pedestal in an icy blue suit. Renaissance wanted to appear as Casual Michelle, as one of her Washington friends had described her, with her homey knack for putting things together—colors, patterns, and accessories. The soft cardigans made her approachable, and yet they were always chosen in bright colors that made her stand out, that said, "I am no shrinking violet, I'm not hiding from the task at hand." And her accessories—the unusually wide belts, the chunky necklaces—always accented her individuality and her fearlessness when it comes to fashion. Her look was casual, and yet every element of her style—every belt, shoe, earring, and sweater—clearly conveyed a message to the public about who she was, where she was going, what she wanted from her position.

When it was Casual Michelle's turn to speak, she greeted the kids assembled before her on the lawn and ran through the list of demonstrations we were about to see: judo, gymnastics, fencing. She talked about the city that's "near and dear" to her heart—her enthusiasm somehow making the phrase seem less banal. She reviewed the Olympic values that just so happened to match the apple pie of her own: commitment to excellence, drive to succeed, education, and a healthy lifestyle. As she spoke I was struck by her gestures, her long and graceful hands. Occasionally she would tuck a stray strand of hair behind her ear or pause to look down at her notes. She seemed unhindered, as if she were addressing a P&T meeting at Sidwell Friends or talking to a circle of pals at a book club meeting. "If you dream big enough and work hard enough, there are no limits to what you can achieve," she said, squinting

Casual Michelle steps out of the White House Diplomatic Room to greet local middle school students, Olympians, and Paralympians on the South Lawn at a demonstration of judo, fencing, and gymnastics to promote her ill-fated bid for Chicago to win the 2016 Olympics.

in the noonday sun. The way she held her chest reminded me of a ballet teacher I once had who told her students to walk as if a string were pulling the sternum up to the sun. She was completely at ease with herself in this august setting, not stiff in any way. Though a small detail, her posture conveyed her pride and self-confidence to the kids sitting on the lawn in front of her. She seemed sincerely determined to make an almost inhumanly positive impression.

But as is so often the case, it was when the First Lady departed from the prepared remarks that she seemed to lose the robotic uplift of a motivational speaker and come alive. "You should have seen the president in there fencing," she said, motioning to the Diplomatic Room behind her. "It was pathetic. But he passed the baton really well." The crowd laughed. Some appreciatively, some it seemed to me, nervously, worried perhaps by the flash of Michelle the famous taskmaster—the blunt, unscripted, competitive, ambitious, more-than-equal Amazon striver from Chicago's South Side; the woman who could take or leave Renegade and his dirty socks, the wife exasperated by her husband's self-centeredness, his readiness to dump the responsibilities of raising two daughters on her. With one witty crack on the South Lawn she had reminded the world of his frailties, reaffirmed the rights of women, and reset the balance of First Family power. And all with a joke. She was just joking, wasn't she?

Following the speeches the Obamas sauntered over to the judo mats to watch the demonstration. They bantered with Jackie Joyner-Kersee and April Holmes, and the small talk was funny and natural. The First Lady often uses the word *seamless*—seamlessly is how she wants to interact with her staff. No drama, no rifts, no ragged stitching revealed. With the children and the athletes and her husband, at whose expense she had extracted some laughs, she now worked seamlessly. She and the president seemed to have genuine affection for each other. Unlike the judo and gymnastics their

performance wasn't just for show. He put his arm around her, she held his jacket while he jabbed a fake sword Obi Wan Kenobi–style at the fencers. The president seemed happily distracted from the grinding business of health care reform and Iranian nuclear capability. For her part, his wife had much more invested in the event. Her chief of staff, Susan Sher, had standing orders to make sure all of the First Lady's public appearances had something substantive about them, a message "near and dear" to her. She would gladly take on the traditional hostess responsibilities of her role—choosing the spousal gift for the Group of 20 summit or picking out the china for the first state dinner, honoring Indian Prime Minister Manmohan Singh—but in the White House she wanted every gesture of style to resonate more deeply with meaning, with a message or with a lesson. And so this Chicago Olympic bid—meaningful because the proposed Olympic village would be blocks from her former South Shore neighborhood—would also provide a lesson where the kids on the lawn could learn about sportsmanship and what it takes to win.

When the judo wrestler landed with a thwack on his back, Michelle turned to the president and joked, "You should try that!" Then, realizing that the young female students were not volunteering for any of the demonstrations, she piped up, "Hey, where are the girls? Get the girls out here." A girl in metallic gold flip-flops volunteered to be flipped out in front of the First Lady, who, in turn, offered to hold the girl's bracelets, just as a classmate or a best friend would. When it was done, the First Lady cheered, raising her long, slender arms above her head like a Cubs fan at Wrigley Field.

By the time the First Couple had made the rounds of the three

> "This is a big responsibility, a wonderful platform, and I just want to make sure I take every advantage to serve as a role model, to provide good messages."
>
> —MICHELLE OBAMA

demonstrations, it was time for the president to get back to the fate of the world. "Hey, FLOTUS!" he called to his wife as he headed toward the West Wing. But the mom in chief was in no apparent hurry to leave. She lingered to have her photo taken with a kid in round glasses sitting in a wheelchair. And then shared a joke with Joyner-Kersee and Holmes. POTUS finally gave up, waved to his wife, and headed back to the Oval Office with his entourage.

I edged closer to where Casual Michelle was, pushing against the white rope. There was something that compelled you to linger, to clap your eyes on her as she loped across the grass in her Jimmy Choo kitten heels, flicking a strand of hair or a sloughed eyelash out of her eye, flattening her skirt when it ballooned in the breeze. I'd been standing there for over an hour, but it felt like a few minutes. Obviously inured to the spectacle, the shark-eyed reporters next to me were unimpressed. Lynn Sweet of the *Chicago Sun-Times* was talking into a cell phone. "We have to wrap this up," she said impatiently. It was just another day at the White House. But for me it was a whole new show—a revelation of personal style beyond the laboratory of a runway where fashion sometimes seems incomprehensible or out of touch with reality. What seemed so novel and inspiring was not just Casual Michelle's creativity—the bright colors, the cardigan, the goofy belt, and the flowery skirt—but also the way she moved, cheered, smiled, and interacted with her husband. Style in action, carried off with confidence, power, and an authentic unself-conscious ease that is rare. To actually see the synthesis of style and substance was thrilling—thrilling because it was so unusual and unaccountable, all the more given the First Lady's oft-repeated line, "I'm not supposed to be here." Indeed, what were the chances that a black girl from Chicago's South Side, a descendant of South Carolina slaves, could be the First Lady of the United States and could pull it off with such élan? And yet on that muggy September day she looked as if she'd been born for nothing else.

Michelle Obama's clean, crisp style was in evidence long before she got to the White House. On the first night of the Democratic National Convention in Denver, she wore a cotton jacquard Peter Soronen dress (*top*), and on the campaign trail she often wore her signature wide belt and cardigan over pants or a skirt (*bottom*). *Page 144:* With Malia at the Iowa State Fair in Des Moines in August 2007.

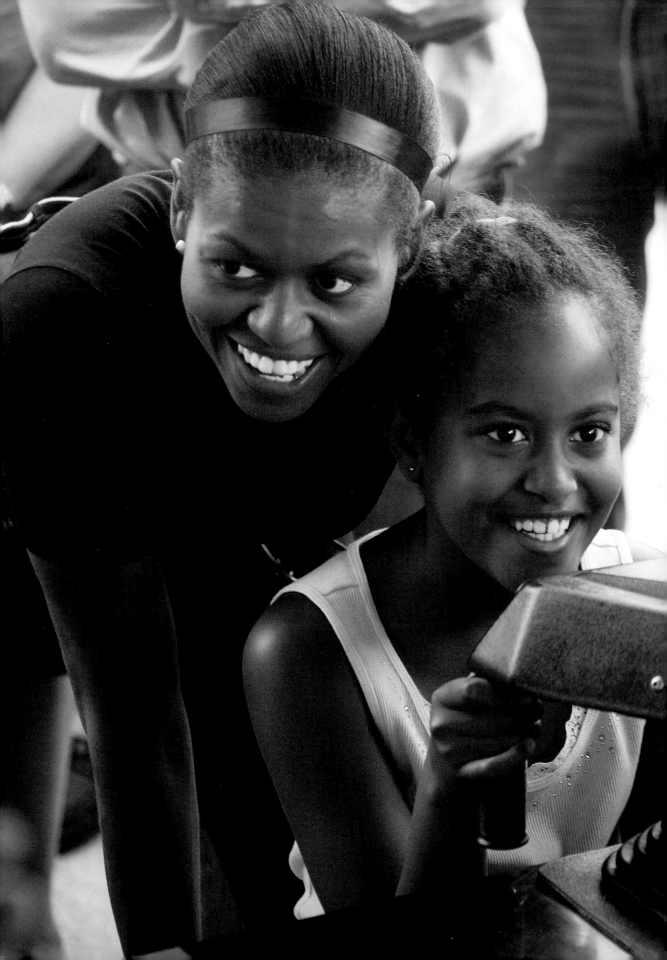

ONE STYLE, TWO WORLDS

In so many ways Michelle Obama is what Hillary Clinton described as "the ideal concept of American womanhood." She has embraced the caretaker role of First Lady with flair, opening up the White House to public school children and poetry jammers, foreign heads of state and organic chefs. At the same time she has made it a real home for her young family, instructing the staff to let her kids make their own beds. Her "seamless" performance that day on the South Lawn made me all the more curious about where she had come from—the how and where of her style. Who was this woman with the brio to throw on flats with cocktail dresses, bare her arms in Congress, or tease the pathetic swordsmanship of Mr. President? So much of her behavior and character seemed paradoxical: on the one hand she professed not to care what opinions others had of her; on the other hand she was deeply empathetic. She presented herself as being apolitical and yet also very engaged; she espoused traditional values and yet was seemingly fearless, determined to write her own rules as First Lady. Was her confidence innate, a matter of character and genes, or was it acquired over the course of her journey from the South Side of Chicago to Princeton to corporate lawyer land? Was this x factor, this seamless synthesis of substance and style, something her parents—her stay-at-home mother and her father, a partially disabled pump operator for a city water plant—instilled in her early on? Or did she develop it on her own, the result of learning to adapt to places like Princeton and blue-chip corporate law firms? Did it result from learning to move in new domains without letting the stitches show?

TO BETTER EXPLORE the riddle of the First Lady's sine qua non style, I traveled to Chicago to see where Michelle Obama grew up. We know the cliché Chicago, the one A. J. Liebling dubbed the "Second City," the home of grubby political deal making, Prohibition-era bootleggers, and notorious gangsters like Al Capone. Historically it has always been known as an immigrant city—from the early French fur traders to the Irish workers, the Polish, the Germans, and when World War I cut off European immigration, the Great Migration of African Americans from the South. It's the place with the small-town attitude and the big-shoulder profile, the home of the first steel frame skyscraper as well as the first nuclear chain reaction. But how had contemporary Chicago—the actual place— influenced Michelle Obama's style?

When I landed I went to see Maria Pinto, the designer who can be credited with dressing Casual Michelle in brilliant shades of turquoise, periwinkle, and red. Although she has since closed her business, Pinto's former third-floor West Loop studio on Jefferson was in the same building as her loftlike store, where she once sold sculpted pinstriped suits, satin evening gowns, and practical mohair shawls to some of Chicago's most powerful female executives. On the morning I met Pinto she was wearing a denim jacket and army boots, and her seamstresses were busy sewing the uniforms for Chicago's twenty delegates—including Oprah, Valerie Jarrett, and Michelle—who would be traveling to Copenhagen to lobby (in vain) for the Olympic bid. "They wanted a uniform for this, but I said, Chicago is a city about diversity, how can we put them all in uniforms?" Pinto laughed. "I don't think people necessarily like to draw attention to themselves here, but they care about being individuals." Individuality is one of the defining characteristics of Michelle Obama's style, which is probably why she chose to mix the Woodrow Wilson china with the World's Fair service for the Governors' Dinner and why she turned the White House fountain green on St. Patrick's Day, a quirky tradition she undoubt-

edly poached from her hometown, where the Chicago River is dyed green on that day.

Another local fashion expert, Nena Ivon, the grande dame and special events manager of Saks Fifth Avenue on Michigan Avenue, pointed out that style is not necessarily something you learn: either you have it or you don't. Ivon, who has worked at Saks since she was fifteen, wears only black and looks and sounds like a midwestern reincarnation of Diana Vreeland. In the fifty-some years she has been organizing designer appearances and fashion benefits for Saks, Ivon has dressed many executive and society women in Chicago. "Michelle Obama is obviously very secure in who she is, and she dresses accordingly," said Ivon, arching her eyebrows. "Do we want her to look dowdy like Mamie Eisenhower or Rosalynn Carter? That annoys me."

Chicago style is difficult to pin down, Ivon told me, because the city is made up of such diverse neighborhoods. "Pockets," she called them, each with its own distinct style: conservative Oakdale, trendy North Shore, and academic Hyde Park. And reigning above all is the Gold Coast, with ritzy streets like Oak and North Rush. The Gold Coast is where Oprah lives. It was home to specialty boutiques like Ultimo and Ikram, and global brands like Hermès, Jil Sander, and Prada. Fashion-hungry Chicagoans shop the Gold Coast, but you could look forever in that neighborhood and not find a clue to Michelle Obama's style. I went instead to the neighborhood known as South Shore, where Michelle Obama grew up.

My guide was Seth Patner, a public high school history teacher who taught for eight years at South Shore High and who grew up in Hyde Park, a few blocks away from the Georgian mansion the Obamas lived in before they moved to the White House. One of his best friends from childhood, Richard Payne, was a guy he referred to as "Smurf," who, it turned out, was a first cousin of Barack Obama. Patner graduated from Kenwood Academy, a school Michelle might have gone to had she not tested into one of Chicago's first mag-

net schools for gifted students, Whitney M. Young High, and traveled an hour and a half each way by bus and El train every day. It's hard to imagine the physical and psychological distance that a school like Whitney M. Young would present to a young woman like Michelle Obama unless you make the trip yourself.

We met outside the Peninsula Hotel in the heart of the Gold Coast and drove south in Patner's Prius on Lake Shore Drive. We crossed the Chicago River and passed under the big-shouldered skyscrapers of the Loop, then by Grant Park and Buckingham Fountain, and the sprawling Museum of Science and Industry. On the way, Patner talked about the particular demographics of the South Side, the largest and most segregated African American population in the United States. Although Michelle's family was working class, and her neighborhood is said to have had the largest number of African Americans with master's degrees in Chicago because of its proximity to the University of Chicago, pockets of the South Shore suffer from crime and violence. South Euclid Street, where Michelle lived, is still lined with comfortable brick bungalows, but a few blocks away on commercial strips like Seventy-fifth Street or farther into the Woodlawn area, you can see that some parts of the neighborhood have deteriorated, mostly due to unemployment. Despite the uneven quality of South Shore, Michelle has often spoken fondly of her childhood there—calling it a neighborhood of families with "modest homes and strong values." She spent a lot of time with her family. She played Monopoly and Scrabble with her older brother, Craig. She listened to jazz with her dad. She was a smart kid, learning to read before kindergarten and skipping second grade. Her parents always encouraged their kids to do their best and get the best education possible. But it wasn't always easy being smart, and Michelle often felt ostracized by the kids in her community who told her she talked like a white girl. "I heard that growing up my whole life. I was like, 'I don't even know what that

means,'" she told a group of students at Washington, D.C.'s Anacostia Senior High School. "But you know what? I'm still getting my As." Like many middle-class black kids around her, she made decisions early on that would propel her into other worlds and teach her how to adapt to unfamiliar surroundings.

At Whitney M. Young High Michelle was able to indulge her love of dance and choral music. She was elected class treasurer her senior year. She learned to manage a budget. She was exposed to a more diverse student body and made friends with children of Chicago's black elite, including Santita Jackson, daughter of civil rights leader Jesse Jackson. She excelled academically, taking biology courses at a local college, and qualifying for the National Honor Society. All the hard work paid off: she got into Princeton.

The move east required a big adjustment, even though Michelle's older brother, Craig, was already enrolled at Princeton. He had been recruited by the school's legendary basketball coach Pete Carril and was a two-time Ivy League player of the year. Craig introduced her to his friends, but in many ways he overshadowed Michelle because of his popularity. In 1981, when Michelle was a freshman, Princeton was still very much a male-dominated and largely white university. At the time only about 8 percent of her class was African American. It was also intensely competitive. Most of the students were the sort who if they hadn't graduated first in their class, they had studied Russian since age six, or had written a novel during their summer tagging parrots in Belize. They were all type A kids who hailed from backgrounds even more economically diverse than Chicago's South Side. And the heavy load of course work amplified social anxieties.

"Whenever she would come in for a fitting she was always poised and calm. You never saw her sweat. She was always composed and dignified." —MARIA PINTO

Michelle found her place at Princeton majoring in sociology and African American studies. She socialized at the Third World Center, a club at the end of Prospect Street that was physically close to the elaborate mansions that house the selective eating clubs like Cottage and Ivy but psychologically worlds away. The eating clubs at that time were the main focus of social life on campus. Several of them were all-male bastions, and most of them were still selective; you had to "bicker," or apply, to get into them. The Third World Center provided a haven for African Americans and international students who felt sidelined by the clubs and the elitist vibe of the school. Michelle spent a lot of time there, coordinating an after-school program for local children and serving on the center's governance board. But in her thesis she wrote about feeling isolated at Princeton: "My experiences at Princeton have made me far more aware of my 'Blackness' than ever before," she wrote. "I sometimes feel like a visitor on campus; as if I really don't belong."

"There was not a large black community at Princeton so we all knew each other, we hung out at the same places," says Karen Jackson Ruffin, a friend of Michelle's who was a year behind her at Princeton. "There was a real support network there and we all got really close." Jackson Ruffin, who was an aspiring fashion designer from Orange, New Jersey, got to know Michelle after enlisting her to model in a student fashion show her sophomore year. "She was always very statuesque, very pretty and graceful," Jackson Ruffin remembers. "It wasn't even about her style, per se, it was about her presence. She's an imposing presence and not in a negative way. When she walks into a room you say, 'Who's that?'" Like most students, Michelle wore very casual clothes—sweatshirts, jeans, sneakers, and minimal makeup. "She had the same kind of style she has now," says another friend, Stacy Scott-McKinney, an art history major who was a class ahead of Michelle at Princeton. "She was very feminine and always had an air of confidence. She knew who she was and she didn't need to dress to impress."

Patricia Cole-Green, another student designer who worked with Jackson Ruffin on the fashion shows, remembers meeting Michelle while visiting Princeton as a high school senior. "She showed me around campus and she was unbelievably nice. I always had a fondness for her because of that," says Cole, who also remembers Michelle as one of the most statuesque and striking-looking women on campus. "I'm sure there were other tall women at Princeton, but she was just so graceful and amazing-looking, so I asked her to model my clothes in the show, too."

The fashion shows, which raised money for charities like Community House and the Ethiopian Famine Relief Fund, became an annual event and Michelle an eager participant. She walked the runway at a show held at Wu Hall in an oversize 1980s-style sweater with a matching headband. She even modeled a cotton batiste peasant dress by Jackson Ruffin for a photograph that ran alongside a story about the student designer in the *Newark Star-Ledger* in February 1985. But Jackson Ruffin chuckles when she tries to remember now if Michelle had style back then. "She would think that was the funniest thing ever. That someone would call her stylish at Princeton would crack her up," says Jackson Ruffin. "You know, nobody is cute when they're writing a thesis."

It's true that substance and style still seemed antithetical in those days. Most students at Princeton and elsewhere looked askance at makeup or trendy clothes. The prevailing dress code was preppy, not glamorous: L.L. Bean turtlenecks, sweatshirts, and jeans. In many ways the toned-down, conservative style of the school reflected the conservative career choices of most of the graduating class. Like many of her peers who were headed to Wall Street jobs or graduate school, Michelle took the establishment route after graduating cum laude. She got her law degree at Harvard where, according to her law adviser, Charles Ogletree, she showed a keen interest in public service, spending hundreds of hours volunteering as a student attorney in the Harvard Legal Aid Bureau. After

graduating she probably could have gone anywhere, but she went home. She accepted a job in the intellectual property department at the prestigious Chicago firm Sidley Austin. She has said that she made more money in her first year at Sidley than both of her parents combined.

By that time Michelle had become quite capable at adapting to foreign environments. She fit in well, according to Mary Hutchings Reed, the female partner in the group to which Michelle was assigned in the firm's intellectual property department. Even in the early days of her career, Michelle was not one to compromise her hard-won sense of self. "She'd sit there as an associate and she'd tell us what she thought, not disrespectfully. I've always admired her for that," says Reed, who had lived through the days when female first-year associates at corporate law firms weren't allowed to eat in public in the clubs that lawyers frequented, only in the private dining rooms. At Christmas parties they were asked to enter through a side door. "Michelle is who she is. She's not putting it on. She doesn't care what you think." Reed's description is a surprising one, not for an overachiever from Chicago's South Side, but for a First Lady of the United States, the woman whom we still envision as our nation's caretaker. It's hard to imagine Nancy Reagan or even Hillary Clinton being so unabashedly forthright.

One story Reed says has been told so many times she cannot remember if it's true. It's about the time in the summer of 1989 when Michelle came into the office to introduce her colleagues to Barack Obama, the summer associate she had been assigned to oversee. "She stood in the doorway and introduced him and said, 'He will be the first black president.'" Although Michelle initially resisted the romantic overtures from her advisee, she eventually gave in and went on a date with him. Barack would later write in his autobiography, *The Audacity of Hope,* that he was attracted to his wife's laugh and her smarts and her vulnerability, as "if deep inside

she knew how fragile things really were, and that if she ever let go, even for a moment, all her plans might quickly unravel."

They were married in 1992 at the South Shore Cultural Center. Traditional Michelle wore a big off-the-shoulder white taffeta gown with a sweetheart neckline and a princess veil and full-length gloves. They moved into a first-floor condo on South East View Park, a gated complex on a dead-end street in Hyde Park, the city's most racially and economically diverse neighborhood. After three years at Sidley, Michelle had grown disillusioned with corporate life and took a job as an assistant in Mayor Daley's office in 1991. Later she went to work for Public Allies, a nonprofit organization that places kids from diverse backgrounds in paid internships. She has attributed her change of heart about her career to the sudden death of her father in 1991 from complications of multiple sclerosis. It was a devastating blow that showed her how fragile things were—how quickly her plans could unravel. His death inspired her to seek work she believed could improve her community—her father, after all, was the one who had always encouraged her to help strengthen the neighborhood by returning to it. She has said that as a corporate lawyer working on the forty-seventh floor of a big, fancy Chicago office building she looked out on her old South Shore neighborhood and wondered about the kids who were just as smart as she was growing up but had not benefited from the same opportunities. Ultimately she left the corporate world because she wanted to help bridge the gap between herself and those less fortunate. She was also inspired by her future husband's interest in public service. But she never imagined the kind of public life that it would lead to.

When Barack announced to her that he was running for the Illinois State Senate in 1995, Michelle was taken by surprise. Politics was not something she particularly enjoyed. In *The Audacity of Hope*, Barack Obama describes Michelle's unhappy reaction to his decision to run for Congress in 2000. "My wife's anger toward me seemed

Michelle's traditional style was on display at her wedding to Barack Obama in 1992 in Chicago (*previous page*) and strolling through Hyde Park in 2000 with Malia (*top*). Getting ready with her husband, then a Senator, at their Chicago home in December 2004 (*bottom*). She was wearing the sleeveless look long before her White House debut.

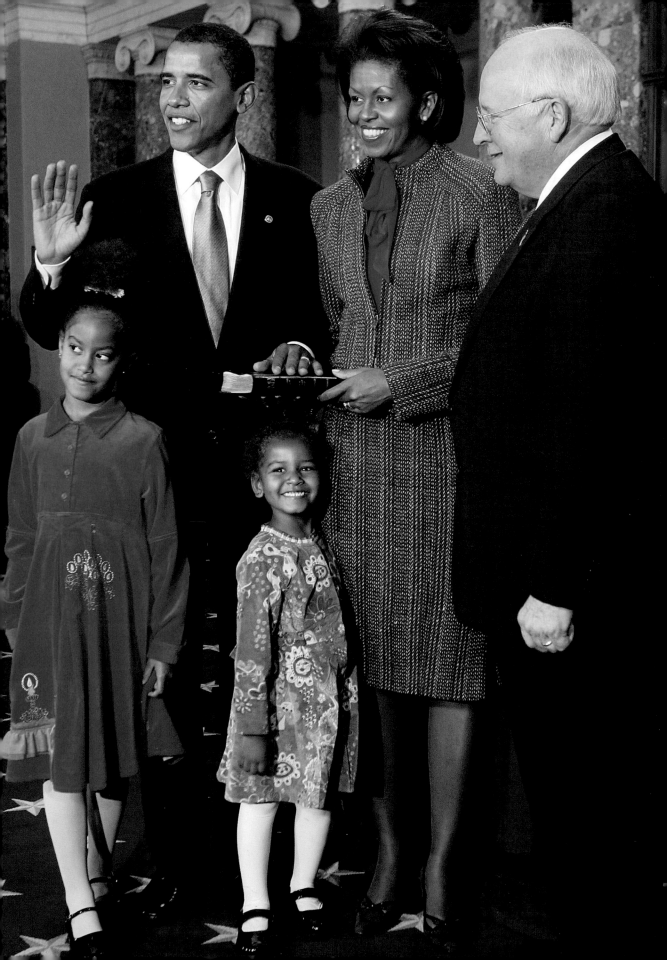

From corporate to casual, the evolution of an image: Michelle Obama wears a boardroom-bound tweed suit with a flash of fuchsia at the neckline (*opposite*) for her husband's swearing in to Congress in January 2005; at home in Chicago, Michelle relaxing the dress code a bit in a crisp cotton outfit (*top*); posing with the family for a portrait in the backyard (*left*), Michelle's casual style played an important part in positioning her as a potential mom in chief rather than a hard-driving, West Wing–bound careerist.

barely contained," he wrote. "'You only think about yourself,' she would tell me. 'I never thought I'd have to raise a family alone.'"

ROLE MODEL 2.0

On the plane back to New York City I found myself thinking about how Michelle Obama had flown: from Chicago's South Side to Princeton to the world of corporate law covering social and cultural distances far more vast than the geographical journey. What had it taken for someone like Michelle—no shrinking violet—to adapt to so many new and strange environments? How had she managed to hold on to such a clear sense of herself? It seemed that style had been some sort of talisman for her—a symbol of what she wouldn't change, values that wouldn't bend in the wind, a way for her to hold on to the traditions she had absorbed growing up in that one-bedroom apartment on South Euclid Street. Or was style a way for her to hide the stitches—to cover up the seams in a self that prized "seamlessness"? Was style a crutch to help her with uncertain footing? Style can go either way: it can be an expression of confidence, or a substitute for confidence. For many women, we remember our rockiest transitions in life by the regrettable outfit we were wearing at the time. We wear our insecurities on our sleeves. So often that regrettable appearance can reveal that fish-out-of-water feeling of a new job, a new school, a new city. And yet Michelle has always been Casual Michelle. At ease with herself, "seamlessly" presenting her outward appearance as a natural extension of her intellectual confidence. As Karen Jackson Ruffin, her friend from Princeton, had told me, Michelle was always above the fray, not ruffled by the seemingly irrelevant insecurities or anxieties of the moment. "She always seemed to

know exactly what she was doing, and why she was doing it. She was very focused," Jackson Ruffin had told me.

Thinking about this reminded me of something Maria Pinto had said while we were talking in her studio back in Chicago. "A lot of women relate to her because she's juggling a lot and so are we and she does it beautifully," Pinto told me. "Her image is so strong. For lack of a better expression, you never see her sweat, she always maintains dignity and composure." Ultimately her style reflects her deep-rooted confidence and serves as an expression of her ideal self—the Michelle Obama whose parents taught her to speak her mind, to make mistakes, to have the courage to venture into unfamiliar territory.

So much of the intrigue surrounding Michelle Obama had to do with her—what other word is so apt?—"seamless" solutions to dilemmas that have plagued so many women since women began entering the workforce. Women of my generation are grateful—or ought to be—for women who broke the ground and cleared the professional fields. This generation of women born in the 1960s—Michelle Obama's generation—was brought up to believe they could do anything. Every woman in a corner office owes a debt to women of an earlier time who hammered at the locks on their behalf. And yet, despite the pioneering efforts of feminists, so many women still feel challenged daily by the prospect of juggling the responsibilities of job, family, husband, friends. We're haunted by that infernal feminist phrase "having it all," which once promised women so much freedom and now seems to hang over us like a sword of Damocles. There is something deeply liberating about Michelle's honesty when it comes to "having it all." As she had put it so perfectly at a Chicago fund-raiser lunch back in July 2008, "I wake up every morning wondering how on earth I'm going to pull off that next minor miracle to get through the day."

One of the most telling stories I came across about Michelle had

to do with her finesse on the high wire of having it all. Just after her second daughter, Sasha, was born in 2001 Michelle was called for a job interview for an executive position at the University of Chicago Hospitals. Unable to find a babysitter, she brought her baby with her to the interview—not necessarily the best accessory for the occasion. But she got the job. Her boss, Susan Sher, now the First Lady's chief of staff, said later it was classic Michelle behavior; the prospective employee was not afraid to say "This is who I am, this is my life." That same forthright attitude that helped her navigate the tricky work-family balancing act had also helped her navigate unfamiliar territory in school and in her career. It's an attitude that informs every aspect of her style—her confident gestures, her bold outfits.

Her recipe seems part postfeminist juggler, part traditional throwback. She has an almost uncanny ability to straddle contradictions. For smart working women accustomed to suppressing their femininity in the armor of a mannish pantsuit, she has made it okay to care about how you look and to even have a little fun with it. Why should birdbrains have a monopoly on fashion? With her cozy cardigans, floral prints, and 1950s belted shirtwaist dresses she has tapped the power of femininity. We don't need the shoulder pads, she seems to be telling us, we need the Jimmy Choos and the statement necklaces. We need to express ourselves, finally, as women. It's almost as if she is taking Hillary Clinton's intelligence but dressing it in Jackie Kennedy's clothes.

And Traditional Michelle—the one who prefers "Mrs." to "Ms."—says it's okay to drop out of the professional scrum provided you can afford to. She certainly now seems okay about tailoring her professional life to accommodate her husband's ambitions. But putting her career on hold so that her husband can run the country—or try to—is a big sacrifice, perhaps bigger than anyone will ever know. Although Michelle has repeatedly said that her primary role is Mom in Chief, there are hints that it has not been easy for her to relinquish her hard-won professional life. After all, this is

a woman who calls herself a "120-percenter"—if she isn't performing at 120 percent, she feels as though she is failing. Her mother told *People* magazine, "Michelle worked so hard to get where she was. I kind of feel bad for her." But the First Lady doesn't flinch. Self-pity isn't one of her core values. She declared to CNN's Soledad O'Brien: "I am a mother first. My career does not define me, what I do in my life defines me."

Where Hillary Clinton and Rosalynn Carter saw feminism defined largely as the chance to compete with men and have a professional career, Michelle has brought a new wrinkle to the notion that work isn't just in the office. In many ways she is reshaping the feminist dream, correcting its oversights, compensating for its defects. When she told Gwen Ifill in *Essence* magazine that "we potentially may not be able to have it all—not at the same time," she seemed to be releasing all working mothers from the scary prospect that we were going to be held to an impossible standard.

I SAW HER empathy for working moms up close for the first time at a *Time* magazine event in New York City in May 2009. The annual dinner, which is a celebration of the Time 100 list and involves 300 or so of what the editors call "influencers," is held at the Time Warner Center. The room is always filled with high-profile people from all over the world: Nobel Prize–winning economist Paul Krugman, Twitter founder Biz Stone, French *Vogue* editor Carine Roitfeld, the Sri Lankan rapper M.I.A. It's an event that inadvertently highlights the yawning gulf between style and substance. Glamazon clotheshorses versus academics with stains on their ties. But that night people were mingling, it seemed. Most of the guests knew the First Lady was making an appearance, and no matter how much they feigned interest in one another with cocktail chatter, it was clear everyone was waiting for her arrival.

Reporters had been told not to approach the First Lady. And

there were plenty of Secret Service guys and press flacks to fend off overzealous guests. By the time the crowd was ushered into the Frederick P. Rose Hall for dinner, Michelle was already hunkered down at table number six with her chitchat buddy Oprah. Both Chicago ladies were dressed discreetly in long black gowns, as if they were trying to keep a low profile among the crowd of power brokers. As if. Also at the table was A. R. Rahman, the Indian composer who wrote the hit song from *Slumdog Millionaire*. He had been delayed for ten hours on a flight from Mumbai and was given a police escort from Kennedy Airport so he could get to dinner in time to perform the ebullient Oscar-winning theme song "Jai Ho" for the First Lady.

Everyone in the room that night wanted to meet her. Some held back, others did not. After chatting for twenty minutes at my table with Desirée Rogers I decided to go for it. I made my way toward table number six, grabbing the designer Stella McCartney along the way. We wormed our way through a scrum engulfing the First Lady's table. I introduced her to Stella, and the First Lady beamed. "I love what you do!" she said, shaking Stella's hand. Somehow the subject of kids came up, and Stella began reciting the names and ages of each of her children.

"You have the hard job," Michelle said when Stella mentioned that her youngest had just celebrated his first birthday. Before either of us could even point out the absurdity of that statement we were squeezed away by the pulsating crowd. *We have the hard job?* In the swirl of influencers and red carpet fabulousness I'd glimpsed the "real deal" Michelle, the one her friends describe as regular. The Michelle who says things like "hey, girlfriend" and "way cool." The Michelle who renounces panty hose on national television

"This is a person who worked hard and triumphed. She traded on her brain. Her style gives her a window into her intellect."

—MELLODY HOBSON

with Barbara Walters and tells a rapt audience of global spouses at the Group of 20 summit in Pittsburgh that her favorite song on her iPod is Sara Bareilles's "Gravity." The Michelle who says maybe as women we can have it all, but maybe not at the same time. And, hey, that's okay.

That Michelle, the Michelle who was seemingly at the center of so many paradoxes, was a powerful role model in her honest, confident, be-who-you-are attitude. In a culture that seems to prize only what is aesthetically perfect and those who strive professionally to achieve the unachievable, there is something about Casual Michelle that is not only inspiring but also refreshing, almost like taking a deep breath. It was moving to see her doing everyday things around the White House: shelling peas from the kitchen garden, handing out Halloween candy to young visitors under the

The real Michelle: With Oprah Winfrey at the Time 100 dinner in May 2009, the First Lady wears her signature statement necklace.
Page 165: At the White House for a reception for Supreme Court Justice Sonia Sotomayor, she replaced the officious shantung suit favored by most Washington women with a breezy chiffon dress accessorized with a funky brooch.

"It was Yves Saint Laurent who said, 'What is the most beautiful thing? To have love on your arm.' She has love on her arm." —SOPHIE THEALLET

North Portico, teaching Bo how to high-five. It reminded me of a conversation I had with Mellody Hobson, one of the last people I had seen in Chicago. Like Michelle, Mellody was from Chicago, the youngest of six kids in a family raised by a single mom. Hobson had also gone to Princeton and was now at the top of her field, as the president of Chicago-based Ariel Capital Management, one of only a few African American women to reach the corner office in the world of finance. She explained Casual Michelle's impact perfectly.

"We've seen the person who looks like a shiny, new penny and that's not her," said Hobson, who also subscribed to the First Lady's ultrafeminine fashion sense and was wearing a silver Azzedine Alaïa miniskirt with a matching cardigan. "This is a person who worked hard and triumphed. She traded on her brain. Her style gives her a window into her intellect. She's not fussy; she's an individual. And she has had a profound effect on sixteen-year-old girls."

More than anything else she does in the White House, Michelle Obama will affect young African American women the most. The example of her work ethic is as powerful as her style. In paying careful attention to her appearance, she is acknowledging how much it matters. She is showing women—all women—how to take care of themselves, how to improve themselves, how to make their lives better. As one of the most powerful role models African American women have ever had, she knows that she is trampling pernicious stereotypes. Maybe more than any First Lady before her she is being scrutinized. Every step, every gesture, matters not just as a demonstration of her style and her ability to marry style and smarts, but also for the precedent of her place in American history. Her synthesis of style and substance is particularly

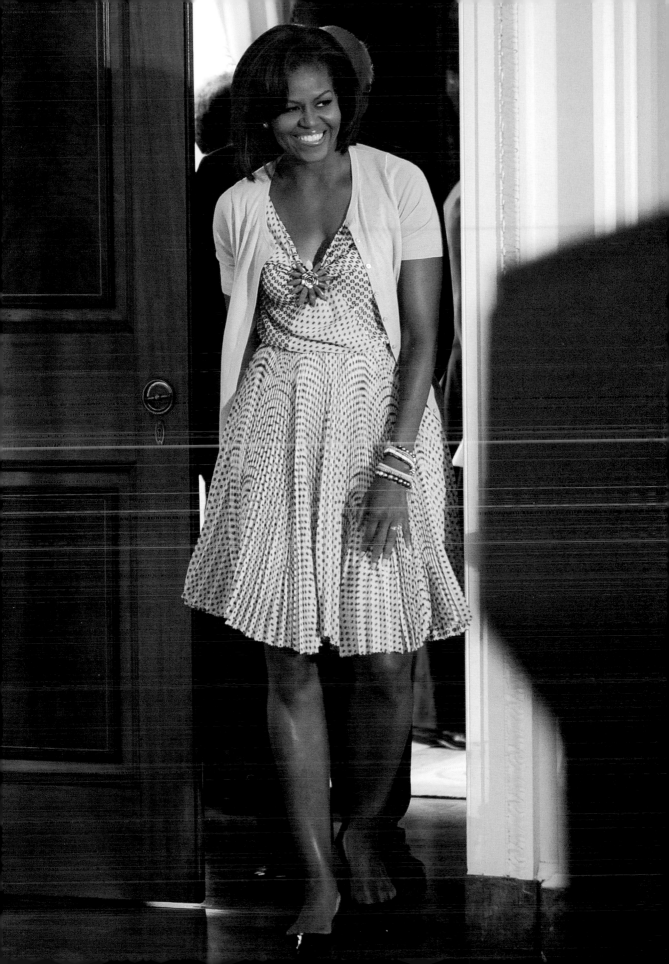

powerful among a demographic of women whose style icons and leaders most commonly rise up through the worlds of sports or entertainment and who don't get a chance to see themselves on the cover of *Vogue* very often.

As Hobson explained it, most African American women have never had a "regular" role model. "When I was young we had Iman, who was a gorgeous supermodel, or Naomi Campbell, but we did not have someone regular who got where she got for her hard work and brains."

And clearly Michelle wants to show the world what it means to be black and "regular." In one of her first public ceremonies as First Lady, she unveiled the bust of abolitionist Sojourner Truth—an early champion of women's rights—in the Capitol's Emancipation Hall. "Now many young boys and girls, like my own daughters, will come to Emancipation Hall and see the face of a woman who looks like them," she told the crowd, which included Nancy Pelosi and Hillary Clinton. Like the feminist pioneer she was referring to, Michelle Obama was changing the way African American women are perceived.

Kitchen classics: She may not like to cook, but Michelle Obama likes to get involved in the goings-on of the White House kitchen, from planting the vegetable garden to showing off some of the elaborate pastries prepared by dessert chef Bill Yosses (*above*) for the Governors' Dinner in February 2009. The First Lady even rolls up her sleeves and gives a hand with some of the prep work (*opposite*).

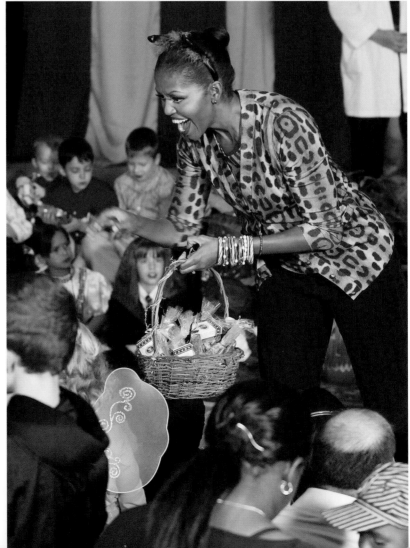

"She epitomizes that thing Toni Morrison said: she is both a ship and a safe harbor," says Veronica Chambers, author of *Having It All? Black Women and Success.* "She is taking black women to places we've never been and yet she is not the housewife, Stepford wife First Lady. She is saying, 'I am here to do good.' That is something black women admire. Most of us were raised to believe in our purpose."

Although she would be the first to say it's not enough merely to get to the White House, you have to do something once you're there, Michelle took her time before telling the world how she would leave her mark as First Lady. She spent her first year in Washington settling her kids into their new life, planting her kitchen garden, and paying a personal visit to different cabinet departments. Then she got down to work, officially announcing her Let's Move! initiative to combat childhood obesity and teach kids about healthy eating and exercise. She traveled the country to enlist the help of PTAs, food manufacturers, school food-service employees, and large beverage companies. A federal task force was set up, and experts were summoned from around the country for their input on what she called a growing health epidemic. Mayors, governors, and pediatricians pledged their support. She was not kidding when she said get moving: healthy eating and exercise quickly became routine in all of the First Lady's White House activities. Even Dolley Madison's beloved Easter Egg Roll on the South Lawn got an aerobic boost with the addition of dancing, yoga, football, basketball, golf, softball, and tennis. The final judgment of history has yet to come for the Obama White House, but this First Lady has already kicked up the heartbeat of the place.

I had another fleeting glimpse of Michelle the role model on my way out of the White House that September day in 2009. The Olympic promotional event on the South Lawn had just ended, and I was walking back through the Palm Room when I paused for a moment in front of a glass door that leads to the Center Hall.

Making herself at home: Descending the main staircase from the residence (*top*) on their way to the grand foyer to greet ambassadors for the United States at a reception in July 2009. For many of her White House events, the First Lady likes to include children. For Halloween (*bottom*) she dressed as Cat Woman and, along with the president, handed out dried apricots, apples, and papayas, M&M's, and cookies to 2,600 kids and their parents.

Looking east down the long, wide hall with its potted palms and regal red carpet the First Lady suddenly appeared about a hundred yards away. She had just come out of the Diplomatic Room and was walking purposefully—and alone—toward her next appointment, pushing up her sleeves, as if to say, "Back to work." She seemed so approachable, I was tempted to push the door in and walk toward her. Instead I glanced around sheepishly to see if anyone was watching. When I looked back she was gone. I don't know the White House well enough to know if she turned right into the kitchen to give Sam Kass, her personal chef transplanted from Chicago, instructions for Sasha and Malia's dinner that night, or whether she headed upstairs to prepare for an appearance the following day at the opening of a new farmers' market a few blocks away on Vermont Avenue. Either way, for Michelle Obama it was just another day in the White House.

To reflect her own simple origins, Michelle Obama chose a simple cotton shirtwaist dress inspired by French peasant clothes for the unveiling of the bust of abolitionist Sojourner Truth in the Capitol (*opposite*). "I hope Sojourner Truth would be proud to see me, a descendant of slaves, serving as First Lady of the United States," she said. Designer Sophie Theallet's sketch of the dress (*right*). *Following pages:* the First Lady and her chef, Sam Kass, celebrate the opening of a new green market in Washington, D.C.

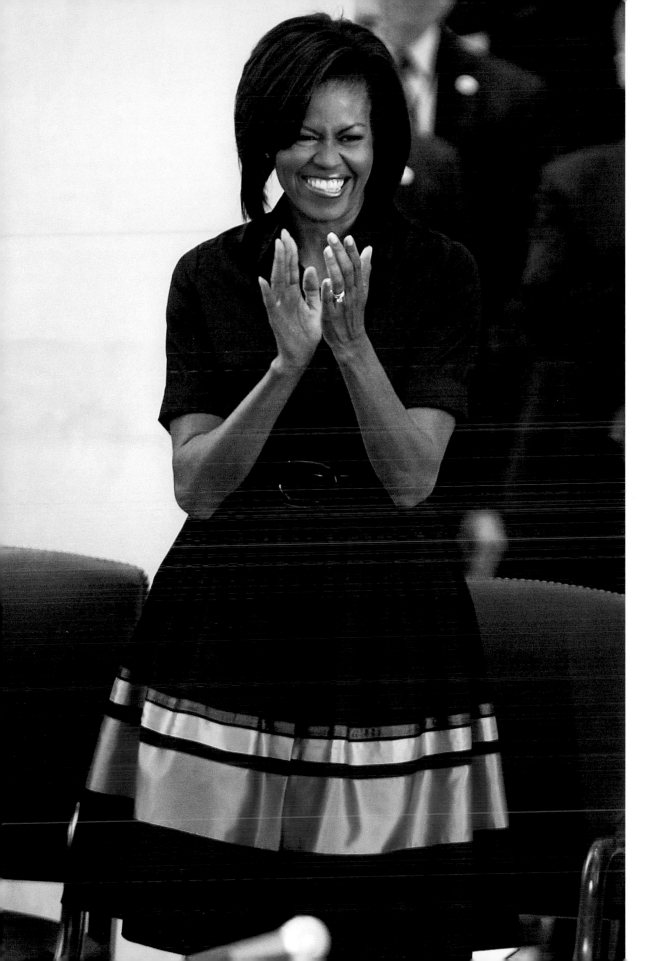

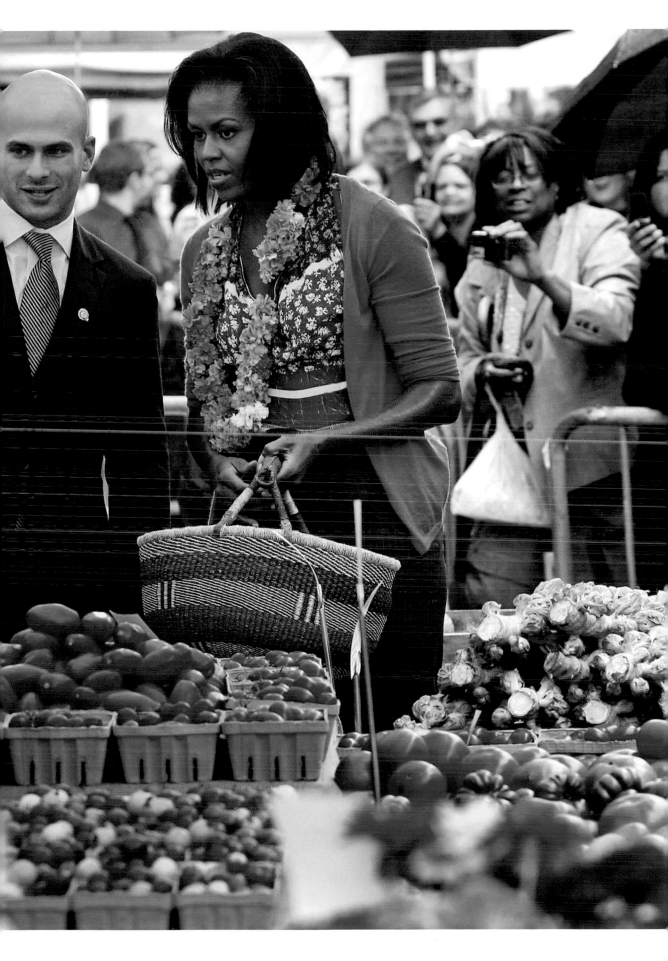

UNDER CONSTRUCTION

Crafting an image for a public figure as scrutinized as the First Lady is one challenge. Crafting the perfect evening dress is quite another. Some of the most alluring gowns Michelle Obama has worn since she got to the White House are the work of New York–based designer Peter Soronen. He has a knack for building his dresses from the inside out, sewing an old-fashioned corset inside the seams. And he can do it faster than you can thread a bobbin. The dress she wore to the Alfalfa Club Dinner in February 2009 was whipped up at the last minute, literally. Soronen got a call from the First Lady's fashion guru, Ikram Goldman, saying she needed a red dress the following day by 10 A.M. "I said, 'For whom?'" he recalls, "and she said, 'Who do you think?'" They discussed the fabric of a strapless dress Soronen had already made, a red bobbinet over red satin. But the First Lady

needed straps. So Soronen stayed up until 2 A.M. cutting the fabric and sewing the dress. He delivered it to Goldman the next morning. A few weeks later Soronen whipped up a similar gown in sequin-embroidered charcoal gray chiffon for the First Lady to wear to the Governors' Dinner. For her appearance at the Kennedy Center Honors in December 2009 he made yet another stunner: a draped periwinkle chiffon strapless gown with lacing up the back. Adding a shot of glamour to the state dinner honoring Mexican president Felipe Calderón and his wife, Margarita Zavala, Soronen created a cobalt blue one-shouldered corset dress with layers of sparkling tulle and lamé.

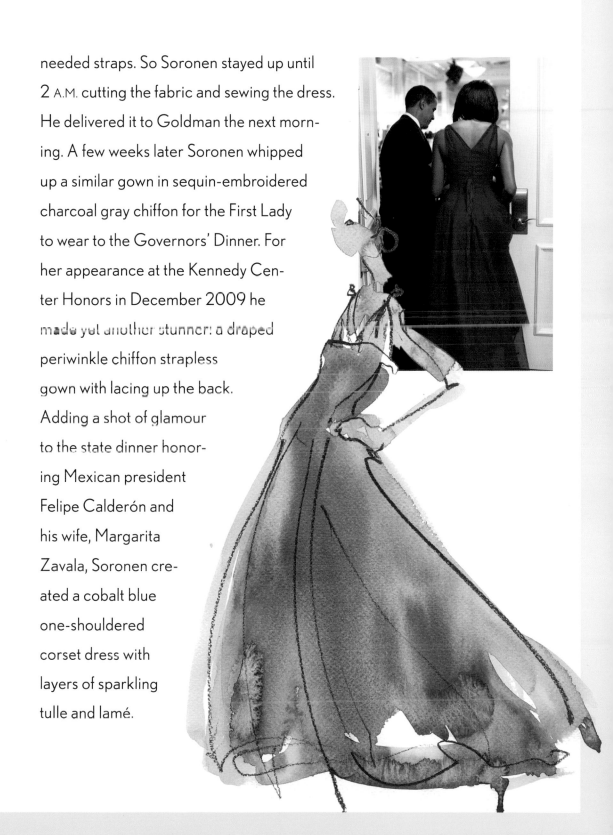

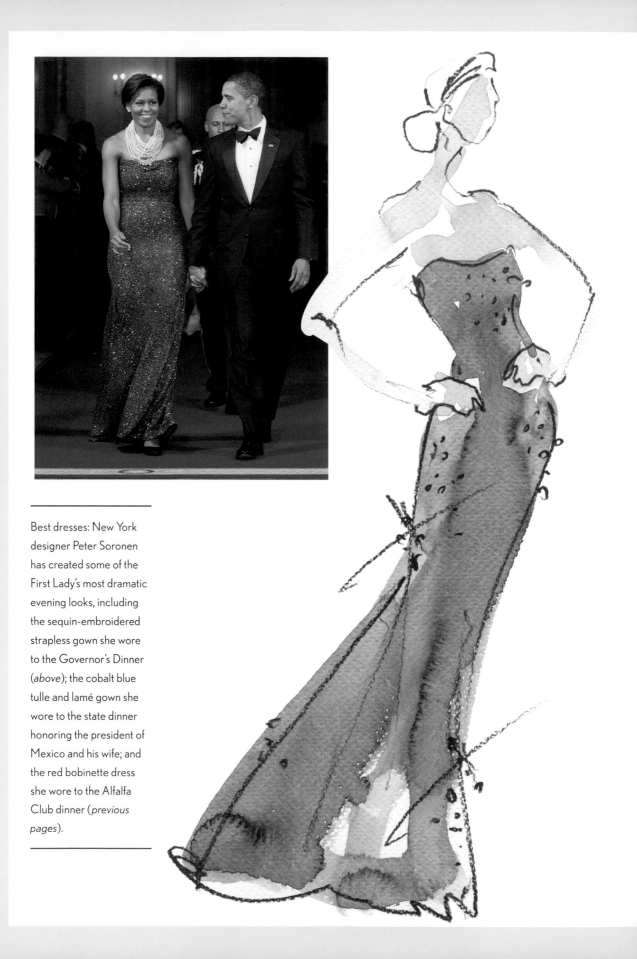

Best dresses: New York designer Peter Soronen has created some of the First Lady's most dramatic evening looks, including the sequin-embroidered strapless gown she wore to the Governor's Dinner (*above*); the cobalt blue tulle and lamé gown she wore to the state dinner honoring the president of Mexico and his wife; and the red bobinette dress she wore to the Alfalfa Club dinner (*previous pages*).

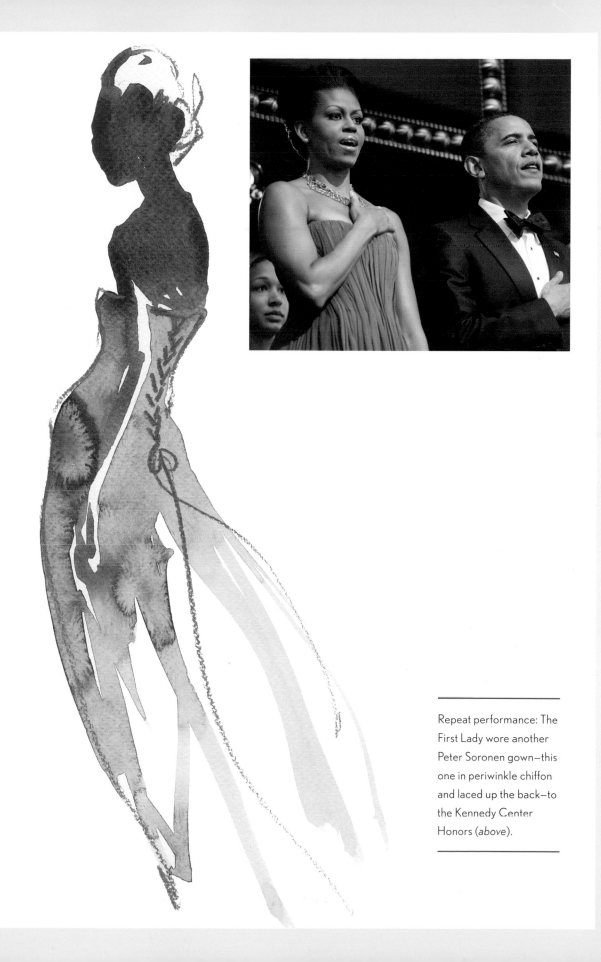

Repeat performance: The First Lady wore another Peter Soronen gown—this one in periwinkle chiffon and laced up the back—to the Kennedy Center Honors (*above*).

THE CONTROVERSIAL CARDIGAN

Buttoned up: Michelle Obama has made the cardigan her signature, even for formal occasions. On her first official trip to London in April 2009 she wore a beaded ivory J.Crew cardigan (*right*) and on the eve of the inauguration she wore a similar style in chartreuse to the Kids Concert (*left*).

Grace Kelly made it glamorous in the 1950s, Brigitte Bardot gave it sex appeal in the 1960s, Jimmy Carter made it political in the 1970s, and Kurt Cobain gave it grungy gravitas in the 1990s. But the cardigan sweater didn't become downright contentious until Michelle Obama wore one to Buckingham Palace to meet the Queen of England for the first time in early 2009. Critics around the world decried the fashionable First Lady's lack of formality and her apparent disregard for protocol. Perhaps they thought a jacket might be more appropriate. But little did they know that the cardigan is more buttoned-up than just any jacket, boasting its own aristocratic lineage. The sweater was originally named for (and probably invented by) the seventh Earl of Cardigan—aka James Thomas Brudenell—in the 1830s. Thanks to Casual Michelle, the cardigan is now caught in a generation gap between women of a certain age who view it as too casual for the professional arena and younger women who find it as well suited to the office as it is to any off-duty wardrobe.

GETTING A BEAD
ON PEARLS

Cleopatra liked her pearls in vinegar—or so goes the famous story Pliny the Elder tells in *Natural History* about the time the Egyptian queen recklessly dropped a priceless pearl into a goblet of vinegar to show Mark Antony a thing or two about ostentatious consumption. Pearls have always been prized. At the height of the Roman Empire, General Vitellius financed an entire military campaign by selling just one of his mother's pearl earrings. Rome's pearl craze reached fever pitch during the first century B.C. when Roman women would upholster couches with pearls. During the Renaissance natural pearls were so rare and expensive that only nobility wore them. Rulers like England's Elizabeth I and France's

Marie Antoinette were seldom portrayed without pearls. Dolley Madison was the first First Lady to wear them in the White House. To her husband's inauguration she wore pearls strung on a gold chain. By the 1900s, cultured pearls were invented, allowing more common folk to enjoy the prized gems. Coco Chanel lent them fashion credibility when she mixed them with costume jewelry. In the mid-1920s she began creating imitation pearl jewelry out of coated glass beads. Her stamp of approval gave women the freedom to smother themselves in costume pearls. But it was First Ladies like Jacqueline Kennedy and Barbara Bush who made pearls a signature of White House style. When Jackie wore her three-strand pearl necklace—a look that was both prim and classic—pearls had a very polished reputation. But when Barbara Bush started wearing fake pearls, the look began to lose its luster. There was absolutely nothing individualistic about pearls until Mrs. Obama came along and gave the conservative look a twist. During the campaign, she wore Gobstopper-size pearls—a kind of funky wink at the tradition-bound role she was about to embrace. Although she wore a two-strand pearl necklace for her official White House portrait, the First Lady usually makes a bolder statement by wearing punk-inspired pearls by designer Tom Binns, or Erickson Beamon's long, multicolored costume pearls. Even with such a traditional accessory, she makes it her own. Cleopatra would have approved.

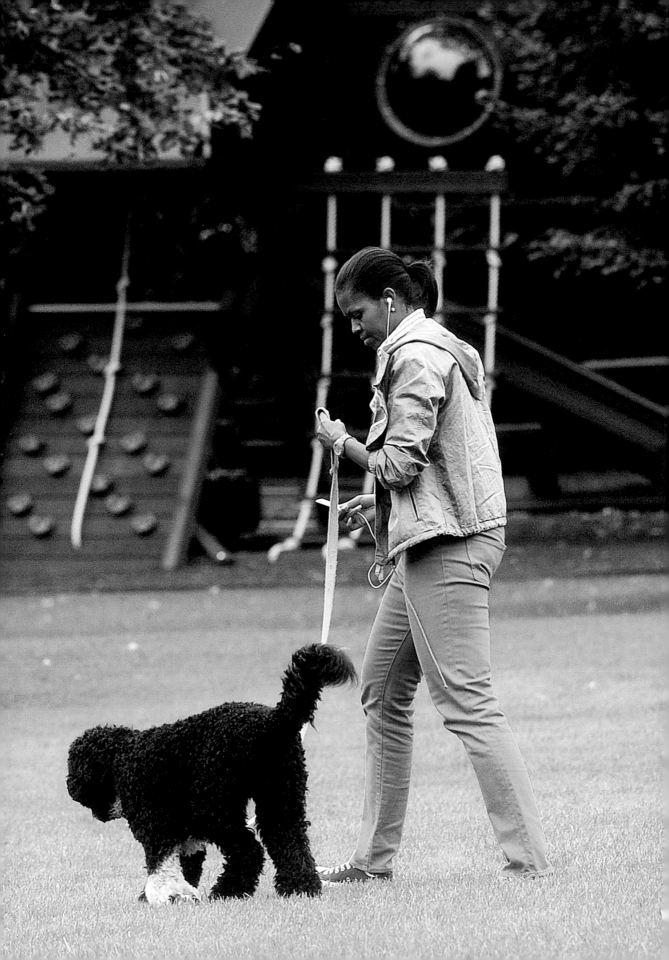

6 ONLY CONNECT

There is a photograph of Michelle Obama that I love because among the tens of thousands of pictures of her it captures the essence of her style. It is not your usual First Lady snapshot. No pearls. No power suits. No plastic grin. She is wearing a pair of turquoise jeans and violet Converse sneakers. She is walking across the South Lawn of the White House, tugging the leash of the First Dog, Bo. She has iPod headphones planted in her ears. She is the very picture of a modern American woman, a working mom with a hard-won résumé taking the dog out for a morning walk. She could be any of us superimposed on the august grounds of the White House. Somehow we've all been in her sneakers: overscheduled, juggling chores, running from school parent-teacher conferences to orthodontic appointments, perhaps a PowerPoint presentation at 4:00 P.M. followed by a mad dash to the

store for chicken nuggets at 5:30. Somebody please tell me why we got a dog again?

Who doesn't dream of slipping away from the tyranny of the "to do" list for a moment to drift into some imaginary unscheduled life? Maybe the darned dog wasn't such a bad idea after all. . . . Sometimes an image can reach beyond its own elements and resonate with ideas we are hardly aware of until we see them caught in a photograph. It was just a fleeting moment in the First Lady's life, but that photo captures so much of what defines American style, the informality, the easy unimpeded confidence, the sense of self-possession. She could not look more casual or at home with herself, free from the trappings and expectations of her office, uninhibited by the demands of her position.

I thought *First Lady with iPod and Dog* was my favorite photo, but there are others that I find myself studying as if they were archaeological discoveries from the secret history of women. One is a sports shot, Michelle Obama leaping over a low gate that was part of an obstacle course set up on the South Lawn of the White House for an event to promote healthy eating and exercise for kids. She's wearing a cerulean blue cardigan with a wide purple belt and black pants. What's striking is not the First Lady's joyful zeal, her athleticism, or her Olympic determination to clear the hurdle, but the fact that she's barefoot.

Another shot from the same event has her swirling her hips inside a Hula-Hoop; another, jumping rope double Dutch. Can you imagine Laura Bush or Hillary Clinton or Barbara Bush jumping double Dutch anywhere, much less on the South Lawn of the White House? It seems inconceivable those ladies would even have it in them to try, or ever feel free enough to risk compromising their dignity if the adventure turned out badly. (And more power to them—certainly part of style is knowing how to spare yourself moments of abject humiliation.) Perhaps the fact that it's so hard to

Taking it all in stride: Michelle Obama adapts her casual sensibility to her very public profile. She wears what suits her— whether she is leaping over an obstacle course on the South Lawn as part of her healthy eating and exercise program or taking time to chill out and walk the First Family's dog, Bo (*page 182*), upon her return from Malia's soccer game.

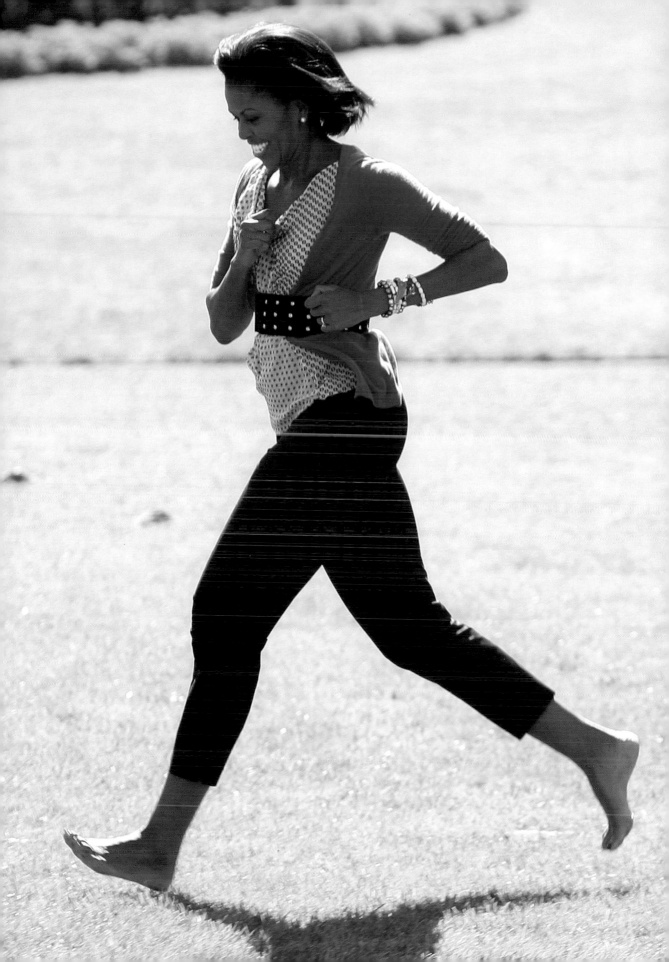

"There are no rules for her. She's done everything in her own way. She's just a straight shooter. Every time she speaks it always seems from the heart, it seems genuine. That's hard to do."

–JENNA LYONS

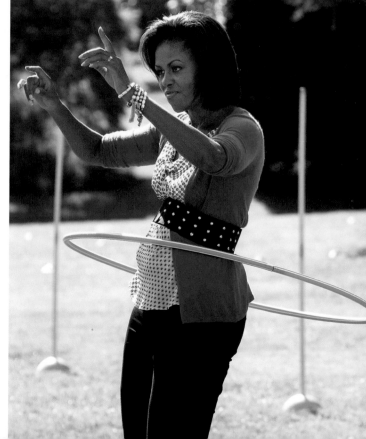

imagine Hillary or Laura leaping across the South Lawn says more about Michelle Obama's generation and their hard-won independence than it does about either former First Lady. Michelle's South Lawn athletic prowess is thrilling because it instantly unhinges us from all of our traditional expectations of First Lady protocol. Leaping across the lawn with confidence, pride, and assured dignity, she is completely herself—the synthesis of the private person and the projected public persona is seamless—the ultimate expression of style.

The more I studied the photos of Michelle Obama—the more I watched her in action, and talked to people who knew her or designed clothing for her or were just intrigued by her—the more remarkable the power of her style seemed. In photographs the First Lady seemed like one of those rare figures who comes along once in a generation to personify the transformative power of style, how it can alter the people around us, change a mood, diffuse a crisis, and help render the most dreamy aspirations and fantasies into material truths.

And yet the pictures left me with many questions. What is it exactly about Michelle Obama's style that many of us find so engrossing? No photo can explain the feeling of sympathy and connection the First Lady evokes, or why so many of us find her clothes, her manners, her causes, and her presence so compelling. Pictures can't account for the power of anybody's style or explain where its mysterious qualities come from and what they mean. I realized I would have to look outside the frame of the photographs and explore the possibility that the power of the First Lady's style has as much to do with the people looking at the pictures as with the person in them.

It would be difficult to envision any other First Lady jumping double Dutch on the South Lawn and yet Michelle Obama is clearly unafraid to look silly or appear out of step as she takes part in a Healthy Kids Fair in October 2009 (*top*). Later at the same event she showed off her prowess with a Hula-Hoop (*bottom*).

THE NEW ETIQUETTE

Shoeless double Dutch on the White House lawn. A friendly hand on the back of the Queen of England. Bare arms in Congress. You can't help but be amazed at the rules Michelle Obama has broken and wonder about what rules she might break next. She has transfixed us not just with her sense of style but also with what seems like a new set of you-go-girl guidelines—a new etiquette based on brio, enthusiasm, and her oft-repeated and seemingly unassailable fashion principle: "Wear what you love."

It's a wonderful openhearted idea with a sprinkle of Emerson and a dash of Thoreau crowned by a swirl of Joseph "Follow Your Bliss" Campbell. The First Lady's new what-to-wear etiquette says: Follow your heart. Go with your instincts. Have the courage of your convictions. Don't be buffaloed by skinny fashion editors with their lists of dos and don'ts.

Wear what you love.

Sure it's a bromide, but it's hard to quarrel with it when you see the idea in action, the confidence such a simple guideline seems to have infused in Michelle Obama. We've gotten to the point where we would all be disappointed if she didn't wear what she loved or follow her instincts and cut against the grain. What's on her agenda may be topics that have nothing to do with what she is wearing—she promotes issues as disparate as health care reform, military family support, and the dangers of bingeing on huckleberry cobbler—but she seems to see fashion and the charismatic power of style as useful ways of galvanizing the public's attention. And once you have their attention, you can use it.

There are a number of things to say about the New Etiquette, the first being its limits. It's not a license to do whatever you feel like, or a narcissistic revolt against all social conventions. It doesn't

sanction wearing hot pink sleeveless dresses at funerals or hiking shorts in the office or Converse sneakers at state dinners. The First Lady may be rewriting the fashion code in the nation's capital; she's working on the margins.

A second point to make is the strange position the whole preoccupation with her style has put her in. No one would have picked Michelle Obama to open a new frontier in fashion etiquette. As a serious career woman, a lawyer for heaven's sake, she had a flair for clothes but not an interest that would eclipse what was on her mind. Before the White House, the attention she paid to style was perfunctory. There were the standing Friday-afternoon mani-cures we've all heard about in preparation for date night with the president, but she certainly wasn't zipping into New York to preview Oscar de la Renta's fall collection. Now that she is trailed wherever she goes by one of the big-gest spotlights in the world, now that she has an unimaginable amount of power to influence the culture— to advocate causes and change people's lives—it's suddenly incumbent upon her to pay attention to style and particularly to the nuance of political image. To be success-ful, she has to craft an effective appearance and dress for the stage, as it were. The genius of her stagecraft is how free, spontaneous, and unself-conscious it seems. She has fashioned a finely controlled image that seems uninhib-ited and free from too much control. It's ironic that Michelle Obama now needs to look good in order to be seen and heard and respected, or that the woman of substance is capitalizing on the power of appearing a certain way in order

"For me she is like a heroine because she has stayed and remains the same. They see the same people and she goes on vacation and she wears the shorts. And why not? She does what she believes and what she wants to do." —ALBER ELBAZ

to move the culture past its preoccupation with the superficialities of appearance.

And finally a third point: it's interesting how little time the First Lady or her staff spends talking about her clothes. The White House was taken aback during the inauguration by the outpouring of attention to her clothes. The attention was discombobulating. After the Time 100 dinner in May 2009, her press office sent out a release saying her dress—a long black entrance-maker—was by Azzedine Alaïa. *Quelle horreur!* It had actually been designed by Michael Kors. A correction was quickly issued. Eventually the First Lady and her staff learned what could be done with all the limelight around her clothes. But to this day it's very hard to get anyone in the East Wing to talk about Michelle Obama's feelings about style and fashion, despite the fact that everyone outside the East Wing—especially women—seems to have something to say about her style. She shows up to photo shoots for fashion magazine covers with her own clothes. It's as if her staff and the First Lady are still dogged by the old dread of being seen as frivolous, or thinking too much about such a traditionally lightweight subject. Or maybe she just likes her own clothes, and wearing them allows her to completely control her own image—"Stay out of my closet!"

Clearly Michelle Obama is not a fashionista hankering after the latest Rodarte platform buckled boot or Givenchy hobo bag. She outmaneuvered Sarah Palin brilliantly by playing up her fondness for more accessible outfits from J.Crew while the vice presidential candidate was pillaging high-end stores like Neiman Marcus. And yet, paradoxically, the First Lady, who is too busy with her kids and her Let's Move! healthy eating, antiobesity initiative to talk about clothes, wears some of the trendiest labels in the business, including Thakoon, Narciso Rodriguez, and Rick Owens. Her favorite belt is a pricey number by Azzedine Alaïa. Azzedine Alaïa is not a name casually uttered by a woman indifferent to the allure of fashion.

Perhaps the discomfort with the subject of fashion has to do with the possibility that the New Etiquette of "wear what you love" is a political calculation. In the end, the First Lady is the First Lady, and a large part of her life is symbolic and not at all like the lives of ordinary women. Thus you have to wonder how much of the way she dresses and acts is part of the careful program of image mongering. Are those pictures that engross us—*First Lady with iPod and Dog, South Lawn Hula-Hoop*—just images cooked up by a communications consultant eager to pluck the heartstrings of a target audience in the long and manipulative tradition of the consultants who carefully posed Ronald Reagan against the backdrop of the American flag, and made sure George W. Bush was wearing a he-man flight suit when he bounced down onto the deck of the USS *Abraham Lincoln*?

The idea of a "real" image is a contradiction in terms. All images are designed and manufactured—arranged depictions of reality. We can't really ever know how much of the First Lady's willingness to flaunt convention is an expression of her true personality and how much of it is political calculation. Did she kick off her shoes that October afternoon on the South Lawn and leap over the hurdles because she felt comfortable enough to have a go at the obstacle course and thought her high spirits would help the cause? Or perhaps she knew she could let her hair down a bit because there were only a few still photographers in the press contingent that day, which in her life almost constitutes privacy.

I have to believe the dash on the grass was spontaneous and done without undue concern for how it might look or what the political ramifications would be. Perhaps it is getting increasingly difficult to distinguish, but there is a difference between an image manufactured for an effect and an image that gets to the essence of a moment or a person. As carefully cultivated as the First Lady might be—groomed, dressed, scripted, scheduled, enveloped in

an entourage of aides—she carries herself with a spontaneity that seems impossible to counterfeit. It is part of her style, style being self-evidently what it seems.

When I lived in Paris I remember my French friends talking about style as if it were a dimension of a person's life that could be evaluated, much as you would evaluate someone's education, the range of her interests and references. If you didn't have style, or didn't make an effort to develop and express it, you had no genuine substance either. To ignore the realm of style was to negate your own intellectual vitality. My friend Carlyne, one of the most inherently stylish people I know, always describes style—or "chic," as she calls it—as something that comes from within. You either have it or you don't. "It's here," she says, tapping her fist on her chest. When you have that chic inside you, it's expressed in everything you do, from how you roll up your sleeves to the food you cook to the color of the curtains in your office. (I guess this is precisely why Paris is still referred to as a fashion capital, but Washington, D.C., not so much.)

One day I went to see Jenna Lyons, who as the designer of J.Crew may know as much about the New Etiquette as the First Lady. Lyons recently received a $1 million bonus, no doubt in part for dreaming up the outfit that Obama wore on the *Tonight* show in the midst of the presidential campaign and so set herself apart from the free-spending Sarah Palin. For Lyons, the New Etiquette reflects the evolution of style. "If no one broke the rules, we still wouldn't have the bikini," she says. "Everything you do speaks to who you are. I don't think she needs a power suit. It exudes an attitude that I don't think she's trying to bring to the table. There are no rules for her. She's done everything in her own way. She's just a straight shooter. Every time she speaks it always seems from the heart, it seems genuine. That's hard to do."

Critics of Michelle Obama have attacked her emphasis on fashion and her fondness for feminine floral printed dresses and big colorful brooches as a step backward for women—a deliberate

repudiation of feminist ideals. How many times have I heard women say, "Enough with the fashion, when is she going to do something serious?" They make their points, but I think they are missing the bigger point, which is the emerging style of a postfeminist generation. With her cardigans and funky belts and breezy skirts Michelle has given professional women license to look feminine. She is defining the dress code for the "you can't have it all" generation, a generation that wants to be paid as much as men, and have the same opportunities as men, but doesn't want to dress like them or to define the principle of femininity in male terms. Toughness doesn't have to come in a pinstriped suit, as Dianne Feinstein once said.

"Things have to change," says Lyons. "Things have to evolve. I love that Michelle Obama is making the White House a little bit more approachable and real. I think that means a lot to people. After the Jay Leno show we were getting e-mails from customers saying 'Oh my God I can't believe I have something from J.Crew and the First Lady wears J.Crew.' People felt connected to her through that. It was incredibly smart."

> "Find your spot. Find your space. Wear what you love."
> —MICHELLE OBAMA

CLOSING THE DISTANCE

During the inauguration, I remember thinking that all the news about what Michelle Obama was wearing was just typical inaugural coverage, heightened perhaps by the historic nature of her husband's election. But as the weeks went by the fascination didn't wane. All it seemed anyone wanted to talk about was Michelle Obama's ivory chiffon Jason Wu dress and whether

it fit her or not. Three months later, on her first trip to Europe, the blogosphere exploded anew on the subject of her wardrobe and her protocol-smashing gesture with the queen. Upon her return to the United States, talk was all about the $540 Lanvin sneakers she wore to a food bank. Then the chatter quickly turned to the hot pink dress she wore to the White House Correspondents Dinner. It was difficult to comprehend the intensity of the focus on her style.

I think most people in the fashion business expected Michelle Obama to settle into some sort of White House uniform appropriate to the position. And I think most people assumed the attention to her appearance would die down. But as summer slipped into fall and the Obamas returned from their vacation in the Grand Canyon (hiking shorts—not unheard of or unsuitable in the Grand Canyon, but on a First Lady, still a surprise) and Martha's Vineyard (Crocs Crocs Crocs!) I was getting a blizzard of e-mail from friends and readers with impassioned reactions to the First Lady. In twenty years of covering fashion shows, I don't think I'd ever seen clothing have such a polarizing effect. Karl Lagerfeld's misogynistic feathered face masks, Jean-Paul Gaultier's Hasidic hats, Janet Jackson's wardrobe malfunctions, Madonna's Catholic crosses, Britney Spears's schoolgirl kilts—none of these "scandalous" looks had generated nearly as much controversy as a seemingly harmless pair of hiking shorts or a Hula-Hoop.

The emotions ran to the extremes.

"Not her best look," my sister-in-law wrote from Maine, where she and her mother were embroiled in a discussion about the hiking shorts descending the stairs of Air Force One in Arizona in August.

"She has finally put a stake through the dreaded pantsuit!" one friend wrote urgently on the day in September when Michelle showed up to paint a Habitat for Humanity house in a cardigan, jeans, and sneakers.

"Every morning I get up and put a cardigan on and look in

the mirror and say 'Yes!' " Elaine, a Realtor who lives in my neigh-
borhood, told me one morning in early October at the local green
market.

My friend Stephanie, a self-proclaimed Michelle fan from
Indiana, e-mailed to say the Hula-Hoop photo was "most unfortu-
nate." She wasn't ready for such an approachable First Lady. "I like
my officials to be untouchable," she later explained.

Prompted by the same Hula-Hoop photo, the *New York Times*
op-ed columnist Charles Blow waxed: "Forgive me in advance for
fawning, but Michelle Obama is the coolest First Lady ever." It
was amazing that someone like Michelle Obama, who refused to
talk about fashion and was not previously recognized as someone
impeccably well dressed like the style icons of Babe Paley's era,
could reach so many people with a simple gesture—a cardigan, a
pair of sneakers, a barefoot sprint across the South Lawn. Maybe by
not striving to be stylish, not wanting to be labeled as such, she is
actually enhancing the power of her style.

I remembered how Karen Jackson Ruffin had chuckled over
the notion of Michelle Obama paying attention to style in college.
And yet Jackson Ruffin was always impressed by Michelle's abil-
ity to remain above the fray when everyone else at Princeton was
freaking out about a thesis deadline or a breakup or what to wear
to a party. Jackson Ruffin's refrain—"nobody looks cute writing a
thesis"—made me think again of how style and substance are held
in opposition. But I also began to wonder if Michelle Obama hadn't
learned that style was "show" and not "tell." When you think about
the distance she has come in her life, how many times she's been
the proverbial fish out of water—with a face unlike most of the other
faces in places that, if they were not particularly hostile, were not
especially friendly either—then you have to wonder whether maybe
her style served some special purpose. Maybe it was not just an
expression of clothes she liked or that made her feel comfortable,

but also a way of affirming her own strength, a way of reinforcing the idea of what it took for her to invent the persona that carried her as far as she'd come. For so many people who don't have a head start in life, or who are actively discriminated against, style is not a luxury or a choice but often a necessity.

Now that she is in the White House, her ultimate frontier, maybe the secret of Michelle Obama's style has as much to do with her refusal to be cowed by yet another alien environment. She is not going to get "dressed" in some "appropriate" outfit just to walk the dog. Maybe she insists on her bromides about wearing what you love because she learned you couldn't put on a uniform and just fit in. There was no fashion equivalent of a security blanket. No real confidence that could be borrowed by donning a store-bought suit. The true mark of style, after all, is the person who doesn't have to put something on to be stylish.

THESE THOUGHTS REALLY came into focus for me when I was at the White House one day in the fall of 2009 when Michelle Obama was with a small group of women. For weeks the First Lady had been busy, busy, busy—touring government agencies, sampling zucchini quesadillas at healthy kids fairs, and harvesting the bounty from her White House kitchen garden. In honor of Breast Cancer Awareness Month, one afternoon in late October she hosted a small group of women in the Jacqueline Kennedy Garden just outside the East Wing. Cancer was a cause dear to the First Lady ever since she lost her college roommate and best friend to the disease when she was twenty-five.

I arrived earlier than usual and had a chance to mingle with some of the photographers corralled outside the Palm Room waiting to be led through the back halls and into the garden where Mrs. Obama and Jill Biden would be hosting breast cancer survivors,

advocates, and a handful of women from Congress who were engaged in the health care reform debate. Many of the journalists were buzzing about how it had been at least five years since the White House had staged anything in the Kennedy Garden. As is the case with every move the First Lady makes, there was much discussion over the choice of locale, the timing of the event vis-à-vis the health care reform bill, and some laughs over how many photographers showed up. At the now-famous Hula-Hoop event two days earlier, only a handful of photographers had gotten the shot. So many lenses were aimed at the First Lady now you would have thought she had promised to stand on her head to advance breast cancer awareness. A lot of the photographers were sporting stepladders.

"She is so beloved that people often stand up the whole time," one veteran explained to me. "To get the shot you need some height."

On that particular late October day, the First Lady seemed uninterested in photo ops. As Jill Biden spoke, and was followed by three breast cancer survivors who highlighted their struggles with the disease and with insurance coverage, the First Lady sat listening, partially obscured by the podium. She almost looked like she was hiding behind it. Unlike many of the women on the podium and in the crowd who were wearing pink jackets or blouses in honor of the cause, the First Lady had taken a counterintuitive tack, wearing a sleek brown sweater and silk skirt discreetly patterned with pink and brown flowers. She accessorized the outfit with a wide, corsetlike brown belt and a pink ribbon pinned to her chest. She was going her own way again, not choosing the obvious, prescribed, politically correct pink jacket. She spoke passionately about cancer care, insurance difficulties, and the struggle that lay ahead with health care reform. She acknowledged the brave battles of individuals in the audience. Her empathy was especially palpable for one particular speaker who had repeatedly stumbled over her story, overcome with emotion. Alluding to the ever-present cameras, the

First Lady said, "I know it's hard to make a speech about something so personal in front of a whole lot of cameras." She addressed the survivors in front of her when she said, almost complicitly, "You know about uphill battles and beating the odds." She was, in many ways, telling her own story once again.

What struck me that day, amid the perfectly groomed topiaries and the sprigs of fragrant lavender in the small, private garden, was the effortless way Michelle Obama connected with the crowd, and the crowd with her. For many of us freedom, confidence, and self-possession are as much an aspiration as a fact—attributes of an identity we often seem to be reaching for but are never quite able to grasp. We look to icons of style because they embody the promise inherent in the power of style, which is the promise that we might connect to some fuller part of ourselves. To connect to others naturally and spontaneously is as pure an expression of style as you can find. And that's what struck me while watching the First Lady—how easy she made it all look. There was no sense that she was feigning sympathy with the women who had battled breast cancer; she interacted with them as gracefully as she did with the members of her staff, a group of young women who were as beautifully dressed as she was. She had even thrown a metaphorical arm around those shutterbugs up on their stepladders, wryly acknowledging their presence.

"This isn't about us," she said, looking down at the congress-women in their appropriate pink tweed suits. "This is about our daughters and our granddaughters."

The kids, the family, the generations, and that famous theme summed up in two words by the writer E. M. Forster: only connect. Michelle Obama, the mom in chief, always seemed to bring the conversation back to her family, a metaphor that can be endlessly widened from family to village to nation to world. I found myself thinking about how she had brought her own mother to the White

House to take care of her kids while she fulfilled her duties as the nation's hostess. And I thought of that unforgettable tableau from the inauguration when her children were beautifully dressed in those colorful J.Crew coats. It was one of many pictures where what she and her family were wearing was inseparable from the deep impression of the moment. Nena Ivon, Chicago's grande dame of fashion, had said if you wanted to know the essence of the First Lady's style, look at her kids, look at the impression she hoped to make on the future when she was no longer around. Style, my French friends also say, is something you have in you, a civilizing force that one generation transmits to the next. I thought of my own fiercely intellectual grandmother, dead six years now, who had a singular sense of style and a keen interest in fashion into her late eighties. She used to call me during Fashion Week with her critique of the clothes on the runways based on photos she had seen in the *New York Times*. My mother did the same thing. When I returned from a trip covering the collections in Paris or Milan, the phone would ring. "How are the clothes?" she would ask. The ritual query would make me impatient. I was too young to realize it was my mother's way of connecting to me, eager, like any mother, to close the distance between us. Oh sure she would cluck if my hair was too long, or my outfit wasn't right. She was always elegant and sophisticated, unafraid to express herself through her appearance. She had style inside her, it was second nature, a wordless language, and it wasn't until she died just a couple of summers ago that I finally understood how much of her life was expressed in its graces, or how much I had been taught without knowing I was in the midst of a lesson.

At the end of her speech, Michelle Obama hugged everyone on the podium, including the wife of her husband's vice president. Then she and Jill Biden stepped down onto the grass and moved toward the first row of chairs to greet the congresswomen. The crowd converged. The First Lady stood a full head above the fray.

She hugged and thanked almost every guest. "Thank you," she kept saying over and over again, sometimes leaning in to hear someone speaking to her, sometimes throwing her head back with a complicit laugh. She was always reaching out, her long graceful arms embracing women or touching their shoulder. Some women, too shy to push their way toward Michelle, merely gazed at her admiringly from a few rows back. She had a dignity and composure that seemed to make everyone stand up a little straighter. It was poignant to see how long she lingered, reaching out again and again with those enviably sculpted arms, restlessly closing the distance.

Above the fray: Part of Michelle Obama's innate sense of style is her ability to connect to people from all walks of life. At the Breast Cancer Awareness event she hosted in the Jacqueline Kennedy Garden in October 2009, the First Lady lingered, making sure to greet each guest.

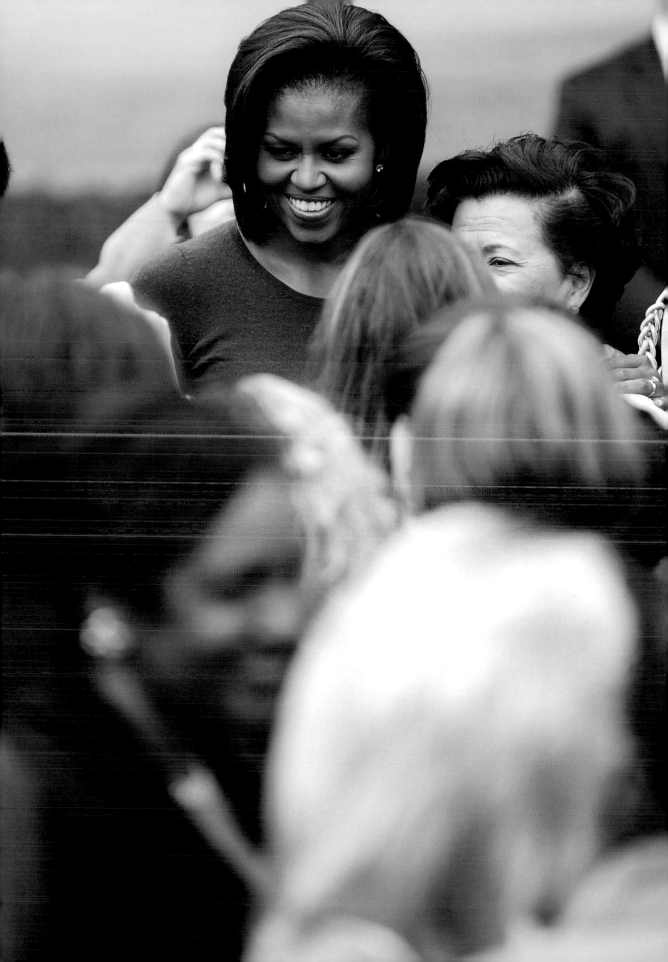

COLOR CODES

First Ladies tend to wear patriotic colors that are symbolic of their position, but to demonstrate her individuality Michelle Obama has chosen more complex colors. Pantone color expert **Leatrice Eiseman** peers through the prism of the First Lady's palette.

" REDS

Every color Michelle Obama has worn has been a good choice, which demonstrates the versatility of the colors she can wear. But of course it's those vibrant purple- and fuchsia-infused reds—the American Beauty reds—that are most spectacular on her.

YELLOW AND YELLOW-GREENS

The greenish yellows are the most difficult to wear because of lighting. As highly reflective colors they radiate back onto the skin, so people who have lighter skin tones almost seem to reflect that color when they wear it. Because Michelle has such beautiful contrast in her skin, she can wear greenish yellows better than most. She has this tremendous ability to wear a wide range of color. And she often wears unexpected colors, which broadens her appeal.

TURQUOISE

Turquoise is a universally flattering color. Many of the greens and turquoises look beautiful with her skin tone. The purples and the blue base colors are especially flattering. She has really dramatic coloring in that she's got such dark hair and dark brown eyes. Her beautiful skin tone looks good in the jewel tones.

PANTONE®
14-0848 TCX
Mimosa

PANTONE®
14-0848 TCX
Mimosa

PANTONE®
13-0633 TCX
Chardonnay

PANTONE®
13-0633 TCX
Chardonnay

PANTONE®
17-1558 TCX
Grenadine

PANTONE®
17-1558 TCX
Grenadine

PANTONE®
15-5519 TCX
Turquoise

PANTONE®
15-5519 TCX
Turquoise

yellow silk crepe sheath w/ draped collar

violet fabric covered skinny belt.

Below knee length.

PANTONE®
18-3943 TCX
Blue Iris

PANTONE®
18-3943 TCX
Blue Iris

PANTONE®
17-3628 TCX
Amethyst Orchid

PANTONE®
17-3628 TCX
Amethyst Orchid

PANTONE®
16-3118 TCX
Cyclamen

PANTONE®
16-3118 TCX
Cyclamen

PERIWINKLE

For those times when we need something that's a bit dependable but still has some happiness associated with it. The periwinkle shades have that touch of red which gives them some whimsy and sensuality. The minute you add reds to blues you're adding excitement and happiness, more optimism. It's a color that a lot of people relate to.

PURPLE

For some people purple is a stretch because it's a complex color. It is perceived as being meditative and spiritual when it leans to the blue side, or it can be sensual when it leans to red. Sometimes it's subliminal, but sometimes that's why people choose it.

BLACK

At one time it did have a severe and negative effect on people. But historically that started to change in the late 1970s and 1980s when the expression 'black is beautiful' came forward as part of the civil rights movement. That influence made us revere black as a color of beauty, and then another influence was the sophistication that came about during the Reagan administration—the black limos, black tuxes, black taffeta dresses. So the impression of black really changed through a lot of different contexts, and now you rarely associate black solely with grief or mourning or evil anymore. It is classic, sophisticated, and elegant.

WHITE

White certainly represents a cleansing of the palette. And for her inaugural gown it was the whole idea of purification and cleaning the slate. For that moment the psychological impact of white was huge.

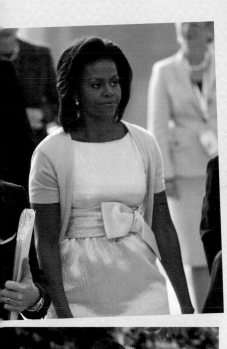

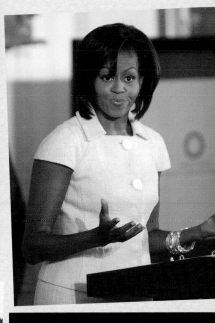

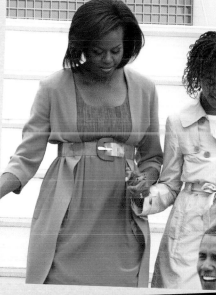
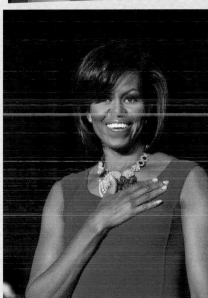

7 FIND YOUR SPOT, FIND YOUR PLACE

Like many women around the world who were watching Michelle Obama closely over the course of her first year in the White House, I began to feel very connected to her. Despite our differences in stature, race, and background, I could relate to some of her experiences as a working mom. The babysitter who cancels on the day of a big interview, the husband who leaves the butter out or, worse, his dirty socks, the nightly perusing of take-out menus. I knew all too well the frustrations that inevitably arise when you take on too much responsibility with kids and job, and I liked the fact that she was so open about her own doubts about having it all. Mostly, though, I felt connected to her through her love of fashion and her sense of humor about it. I loved that she wasn't afraid to experiment with her style and make mistakes. I loved that she wasn't beholden to fashion. But I kept wondering about what style meant to her and why it mattered so much.

Opening doors: In keeping with her inclusive style, Michelle has opened up the White House, inviting as many people in as possible. Here, she and the president await the arrival of Prime Minister Manmohan Singh of India and his wife, Mrs. Gursharan Kaur, for the Obamas' first state dinner in November 2009. *Page 206:* The First Lady joins a group of young women from her White House mentoring program as the White House curator delivers a quick lesson in diplomacy in the state dining room.

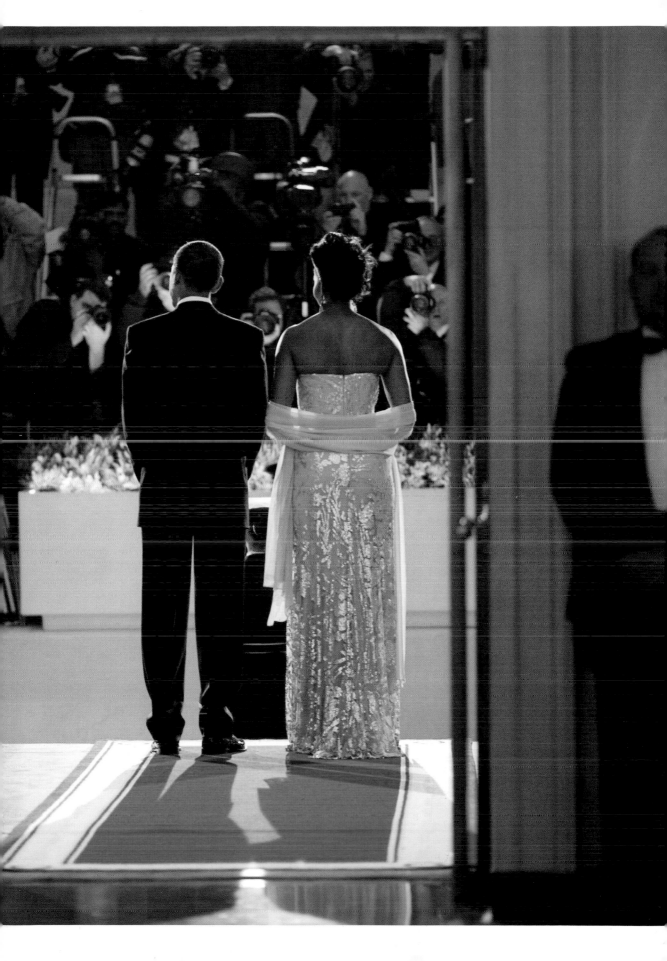

KATE BETTS

As she settled into her role as First Lady, finally choosing to "make her mark" as she put it, by focusing on the health issues surrounding childhood obesity, it became clearer to me how important style was to Michelle Obama's identity as an African American woman. But I didn't fully grasp what her style would mean to future generations of African American women until I went to a luncheon on a bitterly cold day in early January 2010 in honor of the publishing entrepreneur Eunice Johnson.

Johnson, as one guest at the luncheon put it, was Michelle Obama before Michelle Obama. Her love of fashion was one way in which she had inspired African American women, much like the First Lady. Eunice, along with her late husband, John H. Johnson, was the founder of the Johnson Publishing Company, home to *Ebony* and *JET* magazines. It was Eunice who had come up with the name *Ebony,* after the dark-grained wood. But her most memorable contribution to the company was the Ebony Fashion Fair, a traveling fashion show that she started in 1958 to raise money for a hospital in New Orleans. The idea was to bring high fashion to African American communities that never had access to such an exclusive world.

In the early days of the Fashion Fair, Johnson, herself a fashion icon, would travel from Chicago to New York and Paris to convince designers like Valentino, Yves Saint Laurent, and Oscar de la Renta to lend their most extravagant designs to the show. She wasn't interested in their everyday fashions—the beige suits and the little black dresses. She wanted the most extreme runway looks. Her goal was to celebrate African American beauty. She discovered and promoted African American models and encouraged designers to use them. She once told Valentino if he couldn't find any African American models for his runway, she would find them for him. With the Fashion Fair, she encouraged African Americans to express themselves through fashion, to use it as a means of personal valida-

tion. The shows, usually held on Sunday afternoons, were as much about the audience as they were about the models on the runway. Everyone who attended dressed up for the occasion. As her daughter, Linda Johnson Rice, said, "It really was about feeling beautiful about yourself and standing tall." When designers refused to lend her their clothes, Eunice would take out her checkbook and buy whatever creations interested her. Eventually she gained entrée to some of the most prestigious high-fashion houses. She had chutzpah and style. She got to know Yves Saint Laurent personally. Coco Chanel came to her home to donate looks for the Fashion Fair.

In 1973, frustrated by the lack of cosmetics available for darker skin tones, Eunice started Fashion Fair Cosmetics, one of the first makeup lines targeted specifically to African American women. Leontyne Price and Aretha Franklin appeared in the advertisements. The success of the line inspired big cosmetics companies like Revlon and Avon to introduce similar makeup.

At the tribute lunch, which was held in the Metropolitan Museum of Art's majestic Temple of Dendur, several pieces from Johnson's vast collection of clothing were displayed on mannequins, including a razzle-dazzle feathered headdress and sequined jumpsuit by Bob Mackie and a tiny, bright blue cropped vest and miniskirt by the 1960s French fashion renegade, André Courrèges. Some of the models Johnson had discovered and promoted through her fashion shows came to the lunch, too. Johnson herself was not there; she had died just the week before at the age of ninety-three. But her own style legacy lived on in her daughter, Linda, who now runs the family business and her granddaughter, Alexa, who was dressed in a beautiful violet Azzedine Alaïa dress. Desirée Rogers, the then White House social secretary, was on hand to read a statement from the president and the First Lady that said, "As a philanthropist and an entrepreneur, Eunice wrote a chapter in history." One of the First Lady's favorite designers, Isabel Toledo, arrived

in one of her own creations, a chic bronze herringbone tweed suit. The headline guest was former President Bill Clinton, a Johnson family friend from his days as governor of Arkansas. He swept in at the last minute and stepped up onto the podium to talk about how much the Johnson family had done for America. Saucily invoking his own reputation as a ladies' man, he recalled a story about walking Eunice down the church aisle at her husband's funeral in 2005 when she was eighty-eight. "I remember saying to myself, She is still an attractive woman." And then he turned serious, paused reflectively, and appeared to choke up with emotion. "Cosmetics may seem frivolous," he said, "but it's a very big deal. She has done an enormous amount to change the way African Americans see themselves and the way the world sees them."

Looking around at the women seated at the luncheon that day dressed in crisp, colorful suits, sleek, tailored dresses, and a few striking fur-trimmed jackets, I began to understand why style mattered so much to Michelle Obama, and why her emphasis on appearance as a means to pride was such a powerful example, especially to African American women. She was "regular," as Mellody Hobson had explained, not a pop star like Beyoncé or a supermodel like Naomi Campbell. Michelle had used her brains and her drive to get where hardly anyone thought she could. Appearance mattered, frivolous as it might be. It mattered not just for African American women but for all women; it mattered for everyone. It mattered because it was a way of projecting yourself into the world, of getting somewhere before you were actually there. Appearance harnessed a kind of magical faith—the faith of acting "as if." And now, just as Eunice Johnson had brought high fashion to low-income communities, and had given them a chance to experience the pleasure and the affirmation of a style that they otherwise would have never known, Michelle Obama had carried style and the implicit message of self-definition to sections of American

society and perhaps even to corners of the globe that had never encountered it.

In the early days of the Ebony Fashion Fair, Johnson had traveled around the country in a bus filled with models and clothes, sometimes contending with gas station owners who wouldn't allow her models to use the restrooms. Fifty years later, the civil rights movement had dismantled the most humiliating structures of segregation, but the subtler stigmas of race had not been extinguished. Speaking from the country's most prominent pulpit, the First Lady of the United States had taken up Johnson's gospel of self-empowerment and pride through style. She didn't talk about that gospel. She didn't have to. She embodied it. In the way she attended to her own appearance, in the self-evident display of her grace and poise, women could see what it meant in living color to take care of themselves, to reach beyond their circumstances, to aspire to standards, to stand tall.

I had always wondered why at almost every White House event Michelle Obama had included the kids in her mentoring program, students from local schools. They were on hand so frequently a cynical person might have thought the First Lady was deploying squadrons of young people to shield herself from the press. Busying herself speaking to a crowd of kids made it that much easier for her to duck questions from the journalists corralled behind the ropes. And yet how could anyone criticize her efforts to involve and educate the generation coming up? Their faces surely must have reminded her of herself when she was coming of age. Like her they were aspiring, hopeful, maybe a little daunted but still determined, and eager to see someone who looked like her in the places where they wanted to get to. Having seen the First Lady it wouldn't be such a stretch for many of the high school girls to imagine themselves in the White House.

A few months before the Eunice Johnson lunch I had gone

to the White House to cover Michelle Obama's first state dinner, a diplomatic affair that would be the First Lady's first foray into entertaining on a grand scale. Journalists from all over the world descended on the White House to hear about her preparations. The afternoon press gaggle was known among veteran correspondents as "plates and dishes," meaning the First Lady would explain things like why she chose a vegetarian menu for the Indian prime minister and what the significance might be of mixing Clinton State China Service with George W. Bush State China Service. The town was abuzz with guest list gossip—Steven Spielberg, David Geffen, and Republican Louisiana governor Bobby Jindal were on it—and intrigue about the new White House florist who had inadvertently jumped the gun on the East Wing when she announced her appointment on Facebook. Whoops.

Before the First Lady made her entrance at plates and dishes, twenty young women from the White House Leadership and Mentoring Program filed in and took their seats around tables covered in grass green shantung cloths. Most of the girls were dressed in neat khakis and polo shirts. Some were wearing Girl Scout vests. The First Lady came in through a side door and took her place at a podium set up under George Healy's 1869 portrait of Abraham Lincoln. She was radiant, aglitter in a silvery embroidered J.Crew cardigan, a silver skirt, and metallic silver kitten heels. She was dressed to stand out—to shine, literally—not just for the cameras in the room, but also for the girls seated in front of her. She wanted to give them the chance to experience the affirmation of style up close, to see it for themselves. She also wanted to teach them something about diplomacy, something that could help them see the bigger world, lift them out of their comfortable surroundings and force them into unfamiliar territory. She ditched the plates and dishes speech and talked instead about how she had visited eight countries so far as First Lady and how she had seen some amazing historical monuments on those visits—places that "compel us to see the

world through a broader lens." She was more inspired by people, she said, than by the pomp and circumstance of her visits. Quoting Mahatma Gandhi, she urged the girls, finally, to "be the change we wish to see in the world." She was using the occasion to capture her audience's attention and to show them that the world is much bigger than they realize. But she was also setting an example. She was taking Eunice Johnson's message of pride and self-confidence—the one she delivered to small towns around America—and projecting it onto the global stage.

Later that evening, when she and the president finally appeared at the top of the North Portico steps, the First Lady looked more like a movie star than a professor of diplomacy. There was nothing dowdy or shy or pompous about her liquid gold sequined strapless Naeem Khan dress. On her arm, a tangle of traditional Indian gold bangles were yet another tribute to her guests. All of her earnest talk about Gandhi and diplomacy and making connections with people of the world seemed a distant memory now on this most glamorous of red carpets.

Looking at the tableau of faces in front of that august backdrop—African American, Indian—I thought about how much Michelle Obama had already changed the notion of who the president or the First Lady might be ten, twenty, or thirty years from now. Could those girls sitting in the State Dining Room that afternoon really imagine being the First Lady someday? I thought about the young designers who designed clothes for Michelle—Thakoon, Isabel Toledo, Narciso Rodriguez, Jason Wu—and how profoundly their connection to her must have changed their view of America and its possibilities. Now they could imagine a First Lady who might be Thai-American or Cuban-American or Taiwanese-American. I thought of Azzedine Alaïa, who had said Michelle Obama's face—so intelligent and open—had opened the idea of America to the world again.

I thought about Naeem Khan, the Indian-born designer who

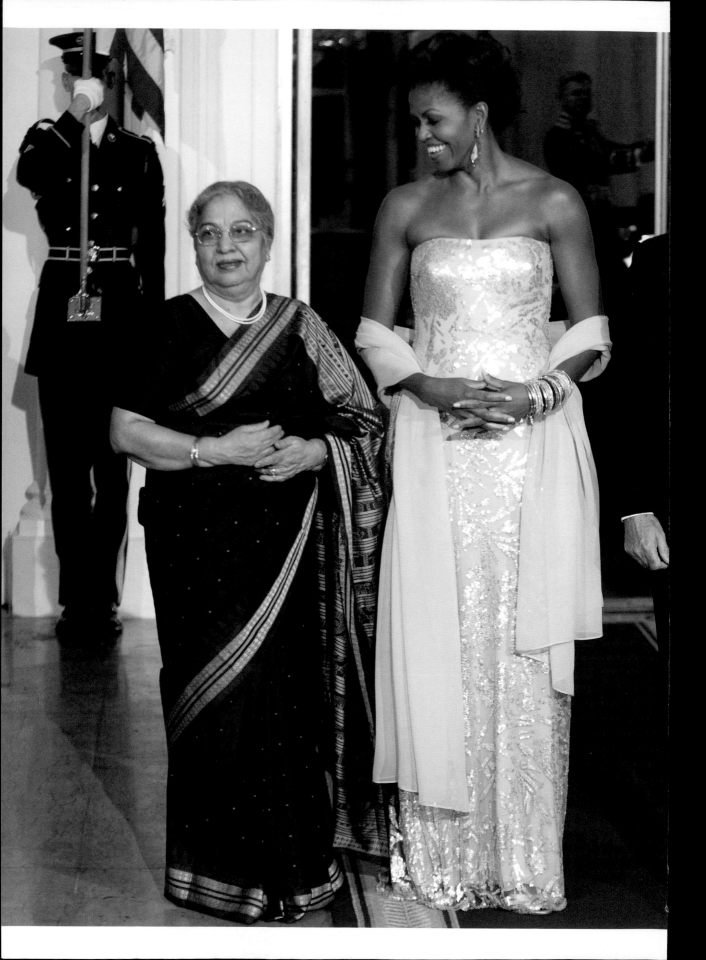

Welcome, *Namaste*: On the occasion of her first state dinner honoring the Indian prime minister and his wife, Michelle Obama wore a strapless sequined gown by Indian designer Naeem Khan. The designer, who learned about the First Lady's choice that night while watching television, said the news changed his life and made him "the son of India."

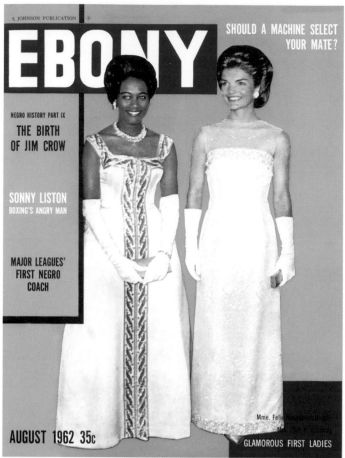

Fashion flair: *Ebony* magazine founder and publisher Eunice Johnson brought high fashion to African American communities that did not have access to it with her Fashion Fair runway shows. She also highlighted First Lady style on the cover of her magazine, including Jackie Kennedy in 1962 (*top*) and Michelle Obama in 2008 (*right*).

had made Michelle's gold dress, the third generation in a family of textile entrepreneurs. His father had started out penniless in Bareilly, a town north of Mumbai, and slowly built the business by working with European and American designers. Today his factory employs two thousand people, and their beadwork can be found on runways all over the world. Khan, who came to America in 1978 to study at FIT, had worked for Halston and represented his father's business in America before starting his own label six years ago. He had dressed famous people—Queen Noor, Jennifer Lopez, Taylor Swift—but none could compare to the First Lady and the kind of attention he would get for her gold strapless dress.

When I went to visit him in his Garment Center offices a week or so after the state dinner, Khan was still vibrating with excitement. "They kept saying 'Breaking news!' " He laughed, recalling the moment when he emerged from the shower in his Miami apartment to see on his television the tableau of Mrs. Obama in his dress receiving the Indian prime minister and his wife. "Brian Williams was talking about 'The Stunner' on the evening news!" For a few hours that evening his was the third most Googled name in America. The next day, headlines in newspapers all over the world made Khan instantly famous in India. His family was so happy about his success, his uncle in Bareilly came out of a ten-year depression. Michelle Obama's dress had made him the pride of his family and also of his country. "Now I am the son of India," he said, laughing. That one dress had connected him to something deeper in the American spirit, and it had connected him to his roots in India, too. Every dress tells a story, and this dress—made from hand-hammered silver sequins embroidered in India in a pattern inspired by an Andy Warhol poppy print—told the story of diplomacy between two countries and of style as a source of self-pride for so many different kinds of people around the world.

She was the quintessential American woman in every respect,

Following pages: Indian designer Naeem Khan created five dresses for the First Lady. He didn't know where or when she would wear them, but he had a specific idea in mind for her silver strapless dress, taking his cue from both Indian and American culture. His design mimics a sari in its shape and the fabric features a print inspired by a Warhol poppy painting traced in hand-hammered traditional Indian sequins.

not just the quintessential African American woman. She had used her style to set an example for African American women who understood how much pride and sense of self could be expressed through fashion. But she had also used style to define herself as an American on the world stage, to find her spot, as she would say. She reminded us that the foundations of American style—the self-possession, informality, and unimpeded confidence—were traits that any person of any race aspires to.

We were all ready for that.

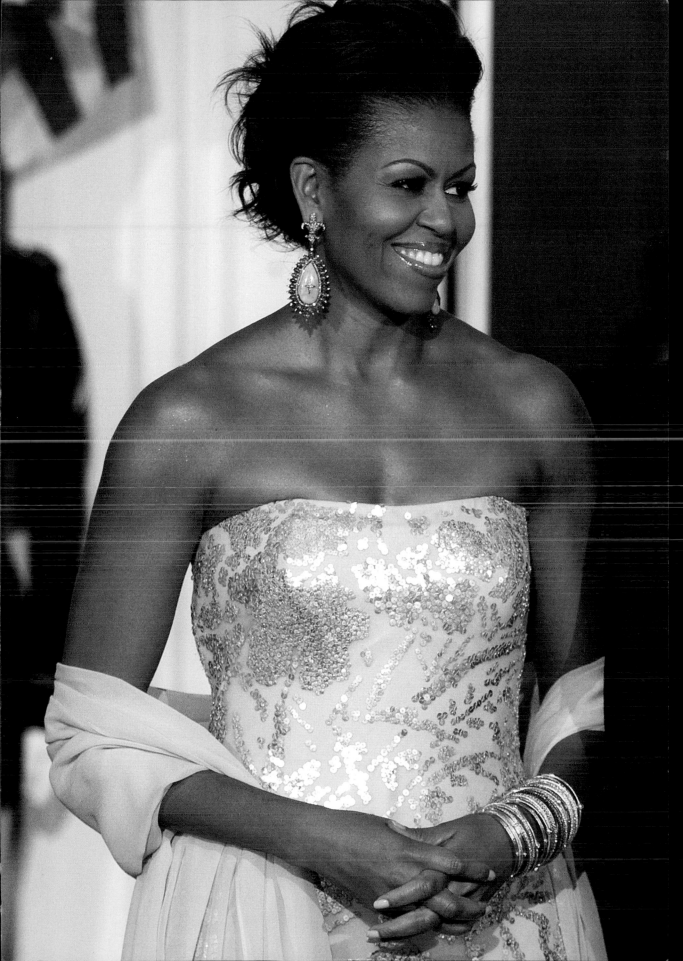

ACKNOWLEDGMENTS

Many people have contributed to this book in so many ways. I would like to thank, first, the fashion designers who shared with me so many of their experiences, ideas, and inspirations, particularly Narciso Rodriguez, Thakoon Panichgul, Isabel and Ruben Toledo, Jason Wu, Maria Pinto, Sophie Theallet, Jenna Lyons, Maria Cornejo, Azzedine Alaïa, Michael Kors, Isaac Mizrahi, Alber Elbaz, Arnold Scaasi, Karl Lagerfeld, Naeem Khan, Oscar de la Renta, Peter Soronen, Michael Smaldone, and Barbara Tfank. Also special thanks to those working alongside these designers who facilitated so many interviews, sketches, and relentless e-mails: Heather McAuliffe, Marysia Woroniecka, Hania Destelle, Anne Fahey-Storment, Meredith Paley, Steve Francour, Billy Daley, Jennifer Nilsson-Weiskott, Caroline Fabre-Bazin, Ellen Carey, Shaye Strager, Erika Bearman, and Danny Pfeffer.

Without the meticulous photo research and editing of Andrea Ferronato this book would not exist. I would also like to thank my colleagues at *Time*, particularly Rick Stengel, Ali Zelenko, Henry Connell, Andrea Dorfman, Paige Reddinger, Betsy Kroll, Mengly Taing, and Brian Fellows. I could never have navigated the Capitol without the help of Michael Duffy, Karen Tumulty, Michael Scherer, Geraldine Baum, Ann Marchant, Jason Weisenfeld, Lisa and Joel Benenson, and Lloyd Grove. In the First Lady's office Katie McCormick Lelyveld and Desirée Rogers gave me much needed guidance. In researching the history of America's First Ladies I learned a tremendous amount from interviews with Nancy Tuckerman, Ann Stock, Catherine Allgor, Carl Sferrazza Anthony, Valerie Steele, and John Fairchild. In researching Michelle Obama's history at Princeton and Harvard I am deeply grateful for the help

of Kenneth Bruce, Karen Jackson Ruffin, Patricia Cole-Green, Stacy Scott-McKinney, and Verna Williams. I had several guides in Chicago, who shared their unique perspectives on the city and its style, including Josh Patner, Seth Patner, Julia Cuddihy Van Nice, Mary Hutchings Reed, Mellody Hobson, Nena Ivon, Jesse Garcia, and Joe Lupo. Many women enlightened me with their observations on women and style, particularly Alexandra Lebenthal, Veronica Chambers, Beverly Smith, Elizabeth Berger, Nancy Gibbs, and Bethann Hardison.

For their invaluable help with visuals, thanks to Patrick Demarchelier, Stephen Lewis, Becky Lewis, Bruno Grizzo, Bill Rancitelli, Joni Cohen, Carole Tanenbaum, Tamara Mellon, Caroline Berthet, Erickson Beamon, Pieter Erasmus, Kelly Vitko, Lenora Cole Alexander, Vickie Wilson, Vinessa Erminio, Pascal Dangin, Giovanna Pugliese, Steve Andrascik, and Tom Tavee. Leatrice Eiseman of Pantone provided me with her unique perspective on color.

So many of my friends helped me in myriad ways, offering much needed advice, guidance, and support, but I would especially like to thank Andrea Topper, Lisa Podos and Mike Wais, Natasha Fraser-Cavassoni, Marion Hume, Carlyne Cerf, Kitty Benedict and Foxy Jones, Katie Sisson, Farnaz Voussoughian, Marcy Granata, Stephanie and John Golfinos, Bibiane and Antoine Deschamps, Stephanie and Chris Clark, James Scully, Lisa Pomerantz, Elaine Griffin, Stephanie Hamada, Alexandra Trower, Elsa Walsh and Bob Woodward, Warner Johnson, Michael Boodro and Robert Pini, Linda and David Maraniss, Tina Brown, Diane von Furstenberg, Kristina Zimbalist, Timothy Rogers, Camille Sanabria, and Rory Tahari. My family has also been endlessly supportive, especially my father, Hobart Betts, my sister and brother, Liz and Will Betts, and my in-laws, Claire and Sandy Brown. I will always be indebted to two women who are like family to me: Yvonne Rose and Norki Khandu.

My agent, David Kuhn, deserves abundant credit for conceiving the idea for this book. His two associates, Billy Kingsland and Jessi Cimafonte, were also incredibly helpful. The team at Clarkson Potter, especially Lauren Shakely and my editor, Doris Cooper, patiently and deftly guided me every step of the way. I also thank Angelin Borsics for her support and Marysarah Quinn and Stephanie Huntwork for their beautiful design work.

I could not have written this book without the three great loves of my life: my children, Oliver and India Brown, and my brilliant husband, Chip Brown.

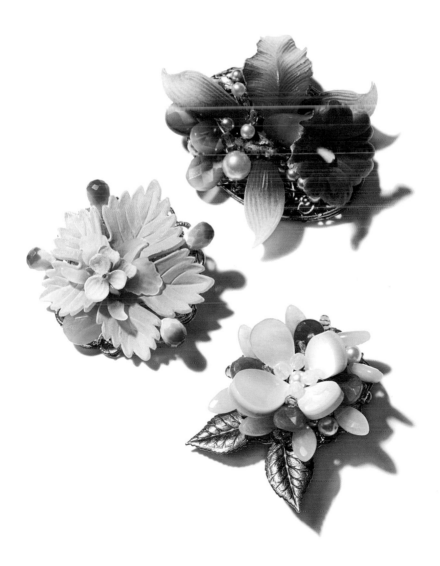

NOTES

1: FIRST IMPRESSIONS

3 *As Obama senior adviser*: Lauren Collins, "The Other Obama: Michelle Obama and the Politics of Candor," *The New Yorker*, March 10, 2008.

3 New York Times *columnist*: Maureen Dowd, "She's Not Buttering Him Up," *New York Times*, April 25, 2007.

3 *"For the first time"*: From Michelle Obama's speech delivered in Milwaukee, Wisconsin, on February 18, 2008.

4 *The syndicated columnist Cal*: From Cal Thomas's appearance on Fox News on June 14, 2008.

4 *Her approval rating lingered*: From a Gallup poll, May 30–June 1, 2008.

7 *At the end of*: From the author's interview with Oscar de la Renta on June 9, 2009.

10 *She told* Marie Claire: Abigail Pesta, "Michelle Obama Keeps It Real," *Marie Claire*, October 2008.

10 *She traded fashion tips*: From Michelle Obama's appearance on *The View*, June 18, 2008.

10 *She danced to Rihanna's*: From Michelle Obama's appearance on *The Ellen DeGeneres Show* on September 8, 2008.

12 *It was at exactly*: From Michelle Obama's appearance on *The Tonight Show* with Jay Leno on October 27, 2008.

12 *At the end of August*: From a Gallup poll, September 5–7, 2008.

12 *Her husband's advisers had known*: Michael Powell and Jodi Kantor, "Michelle Obama Is Ready for Her Close Up," *New York Times*, June 18, 2008.

12 *"With Michelle, it's about"*: From the author's interview with Maria Pinto on January 6, 2009.

13 *She kept everyone guessing*: From the author's interview with Narciso Rodriguez on May 13, 2008.

13 *One blogger said the dress*: From a *USA Today* online poll, November 5, 2008.

18–19 Information on paste jewelry comes from M. D. S. Lewis, *Antique Paste Jewellry* (London: Faber & Faber, 1970), as well as Clare Phillips, *Jewelry: From Antiquity to Present* (New York: Thames and Hudson, 1996).
The origins of the name *strass* differ. Some sources trace it back to the Viennese goldsmith Joseph Strasser who invented the technique in 1758, while other sources reference the French jeweler Georges Frédéric Strass who was appointed court jeweler by Louis XV in 1734.

2: STYLE VERSUS SUBSTANCE

21 *Some arrive at the White House*: Carl Sferrazza Anthony, *First Ladies*, vol. 2, *The Saga of the Presidents' Wives and Their Power, 1961–1990* (New York: William Morrow, 1991), 109.

22 *"I was asking the"*: Hillary Rodham Clinton, *Living History* (New York: Scribner, 2003), 111.

22 *Frugal, recession-savvy Rosalynn*: From the National First Ladies Library biography of Rosalynn Carter.

22 *Even when they hide*: Rachel L. Swarns, "Old Standards with Modern Flourishes as the Obamas Host First State Dinner," *New York Times*, November 24, 2009.

25 *According to some historians*: Carl Sferrazza Anthony, *First Ladies: The Saga of the Presidents' Wives and Their Power, 1789–1961* (New York: William Morrow, 1990), 48.

25 *Her white muslins and*: From the author's interview with Catherine Allgor on August 13, 2009.

27 *She invited artists, writers*: Barbara Silberdick Feinberg, *America's First Ladies: Changing Expectations* (New York: Franklin Watts, 1998), 20.

27 *She emulated the slinky*: Noel B. Gerson, *The Velvet Glove: A Life of Dolley Madison* (Nashville: Thomas Nelson, Inc., 1975), 93.

27 *Josephine Bonaparte, in turn*: Ibid., 125.

27 *"Her style mixed a kind"*: From the author's interview with Catherine Allgor on August 13, 2009.

27 *She dressed according to her own*: Gerson, 80.

28 *It's widely believed that*: Paul F. Boller Jr., *Presidential Wives: An Anecdotal History*, second edition (New York: Oxford University Press, 1998), 36.

28 *She splurged on grand*: Feinberg, 34.

28 *She tried to justify*: Ibid., 33.

28 *One season she had*: Ibid.

28 *During her husband's campaign . . . "absurd costumes"*: Boller, 113.

30 *The president had known*: Ibid., 167.

30 *But Cleveland waited until*: Ibid.

30 *The intrigue meant that*: Anthony, 253.

30 *Impressed by Frankie's popularity*: Feinberg, 38.

30 *Women copied what she wore*: Anthony, 253.

30 *They even mimicked her*: Ibid., 263.

30 *Although she never spoke*: Maurine H. Beasley, *First Ladies and the Press: The Unfinished Partnership of the Media Age* (Evanston, Ill.: Northwestern University Press, 2005), 56.

30 *"She came to the"*: From the author's interview with Carl Sferrazza Anthony on August 19, 2009.

31 *One such visitor, Will Rogers*: Boller, 260.

32 *She invited famous musicians*: Carl Sferrazza Anthony, *As We Remember Her: Jacqueline Kennedy Onassis in the Words of Her Family and Friends* (New York: HarperCollins, 1997), 168.

32 *Raymond Loewy, the industrial*: Pamela Keogh, *Jackie Style* (New York: HarperCollins, 2001), 108.

32 *She knew fashion*: Ibid., 29.

32 *As Nancy Tuckerman*: From the author's interview with Nancy Tuckerman on June 27, 2009.

33 *She continued the habit*: The Metropolitan Museum of Art exhibition catalogue, *Jacqueline Kennedy: The White House Years: Selections from the John F. Kennedy Library and Museum* (New York: Bullfinch Press, 2001), 28.

33 *"I always thought of her"*: Oleg Cassini, *A Thousand Days of Magic: Dressing Jacqueline Kennedy for the White House* (New York: Rizzoli, 1995), 38.

33 *She boated down the Ganges*: Anthony, *As We Remember Her*, 153.

33 *She greeted crowds in*: C. David Heymann, *A Woman Named Jackie: An Intimate Biography of Jacqueline Bouvier Kennedy Onassis* (New York: Lyle Stuart, 1989), 350.

36 *Nancy Tuckerman remembers*: From the author's interview with Nancy Tuckerman on June 27, 2009.

36 *There were Jackie Barbie dolls*: Anthony, *As We Remember Her*, 133.

36 *The fashion critic Hebe*: Heymann, *A Woman Named Jackie*, 269.

37 *"Modern politics is mostly"*: From the author's interview with Catherine Allgor on August 13, 2009.

37 *Mamie Eisenhower had her*: Anthony, *First Ladies*, vol. 2, 553; Georgia Dullea, "To Hillary Clinton, Or Occupant," *New York Times*, November 15, 1992.

37 *Steeped in the royal ambience*: Anthony, *First Ladies*, vol. 2, 321.

37 *The pampered social-climbing*: Kurt Andersen, "Co-Starring at the White House," *Time*, January 14, 1985.

37 *Questions were raised about*: Ed Magnuson, "Why Mrs. Reagan Still Looks like a Million," *Time*, October 24, 1988.

39 *"Remember, she came in"*: From the author's interview with Carl Sferrazza Anthony on August 19, 2009.

39 *"She has not advanced"*: Andersen, "Co-Starring at the White House."

39 *She cared about style enough*: Blanche Wiesen Cook, *Eleanor Roosevelt*, vol. 2, *The Defining Years, 1933–1938* (New York: Penguin Books, 2000), 14.

42 *Her signature touch*: From the author's interview with Carl Sferrazza Anthony on August 19, 2009.

42 *In the White House*: Cook, 290.

42 *and going so far as*: Ibid., 40.

42 *She was appointed deputy*: Boller, 298.

42 *She received a staggering*: Ibid., 293.

43 *Typical of many was*: Ibid., 296.

43 *Mamie Eisenhower famously said*: Kati Marton, *Hidden Power: Presidential Marriages That Shaped Our History* (New York: Anchor Books, 2001), 104.

43 *Pat Nixon was careful*: Anthony, *First Ladies*, vol. 2, 166.

43 *She worked to realize*: Ibid., 188.

43 *She also traveled*: Bonnie Angelo, "Pat Nixon: The Woman in the Cloth Coat," *Time*, July 5, 1993.

44 *She was an ex-dancer*: Anthony, *First Ladies*, vol. 2, 251.

44 *She loved to entertain*: Ibid., 225.

44 *She told Barbara Walters*: Beasley, 125.

45 *"The White House serves"*: From the author's interview with Ann Stock on August 31, 2009.

45 *Rosalynn Carter famously placated*: "Rosalynn: So Many Goals," *Time*, January 10, 1977.

45 *Then she got to work*: Anthony, *First Ladies*, vol. 2, 285.

45 *She campaigned for her*: Ibid., 308.

45 *In the fall of*: Ibid., 314.

45 *She became the first*: Ibid., 294.

45 *"I could never sit"*: "Rosalynn: So Many Goals," *Time*, January 10, 1977.

45 *"Image became a nuisance"*: Rosalynn Carter, *First Lady from Plains* (Boston: Houghton Mifflin, 1984), 183.

46 *Questioned during the campaign*: Response to a reporter's questions on March 16, 1992, and reported on "Making Hillary an Issue," *Nightline*, March 26, 1992.

46 *By not getting it*: Marian Burros, "Hillary Clinton Asks Help in Finding a Softer Image," *New York Times*, January 10, 1995.

48 *"You have to be you"*: Elizabeth Kolbert, "How Hillary Set Out to Master the Senate," *The New Yorker*, October 13, 2003.

48 *In one of her first*: Marian Burros, "Hillary Clinton's New Home: Broccoli's in, Smoking's Out," *New York Times*, February 2, 1992.

48 *"As a mother, wife"*: Maria L. La Ganga, "It's All About Priorities for Michelle Obama," *Los Angeles Times*, August 22, 2007.

49 *"In Dolley Madison's day . . . allowed to be a mom"*: From the author's interview with Catherine Allgor on August 13, 2009.

51 *"When we had the"*: Ibid.

51 *Dolley Madison was criticized*: Ibid.

52 *Jackie Kennedy's iconic sleeveless*: Naomi West and Catherine Wilson, *Jackie Handbook* (London: MQ Publications, 2005), 144.

52 *Over a century earlier*: Anthony, *First Ladies*, vol. 1, 264.

52 *"The rules of the game"*: From the author's interview with Ann Stock on August 31, 2009.

3: THE DRESSMAKERS' DETAILS

64 *Fashion was "on the back burner"*: From the author's telephone interview with Katie McCormick Lelyveld on January 13, 2009.

64 *Back in November, ten*: From the author's interview with Jason Wu on June 16, 2009.

66 Information on the dressmaker Ann Cole Lowe comes from Rosemary E. Reed Miller's book, *The Threads of Time, The Fabric of History: Profiles of African American Dressmakers and Designers from 1850 to the Present*, 3rd ed. (Washington, D.C.: Toast and Strawberries Press, 2007).

67 *Her consigliere was*: Wendy Donahue, "How Ikram Goldman Became Michelle Obama's Closest Fashion Adviser," *Chicago Tribune*, February 25, 2009.

67 *Goldman's expertise lay in*: From the author's interview with Mellody Hobson on September 23, 2009.

67 *A fixture in the front row*: Donahue, "Michelle Obama's Closest Fashion Adviser."

67 *To further accommodate her*: Ibid.

68 *One such client, Michelle*: Ibid.

68 *And as Michelle's public*: From the author's interview with Thakoon Panichgul on June 17, 2009.

68 *(the one her husband refers . . .)*: Marian Burros, "Mrs. Obama Speaks Out about Her Household," *New York Times*, March 21, 2009.

68 *Apart from Rodriguez and Toledo*: From the author's interviews with Narciso Rodriguez on May 13, 2009, and Isabel Toledo on July 15, 2009.

69 *She knew what she*: From the author's interview with Thakoon Panichgul on June 17, 2009.

69 *She was, after all*: Nancy Gibbs and Michael Scherer, "The Meaning of Michelle Obama," *Time*, May 21, 2009.

69 *"You know she likes"*: From the author's interview with Thakoon Panichgul on June 17, 2009.

72 *Rodriguez, another designer . . . but not uptight*: From the author's interview with Narciso Rodriguez on May 13, 2009.

72 *Meanwhile, Toledo who . . . less than two weeks*: From the author's interview with Isabel Toledo on July 15, 2009.

72 *"At first they said . . . layers do that"*: Ibid.

77 *The only caveat . . . the traditional and the new*: From the author's interview with Jason Wu on June 16, 2009.

79 *Goldman also solicited . . . a vintage Dior dress*: From the author's interview with Peter Soronen on July 15, 2009.

79 *Both designs played to*: Ibid.

79 *Instead she called Wu . . . embroiderers in India*: From the author's interview with Jason Wu on June 16, 2009.

79 *When the dress was . . . were doing for her*: Ibid.

80 *On Wednesday, November 26 . . . lost Wu's luggage*: Ibid.

80 *Then on the evening . . . an official ball*: Ibid.

81 *a dress that she would*: From remarks made by Michelle Obama at the unveiling of the inaugural gown at the Smithsonian in Washington, D.C., on March 9, 2010.

81 *"I thought, Oh my God . . . for a long time"*: From the author's interview with Jason Wu on June 16, 2009.

82 *The street outside Toledo's*: From the author's interview with Isabel Toledo on July 15, 2009.

82 *Wu became so famous . . . the door downstairs*: From the author's interview with Jason Wu on June 16, 2009.

82 *His store orders tripled . . . even knowing her*: Ibid.

83 *"I don't think there's"*: From the author's interview with Narciso Rodriguez on May 13, 2009.

83 *"She is someone with authority"*: From the author's interview with Thakoon Panichgul on June 17, 2009.

86 *Goldman got her start*: Donahue, "Michelle Obama's Closest Fashion Adviser."

86 *Weinstein was one of*: Trish Donnally, "The Ultimo Dynamo," *San Francisco Chronicle*, March 20, 1997.

86 *In one famous story*: Ibid.

86 *"If you look it"*: From the author's interview with Jesse Garza on September 17, 2009.

86 *"We didn't sell pieces"*: Ibid.

87 *In addition to Garza*: Ibid.

87 *Weinstein quit the business*: Donahue, "Michelle Obama's Closest Fashion Adviser."

87 *Mellody Hobson, president of*: From the author's interview with Mellody Hobson on September 23, 2009.

87 *"She'll say, 'You won't . . . trust her implicitly'"*: Ibid.

87 *"Ikram is so respectful"*: From the author's interview with Thakoon Panichgul on June 17, 2009.

87 *"It's not a store for"*: Ibid.

4: THE EVERYDAY ICON

92 *Then again, from the Puritan*: The exact de Tocqueville quotation from *Democracy in America*, vol. 1 (1835), is in chapter 3, part 1: "But one also finds in the human heart a depraved taste for equality, which impels the weak to want to bring the strong down to their level, and which reduces men to preferring equality in servitude to inequality in freedom."

93 *Betty Spence, the founder*: Betty Spence, "How We Talk About Women," *Women's Voices for Change*, January 16, 2007.

94 *In the early 1970s*: Gail Collins, *When Everything Changed: The Amazing Journey of American Women from 1960 to the Present* (New York: Little Brown and Company, 2009), 252.

94 *Unhappy with the pace*: Madeleine Albright, *Read My Pins: Stories from a Diplomat's Jewel Box* (New York: HarperCollins, 2009), 86.

95 *"Dominatrix!" wrote Robin Givhan*: Robin Givhan, "Condoleezza Rice's Commanding Clothes," *Washington Post*, February 25, 2005.

96 *"Oh my God," Cindi Leive*: Jodi Kantor, "Michelle Obama Goes Sleeveless, Again," *New York Times*, February 25, 2009.

98 *She seems to have harnessed*: "Interview with Karl Lagerfeld," *ELLE*, October 2009.

99 *When one of the*: From Robin Roberts's interview with Michelle Obama on ABC News' *Good Morning America*, March 13, 2009.

101 *As one Paris-based designer*: From the author's interview with Azzedine Alaïa on July 3, 2009.

101 *"You don't go to"*: Bridget Foley, "Dressing Michelle: Major Designers Wait for First Lady's Call," *Women's Wear Daily*, April 2, 2009.

106 *Not surprisingly, the French*: Axel Madsen, *Chanel: A Woman of Her Own* (New York: Henry Holt, 1990), 292.

113 *"Fashion has become just"*: From the author's interview with Isaac Mizrahi on June 9, 2009.

115 *"It was just about"*: From the author's interview with Thakoon Panichgul on June 17, 2009.

117 *"The old kind of"*: From the author's interview with Oscar de la Renta on June 9, 2009.

118 *"She's kind of amazing"*: From the author's interview with Jenna Lyons on June 8, 2009.

118 *"Because she is not"*: From the author's interview with Thakoon Panichgul on June 17, 2009.

119 *"I used to dread . . . willing to make a mistake"*: From the author's interview with Michael Kors on August 5, 2009.

122 *Even the most intrepid*: The Metropolitan Museum of Art exhibition catalogue, *Jacqueline Kennedy: The White House Years: Selections from the John F. Kennedy Library and Museum* (New York: Bullfinch Press, 2001), 28.

5: WELCOME TO THE WHITE HOUSE

141 *Her chief of staff*: Lois Romano, "A First Lady Who Demands Substance," *Washington Post*, June 25, 2009.

145 *In so many ways*: Hillary Clinton, *Living History* (New York: Scribner, 2003), 119.

145 *At the same time*: Oprah Winfrey, "The Oprah Interview," *O, The Oprah Magazine*, February 2009.

146 *Historically it has always*: Dominic A. Pacyga, *Chicago: A Biography* (Chicago: Chicago University Press, 2009), 204.

146 *"They wanted a uniform"*: From the author's interview with Maria Pinto on September 22, 2009.

147 *Ivon, who has worked*: From the author's interview with Nena Ivon on September 21, 2009.

147 *One of his best*: From the author's interview with Seth Patner on September 21, 2009.

148 *On the way, Patner*: Ann Durkin Keating, *Chicago Neighborhoods and Suburbs: A Historical Guide* (Chicago: The University of Chicago Press, 2008), 51.

148 *Despite the uneven quality*: From Michelle Obama's speech delivered on October 2, 2009, in Copenhagen, Denmark, before the International Olympic Committee.

148 *She played Monopoly*: Lauren Collins, "The Other Obama: Michelle Obama and the Politics of Candor," *The New Yorker*, March 10, 2008.

148 *She was a smart kid*: Sandra Sobieraj Westfall, "Michelle Obama: This Is Who I Am," *People*, June 18, 2007.

148 *But it wasn't always easy*: Christi Parsons, Bruce Japsen, and Bob Secter, "Barack's Rock," *Chicago Tribune*, April 22, 2007.

148 *"I heard that growing up"*: From Michelle Obama's speech delivered on March 19, 2009, to students from Anacostia Senior High School, Washington, D.C.

149 *She was elected class*: Collins, "The Other Obama."

149 *She was exposed to*: Karen Springen, "First Lady in Waiting," *Chicago Magazine*, October 2004.

149 *She excelled academically, taking*: Liza Mundy, *Michelle* (New York: Simon & Schuster, 2009), 57.

149 *He had been recruited*: Peter Slevin, "Mrs. Obama Goes to Washington," *Princeton Alumni Weekly*, March 18, 2009.

149 *Craig introduced her to*: From the author's interview with Stacy Scott-McKinney on January 30, 2010.

149 *At the time only*: Slevin, "Mrs. Obama Goes to Washington."

150 *She socialized at the*: From the author's interview with Stacy Scott-McKinney on January 30, 2010.

150 *Michelle spent a lot*: Mundy, 71.

150 *But in her thesis*: Michelle Obama, "Princeton Educated Blacks and the Black Community" (Bachelor of Arts thesis, Princeton University, Department of Sociology, 1985), 2.

150 *"There was not a large"*: From the author's interview with Karen Jackson Ruffin on November 25, 2009.

150 *Like most students, Michelle*: From the author's interview with Stacy Scott-McKinney on January 30, 2010.

151 *"She showed me around"*: From the author's interview with Patricia Cole-Green on March 10, 2010.

151 *The fashion shows . . . writing a thesis*: From the author's interview with Karen Jackson Ruffin on November 25, 2009.

151 *She got her law degree*: Charles Ogletree, "Reflections from an Obama Mentor," *Modesto Bee*, January 21, 2008.

152 *She has said that*: From remarks by Michelle Obama at the Florida Campus Compact Awards Gala in Miami, Florida, on October 15, 2009.

152 *"She'd sit there as an associate"*: From the author's interview with Mary Hutchings Reed on September 21, 2009.

152 *"She stood in"*: Ibid.

152 *Barack would later write*: Barack Obama, *The Audacity of Hope* (New York: Vintage Books, 2008), 388.

154 *They moved into a*: Collins, "The Other Obama."

154 *After three years at Sidley*: Geraldine Brooks, "Michelle Obama and the Roots of Reinvention," *More*, October 2008.

154 *Later she went to work*: Springen, "First Lady in Waiting."

154 *She has attributed her*: Ibid.

154 *She has said that*: From remarks by Michelle Obama at the Florida Campus Compact Awards Gala in Miami, Florida, on October 15, 2009.

154 *She was also inspired by*: Brooks, "Michelle Obama and the Roots of Reinvention."

154 *Politics was not something*: From Soledad O'Brien's interview with Michelle Obama on CNN's *This American Morning* on February 1, 2008.

154 *In* The Audacity of Hope: Obama, *The Audacity of Hope*, 401.

159 *"A lot of women relate"*: From the author's interview with Maria Pinto on September 22, 2009.

159 *"I wake up every morning"*: From Michelle Obama's speech at a Women for Obama lunch in Chicago on July 28, 2008.

160 *Her boss, Susan Sher*: Sobieraj Westfall, "Michelle Obama: This Is Who I Am."

160 *And Traditional Michelle*: Verna L. Williams, "The First (Black) Lady," *Denver University Law Review* 86 (2009): 833.

160 *After all, this is*: From remarks by Michelle Obama at a Workplace Flexibility conference on March 31, 2010.

161 *Her mother told* People: Sobieraj Westfall, "Michelle Obama: This Is Who I Am."

161 *"I am a mother first"*: From an interview with CNN's Soledad O'Brien on February 1, 2008.

161 *When she told Gwen*: Gwen Ifill, "Beside Barack," *Essence*, September 2007.

164 *"We've seen the person . . . sixteen-year-old girls"*: From the author's interview with Mellody Hobson on September 23, 2009.

167 *"When I was young"*: Ibid.

167 *"Now many young boys and girls"*: From Michelle Obama's speech delivered at Emancipation Hall on April 28, 2009.

169 *"She epitomizes that thing"*: From the author's interview with Veronica Chambers on May 6, 2010.

169 *She traveled the country*: Michelle Obama, "Michelle on a Mission," *Newsweek*, March 22, 2010.

180–181 Information about the history of pearls comes from Fred Ward, *Pearls*, 3rd edition (Malibu, Calif.: Gem Book Publishers, 2002).

6: ONLY CONNECT

192 *Lyons recently received a*: "Jenna Lyons Awarded $1 Million Cash Bonus," *Women's Wear Daily*, October 30, 2009.

192 *"If no one broke the rules . . . That's hard to do"*: From the author's interview with Jenna Lyons on June 8, 2009.

193 *"Things have to change . . . incredibly smart"*: Ibid.

195 *Prompted by the same*: Charles Blow, "The Magic of Michelle," *New York Times*, October 23, 2009.

198 *"I know it's hard"*: From Michelle Obama's remarks in honor of Breast Cancer Awareness Month on October 23, 2009.

7: FIND YOUR SPOT, FIND YOUR PLACE

210 *Eunice, along with her*: Dennis Hevesi, "Eunice Johnson Dies at 93, Gave Ebony Its Name," *New York Times*, January 9, 2010.

210 *It was Eunice who*: Ibid.

210 *But her most memorable*: Ibid.

210 *In the early days . . . designers to use them*: From a videotaped interview with Eunice Johnson on www.Ebonyfashionfair.com.

210 *She once told Valentino*: Hevesi, "Eunice Johnson Dies at 93."

211 *The shows, usually held . . . standing tall*: From remarks given by Linda Johnson Rice at the tribute lunch for Eunice Johnson on January 11, 2010.

211 *She got to know Yves*: From a videotaped interview with Eunice Johnson on www.Ebonyfashionfair.com.

211 *In 1973, frustrated by*: Hevesi, "Eunice Johnson Dies at 93."

211 *Desirée Rogers, the then White House*: From the presentation of proclamations delivered by Desirée Rogers at the tribute luncheon for Eunice Johnson on January 11, 2010.

212 *"I remember saying to"*: From remarks made by President William J. Clinton at the tribute lunch for Eunice Johnson on January 11, 2010.

213 *In the early days*: From a video celebrating Eunice Johnson presented at the tribute lunch for Eunice Johnson on January 11, 2010.

214 *She ditched the plates*: From remarks made by Michelle Obama at the Indian State Dinner press preview on November 24, 2009.

215 *I thought about Naeem . . . gold strapless dress*: From the author's interview with Naeem Khan on December 16, 2009.

219 *"They kept saying 'Breaking'"*: Ibid.

219 *For a few hours*: From Google trends on the evening of November 24, 2009.

219 *His family was so*: From the author's interview with Naeem Khan on December 16, 2009.

INDEX

Note: Page numbers in *italics* refer to illustrations.

Abzug, Bella, 94
Adams, Abigail, 33, 60
Adolfo, 37
Akris Punto, 94
Alaïa, Azzedine, 68, 101, 126, 127, 190, 211, 215
Albright, Madeleine, 94–95
Allgor, Catherine, 27, 49, 51
Anthony, Carl Sferrazza, 31, 39
Armani, Giorgio, 86

Bacall, Lauren, 107
Baker, Josephine, 107, 109, *109*
Bardot, Brigitte, 178
Beckham, Victoria, 112, 113
Beyoncé, 212
Biden, Jill, 122, *123*, 196, 197, 199
Binns, Tom, jewelry, 10, *11*, 68, 181
Bonaparte, Josephine, 27
Boudin, Stéphane, 32
Bourguiba, Habib, 62
Bruni, Carla, *104*, 105, 115, 130, *131*
Bush, Barbara, 7, 23, 37, 46, *56*, 57, 64, *65*, 181, 184
Bush, George W., 102, 191
Bush, Laura, 7, 22, 54, 56, *61*, 62, 63, 64, *65*, 96, 184

Calderón, Felipe, 175
Campbell, Naomi, 167, 212
Cardigans, *8*, 9, *9*, 125, 178, *179*, 194–95
Carter, Jimmy, 178
Carter, Rosalynn, 22, 40, *41*, 45–46, 161
Cassini, Oleg, 33, 35, 66, 122

Chambers, Veronica, 169
Chanel, Coco, 106–7, 181, 211
Choo, Jimmy, 68, 101, 125, 160
Cleopatra, 107, 180
Cleveland, Frances, 22, *26*, 27, 30
Clinton, Bill, 212
Clinton, Hillary, 7, 21, 24, 45, 46, *47*, 48–49, 51, *51*, 52, *52*, 54–55, *55*, *61*, 64, *65*, 96, 117, 145, 152, 160, 161, 167, 184
Cole-Green, Patricia, 151
Colors, 202–5
Constable, Arnold, 39
Coolidge, Grace, 28, *29*, 30–31, 60
Cornejo, Maria, 87
Courrèges, André, 211
Cyrus, Miley, 113

Daley, Richard, 137, 154
Dandridge, Dorothy, *108*, 109
Dean, James, 107
DeGeneres, Ellen, 10
de la Renta, Oscar, 7, 21, 54–55, 64, 66, 101, 118, 189, 210
Democratic National Convention, 12, 13, 14, *14*, *15*, 142, *143*
Diana, Princess of Wales, 59, 107
Diaz, Cameron, 114
Dorsey, Hebe, 36
Dowd, Maureen, 3
Dunaway, Faye, 121
du Pont, Henry Francis, 32

Ebony, 218
Ebony Fashion Fair, 210–11, 213
Eiseman, Leatrice, 202–5

Eisenhower, Mamie, *20*, 21, 22, 37, *38*, *40*, 43, 56–57
Elbaz, Alber, 189
Elizabeth I, queen of England, 180
Elizabeth II, queen of England, 101–2, *103*, 105, 107, *128*, 178, 188, 194
Erickson Beamon, 181
Eugénie, empress of France, 28
Evangelista, Linda, 115
Evan-Picone, 37

Feith, Tracy, outfits by, 96, *97*
Fenty, Adrian and Michelle, 96
Fitzgerald, Ella, 107, 109, *109*
Ford, Betty, 40, *41*, 44
Franklin, Aretha, 211
Fraser, Lady Antonia, 112
Friedan, Betty, 39
Frost, Robert, 33
Fürstenberg, Diane von, 110, *110*, 112

Galanos, James, 37
Galliano, John, 86
Gap, 13, 99, 127
Garbo, Greta, 107, 109, *109*
Garza, Jesse, 86–87
Gaultier, Jean-Paul, 194
Gibson, Charles Dana, 107, 109
Gibson Girl, *108*, 109
Givenchy, Hubert de, 33, 114, 190
Givhan, Robin, 95
Goldman, Ikram, 67–69, 79–80, 86–87, *87*, 115, 174, 175
Gorbachev, Raisa, 105
Guevara, Ché, 107

H&M, 37, 127
Halston, 219
Harding, Florence, 22
Hepburn, Audrey, 107, *108*, 109
Hermès, 147
Hilton, Paris, 113
Hobson, Mellody, 67, 87, 162, 164, 167, 212
Holmes, April, 137, 140

Inaugural Ball gown, *58*, 59, 61, 62–64, 80–81, 84, *85*
Inauguration Day outfits, 1–3, *1*, 18, 64, *65*, 67, 69, *70*, 71–72, 74, *76*, 77, 79–83, 178, 190, 193–94
Ivon, Nena, 147, 199

Jackson, Janet, 194
Jackson Ruffin, Karen, 150–51, 158–59, 195
Jarrett, Valerie, 67, 137, 146
J.Crew, 12, 37, 99, 118, *119*, *132*, 134, 178, 190, 192, 193, 199, 214
Johnson, Eunice, 210–13, 215, 218
Johnson, Lady Bird, 21, 40, *41*, 44
Jolie, Angelina, 121
Joyner-Kersee, Jackie, 137, 140

Kahlo, Frida, 107, *108*, 109
Karan, Donna, outfits by, 51, 52, *52*
Kass, Sam, 170, *172–73*
Kaur, Gursharan, 208, *216–17*
Keaton, Diane, 110, *110*, 112
Kelly, Grace, 107, 117, 178

Kennedy, Jacqueline, 6, 7, 12, 21, 22, 24, 31–33, *34*, *35*, 36–37, 43, 46, 48, *53*, 62, 66, 107, 116, 120–21, *120*, *121*, 122, 160, 181, *218*

Khan, Naeem, dress by, *208–9*, 215, *216–17*, 219, *220*, *221*

Klausová, Livia, *129*

Klein, Calvin, 10, 126
 outfits by, 88, *89*, *129*

Kors, Michael, 96, 119, 120–21, 125, 190

Lagerfeld, Karl, 98, 194

Lane, Kenneth Jay, 37

Lanvin, 194

Lauren, Ralph, 126

Lincoln, Mary Todd, *26*, 27, 28, 51, 60

L.L. Bean, 151

Louboutin, Christian, 87

Lowe, Ann Cole, 66, *66*

Lyons, Jenna, 101, 118, 137, 186, 192

Mackie, Bob, 211

Madison, Dolley, 22, 24, 25, *26*, 27–28, 31, 33, 49, 51, *52*, 169, 181

Madonna, *59*, 110, *110*, 194

Marie Antoinette, 60, 181

McCartney, Stella, 162

McClellan, Cornell, 126

McCormick Lelyveld, Katie, 64

MDLR, 126

Mills, Ernestina Naadu, *130*

Mitchell, Joni, 112

Mizrahi, Isaac, 113

Molloy, John, *Dress for Success*, 93

Morrison, Toni, 169

Moschino, 122, *123*, 127
 outfits by, *129*

Moss, Kate, 121

Mugler, Thierry, 86

Muir, Jean, 112

New Etiquette, 188–91

Nixon, Pat, 40, *41*, 43–44, 46

Obama, Malia (older daughter), *16–17*, 118, *123*, 126, 142, *144*, *154*, *156*, *157*

Obama, Michelle:
 early years of, 148–52
 wedding dress of, *153*, 154

Obama, Sasha (younger daughter), 9, 15, *16–17*, 118, *156*, *157*, 160

Ogletree, Charles, 151

Olsen, Mary-Kate and Ashley, 111, *111*, 113, 121

Onassis, Jacqueline, *see* Kennedy, Jacqueline

Owens, Rick, 190

Paley, Babe, 107, 109, *109*, 195

Panichgul, Thakoon, 37, 68, 69, 71, 83–84, 86, 87, 99, 115
 outfits by, *70*, 71–72, *73*, *100*, *104*, 105, 122, *123*, 125, 130, *131*, 190, 215

Paste jewelry, *18–19*

Patner, Seth, 147, 148

Payne, Richard, 147

Pearls, 180–81, *180*

Pelosi, Nancy, 167

Pinto, Maria, 10, 12, 126, 146, 149, 159
 outfits by, *14*, 15, 122, *123*

Prada, 116, 147

Presidential campaign, 3–7, *5*, *8*, 9, 12–14, 48–49, 142, *143*

Price, Leontyne, 211

Princeton University, x, 149–51, 195

Radziwill, Lee, 33

Rahman, A. R., 162

Reagan, Nancy, 7, 22, 37, *38*, 39, 60, 93, 105, 127, 152

Reed, Mary Hutchings, 152

Reese, Tracy, outfits by, 122, *123*

Rice, Condoleezza, 95

Rodarte, 87, 190

Rodriguez, Narciso, 13–14, 37, 67, 68, 72, 83, 124, 136, 215
 outfits by, *16–17*, 74, *74*, *75*, 88, *89*, 96, *97*, 134, *135*, 190

Rogers, Desirée, 67, 136, 162, 211

Roosevelt, Eleanor, 23, 24, 39, *40*, 42–43, 60, 125

Ross, Diana, 111, *111*, 112

St. John, 94

Saint Laurent, Yves, 106, 164, 210, 211

Saks Fifth Avenue, 94, 147

Sander, Jil, 86, 147

Sarkozy, Nicolas, 105

Scaasi, Arnold, 7, 37, 56–57, 66

Schiffer, Claudia, 115

Sher, Susan, 141, 160

Simon, Carly, 112

Singh, Manmohan, 141, 207, *216–17*

Smithsonian National Museum of American History, 80, 83

Snow, Carmel, xii

Soronen, Peter, outfits by, *5*, 10, *78*, 79, 142, *143*, 174–77, *174–77*

Sotomayor, Sonia, 163

Spears, Britney, 194

Spence, Betty, 93

State dinner, *208–9*, 214–15, *216–17*

Stock, Ann, 45

Stone, Sharon, 114

Streep, Meryl, 112

Swarovski crystals, 79

Talbots, 37, 122, *123*

Tanenbaum, Carole, 19

Target, 10, 37, 127

Taylor, Zachary, 28

Ten Commandments of style, 124–27

Theallet, Sophie, 87, 164
 outfits by, *130*, 170, *170*, *171*

Time 100 dinner, 161–62, 190

Toledo, Isabel, 68, 82, 83, 99, 211–12, 215
 outfits by, 1, *1*, 2, 10, *11*, 72, *76*, 77

Truth, Sojourner, 167, 170

Tuckerman, Nancy, 32, 36

Turlington, Christy, 115

Ultimo, 67, 86–87

Valentino, 210

Verdon, René, 32

Versace, Gianni, 114

Vreeland, Diana, 33, 36

Walters, Barbara, 44, 80, 111, *111*, 112, 163

Warhol, Andy, 107, 219

Washington, Martha, 25, *26*, 27

Watanabe, Junya, 125

Watson, Emma, 113

Weinstein, Joan, 86, 87

Wilson, August, 93

Winfrey, Oprah, 162, *163*

Wu, Jason, 68, *81*, 86, 87, 99
 outfits by, 77, 79–83, *84*, *85*, 88, *89*, *100*, *128*, 193, 215

Yamamoto, Yohji, 86

Yosses, Bill, *167*

Zavala, Margarita, 128, *129*, 175

CREDITS

Page ii: Olivier Douliery/Getty Images. Page v: Brooches courtesy of Carole Tanenbaum Vintage Collection; photo by Stephen Lewis/Art+Commerce. Page vi: Fabric courtesy of Talbots. Page viii: Steve Helber/AP Photo. Page xi: Steve Andrascik/Courtesy of the *Newark Star-Ledger*.

1 Page xiv: Justin Sullivan/Getty Images. Page 5 (*from top*): Stan Honda/AFP/Getty Images; Emmanuel Dunand/AFP/Getty Images; W.A. Harewood/AP Photo. Page 8: Terry Gilliam/AP Photo. Page 9 (*from top*): Callie Shell/Aurora Photos; Alex Brandon/AP Photo. Page 11: Marcel Thomas/FilmMagic/Getty Images. Page 14: Sketches courtesy of Maria Pinto. Page 15: Spencer Platt/Getty Images. Pages 16–17: Joe Raedle/Getty Images. Pages 18–19: Brooches courtesy of Carole Tanenbaum Vintage Collection; photos by Stephen Lewis/Art+Commerce.

2 Page 20: Ed Clark/Time Life Pictures/Getty Images. Page 26 (*clockwise from top left*): Transcendental Graphics/Getty Images; Mary Todd Lincoln courtesy of Library of Congress; Frances Cleveland image by Corbis; Dolley Madison image Stock Montage/Getty Images. Page 29 (*clockwise from left*): Grace Coolidge by Howard Chandler-Christy, courtesy of the White House Historical Association (White House Collection); © Bettmann/Corbis; Courtesy of the Library of Congress. Page 34 (*clockwise from top left*): Ed Clark/Time Life Pictures/Getty Images; Paul Schutzer/Time Life Pictures/Getty Images; Leonard McCombe/Time Life Pictures/Getty Images. Page 35 (*both images*): Art Rickerby/Time Life Pictures/Getty Images. Page 38 (*from top*): © Bettmann/Corbis; Dirck Halstead/Time Life Pictures/Getty Images. Page 40 (*clockwise from top left*): George Silk/Time Life Pictures/Getty Images; Peter Stackpole/Time Life Pictures/Getty Images; Ed Clark/Time Life Pictures/Getty Images. Page 41 (*clockwise from top left*): Karl Schumacher/Everett Collection; AP Photo; © Bettmann/Corbis; © Corbis. Page 47 (*clockwise from top*): Rex Banner/Getty Images; Ron Sachs/Getty Images; Joyce Naltchayan/AFP/Getty Images. Page 51 (*from top*): Dana Felthauser/AP Photo; J. David Ake/AFP/Getty Images. Page 52 (*from top*): Dolley Madison by Rembrandt Peale, image © Bettmann/Corbis; Suzanne DeChillo/The New York Times/Redux Pictures. Page 53 (*from top*): © Bettmann/Corbis; Ron Edmonds/AP Photo. Page 55: Photo by Ted Mathias/AFP/Getty Images; sketch courtesy of Oscar de la Renta. Page 57: Robin Platzer/Twin Images/Time Life Pictures/Getty Images.

3 Page 58: Timothy A. Clary/AFP/Getty Images. Page 61 (*from top*): J. David Ake/AFP/Getty Images; Joe Raedle/Newsmakers/Getty Images. Page 65 (*clockwise from left*): Sketch courtesy of Maria Pinto; Gary Fabiano/**Getty**